Osman Yousefzada was born parents who were illiterate both tongue. An artist and writer v Central Saint Martins, he has a University. His visual art practice – ~~~ sculpture, moving image and textile installation – has been showcased in international programmes at the Whitechapel Gallery, MCA Sydney, Dhaka Art Summit, Ikon, V&A and more. He has made clothes for Beyoncé, Lady Gaga, Lupita Nyong'o, Gwen Stefani, Emma Watson and many more. His experience within the fashion industry continues to inform the politics of his practice concerned with the rights of the anonymous worker and disposable consumerism. He edits *The Collective* and has written for *Vogue*, the *Guardian* and *Observer*. Osman is currently a research practitioner at the Royal College of Art and visiting fellow at Jesus College, Cambridge. *The Go-Between* was longlisted for the Polari First Book Prize in 2022.

'Eloquently honest and eye-openingly frank'
The Times

'Arresting . . . moving . . . What really lingers are the vividnesses of [Yousefzada's] childhood world, the struggles and griefs of his parents, and especially of his mother, to whose life he bears loving witness'
Guardian, Book of the Day

'A moving parable of identity and belonging that is as humorous as it is, at times, heartbreaking'
Vogue

'Through inspiring, humorous and at times harrowing vignettes, Yousefzada explores his struggles with the dual burdens of racism and cultural expectations'
Elle

'A fascinating memoir, quite chilling in parts and uplifting in others'
Nihal Arthanayake

'[A] dazzling memoir . . . This is a remarkable story'
Damian Barr

'Yousefzada is a gifted storyteller who writes with such tender care'
Mona Arshi

'*The Go-Between* is a memoir, but it is also an unstitching of memory's fabric and a fiercely unpretentious reckoning with family and home'
New Voice

'This unmissable memoir sheds light on a largely unseen part of our shared cultural history, told with warmth and insight'
Perspective

'Evokes hope for all misfits, outcasts, underdogs and dreamers'
Nazanin Boniadi

'What Elena Ferrante does for Italy, Yousefzada's *The Go-Between* does for Immigrant Britain'
Dazed

THE GO-BETWEEN

A Portrait of Growing Up
Between Different Worlds

Osman
Yousefzada

CANONGATE

This paperback edition published in Great Britain in 2023
by Canongate Books

First published in Great Britain, the USA and Canada in 2022
by Canongate Books Ltd, 14 High Street, Edinburgh EH1 1TE

Distributed in the USA by Publishers Group West and in Canada by
Publishers Group Canada

canongate.co.uk

2

British Library Cataloguing-in-Publication Data
A catalogue record for this book is available on
request from the British Library

ISBN 978 1 83885 978 7

Typeset in Bembo Std by Palimpsest Book Production Ltd,
Falkirk, Stirlingshire

Printed and bound in Great Britain by Clays Ltd, Elcograf S.p.A.

MIX
Paper from
responsible sources
FSC
www.fsc.org FSC® C018072

AUTHOR'S NOTE

The names and any identifying features of the people, places and events have been changed or merged to ensure that they are not identifiable so as to protect the privacy of individuals. This is a series of vignettes formed around my memories and my experiences and as with all memories recollection sometimes meets fiction.

I would like to dedicate this book to my mum
who is beautiful both inside and out.

To my inspiring sisters who are the most powerful
and strong women I know.

To my brother for his tenacity and for fulfilling
his immigrant dream.

To my dad for your strength and conviction. If it was
not for your voyage to England this story
would have been so different.

CONTENTS

I

OUR HOOD, OUR HOUSE,
AND MUM'S SEWING SALON

No. 12 WILLOWS ROAD WAS our house, with its holy green door. Down here on earth the doors of the faithful were always painted green, signifying the colour of the pure, the colour of Islam. We straddled the boundary of Balsall Heath and Moseley. It was on this street and those around it that all the immigrants – Black, white, brown – were housed; the prostitutes, the pimps, the broke artists and the ultra-orthodox, all searching for a better life here or in the hereafter.

Turning left at the bottom of our road, then walking south up the hill, was Park Road. Here you would see the start of bohemian Moseley, where the housing stock turned from cramped terraces to semi-detached buildings.

Eventually, you'd reach the larger, detached houses around Moseley Village, with their own secret gates into a private park. This was Moseley Park, with its own lake and its own

black swans, ducks, geese, moorhens and waterfowl which would promenade around the manicured lawns, then elegantly descend to swim in this magical oasis. To get inside this enchanted world, away from everyone, you needed a key: Mrs Morris, our primary school teacher, had one, and in the summer she would take us on school trips there, opening the magic door and leading us through it.

I walked through Moseley Village every day to go to school. Big, tranquil oak trees lined each street. The air was different there: you could smell the affluence – the perfectly pruned privet hedges, the magnolia trees, the front drives. It always fascinated me that none of the windows had net curtains; the front rooms were open for all to see, with their mahogany dining tables, candelabras, shelves of books, cut flowers in vases and glossy leather sofas. Even their politics were on display in some of the windows: Red Labour Party posters canvassing for the long-standing Member of Parliament, Roy Hattersley.

Here lived Birmingham's professional middle class – the educated, the educators, the bureaucrats, many of them social-ists – in bucolic streets with their grand names, as if lifted from Jane Austen: Salisbury Road, Chantry Road, Oxford Road, College Road, all elegantly curved lanes that crisscrossed and meandered into idyllic tableaus at each turn.

We marvelled at how expensive and big the houses were in Moseley. My dad, Tolyar, a strong man, a man of few words, a carpenter, had fitted all the joinery for one of the larger houses in Chantry Road. It had twelve bedrooms, a drive, a garage and a granny flat. I would sometimes take Dad his lunch when he

didn't feel like walking the twenty minutes home, and on occasion he would let me explore this cavernous palace. I would run eagerly into the back garden, through to the private park, follow its path that snaked around the small lake – but Dad would quickly summon me back just in case I fell in.

Our own terraced house always had its net curtains drawn, never letting in the light. They hung from an immovable, tight wire and you needed to lift them up if you wanted to see who was at the door. No one could ever see in from the street, and you could just about see out.

Back then our family all lived on the ground floor of a house my parents owned. It comprised a front room, a back room, and a small kitchen-sitting room which opened up to the garden. Dad said he had bought the house from Sikhs, who had let the whole house to the Irish, and no one had cared for it. He had spent weeks cleaning it; the linoleum on the floor had congealed with the previous layers, and underneath he would count everything he cleaned: the balls of hair, human and animal, the layers of dirt, the grease and rat droppings. He had saved money, sending some back home and keeping the rest, so four years after his arrival Dad had bought a home in England's second city – Birmingham. The beds were there when he moved in. When the deal was struck, the Sikhs agreed not to charge interest on the outstanding sum, Dad always proud, when he repeated the story, of how he saved himself from hell-fire by negotiating a higher price upfront, avoiding any profane dealings with usury.

Dad now slept in his huge old double bed in the back room, which my mother, Palwashay, would also sometimes sleep in, and

she had her own single bed on the opposite side of the room. My little sisters, Ruksar and Marjan, would alternate between Dad and Mum's beds. My older brother, Barak-Shah, would sleep in a single bed in the front room, and sometimes, when it was too cramped next to Mum, I would join him there. My elder sister, Banafsha, would sleep on the settee in the back room.

There was a railway track at the end of our back garden, past the apple tree and the vegetable patch where my parents grew beans, spinach, courgettes and mint. Every so often trains would thunder past, and my sisters and I would stand and watch them from the fence at our garden's perimeter. They were mostly cargo trains; wagons with no windows. Occasionally there would be precious open cargo for everyone to view: fresh new cars off the factory floors at Leyland, Rover and Ford. The cars were all packed on top of each other, sprayed in countless polished colours. On these tracks you would rarely see passenger trains. None of the trains ever stopped or slowed down, but we waved at them no matter. We were explorers. We could easily hop over the small fence to pick wild blackberries in the summer, climbing up the mound towards the summit where the railway tracks sat, and we'd stand there at the top, not far from the tracks, watching the trains as they rushed past, the resultant tornado pushing us back, making us unsteady on our feet.

There was an outhouse, too, in the back garden, which at one time had been a coal shed. One day I created a shrine in there, dedicated to my sister's replica Barbie, which I had bought at a local jumble sale. I had made a green Devoré dress using the off-cuts from the floor of Mum and Dad's bedroom, which also

acted as Mum's workroom. I cut three holes, one for Barbie's head and one for each of her arms, sewing up the centre-back by hand. To finish it off, I made her a two-piece pink burqa out of Terylene: a coat with two holes and a popper sewn on the front to fasten it, and a square handkerchief for her hair, with ribbon strips to tie under her chin. Roxana the Barbie was enthroned on an upside-down Dairy Crest crate – in which the milkman deposited the milk each morning – covered with one of Mum's embroidered tablecloths. Beside and in front of Roxana I laid out my offerings of tangerines and homemade cakes.

As I prostrated myself before her, Mum put her head round the curtain and found me with my arms outstretched (it must have been something I had seen on our small TV), bowing to my queen of dolls – my Cleopatra! She sprang at me, grabbed me from my sacraments, yelling, 'What are you *doing*? Are you a Hindu? Just wait till your father gets home!'

I waited for the worst of fates – Dad could get very mad. He'd always said we were lucky to be born Muslims; we would be spared the fires of hell. Muslims were the believers of 'God as one', with no physical form to worship. He was omnipresent, but you could only pray in the direction of his house, the one the Prophet Ibrahim built in Mecca. To be born a Muslim, find the true path, and then turn away as I had just done – to become an idolater – would, I knew, result in an apocalyptic descent into the furnace of hell.

Just before Dad arrived home that evening, I took the precaution of changing into my mosque clothes and hat. (Mum always said I looked angelic all in white.) I had also been frantically

5

practising my prayers. I waited . . . waiting for the moment, for Mum to say something to him. She never did.

Ali Campbell from the reggae band UB40 lived at the bottom of the street. I hadn't seen them on television, but Barak-Shah had, and since they had been on TV, everyone talked about them. Norman Hassan had been a carpet-fitter before he became the trombone player. They had made it, they were famous now, and pride seared through everyone that they lived in our hood. Each one of us had a story about how we knew them. My best friend, Spinzar, would say that his cousin had written the lyrics of the hit 'Red Red Wine'. Barak-Shah would play the songs in his car, the songs written and sung from our streets. He told me that Norman had been to Queensbridge School, like him. I was still at primary school and would probably follow Barak-Shah on to his former school in a few years, especially now that this guy from this famous band had gone there.

Ali Campbell's house on the corner of our road was the biggest. He surrounded it with fir trees – like colossal Christmas trees – which grew at least twenty feet tall. It wasn't as big as the houses in Moseley, but compared to the terraced houses on the street it looked like a mansion. He had painted the outside walls lime green, and hanging from the window frames were venetian blinds, just like the local dentist's office. Those lime-green walls, fir trees and venetian blinds set the house apart,

but these symbols of success didn't stop the ladies of the night standing outside, waiting to be picked up.

These ladies were always on the street after sunset, sometimes in front of our house, or scattered up and down the street on each corner, or under the bridges. They were different; they didn't wear the same clothes the white teachers wore at school, or the clothes our lodger Mary wore. I had been largely oblivious to them, but suddenly I began to notice them and they seemed to be everywhere, sashaying across the stretch of our road under St Paul's bridge.

They would start coming out just before it got dark, when I was on my way to the mosque. On my return, everything would play out like a slow-motion movie, the kerb-crawlers cautiously cruising up and down the streets, flashing their head-lights, stopping under the bridge. I would watch, mesmerised, as the ladies glided by in satin negligées under their fur coats, and golden strappy sandals that dug into their pale skin on cold nights, the straps crisscrossing over their bright-red painted nails. Some of them wore long, thigh-high boots pulled over their knees. Car windows would scroll down and these mermaids would bend forward and say a few words through the window. The door would open, and they put those thigh high boots or bare legs forward, tucking their head under the door frame to jump in.

Spinzar told me that Maggie with the big blonde Barbarella hair was the madam. I didn't know what a madam was – he explained she took all the money. She was the boss lady. Maggie worked with the pimps, looking after all the girls. She was in

charge of the strip that stretched from St Paul's Road all the way down to St Mary's Row. She would always say 'Hello, chuck. How are you?' Here most of the girls stood around in pairs, but five minutes' walk to the east, down Edward Road to the red-light district of Cheddar Road, the more upmarket ladies would turn on the red bulbs in their terraced windows and sit in their brightly-coloured nighties, ready to serve.

The older boys at the mosque were forever telling us to look away from these temptations of Satan. *Never say hello! And always, always keep your gaze to the floor.*

Jameela was different, stunning. She worked the patch along St Paul's Road, under the bridge, and normally took clients into the car park behind Moseley Road. Some of the older boys would follow them and watch. Jameela wasn't white or Black; she had the same skin colour as me, and everyone who came to our neighbourhood wanted to know who she was. When she greeted me, I always said hello back, sheepishly, a bit discreetly in case someone heard. It only seemed polite when she had said 'Hello, love' and smiled so beautifully.

Her bright-red lips, her wet-look Michael Jackson perm and studded oversized leather jacket made her look more like a pop star from the TV. She would stand on a street corner in a faux fur coat in the winter, or leather jacket in the summer, waiting for her customers. At night, she and her friends would decorate the streets like tinsel, strutting up and down, shouting, laughing and smoking. In the mornings, Spinzar and I would look for evidence of these ladies on the streets: soiled condoms in the alleyways and gutters, along with a few syringes that we

occasionally picked up so we could play doctors and nurses. It wasn't only Maggie the madam, the pimps and Jameela selling their wares of flesh who were awake and active into the night. Balsall Heath didn't go to sleep, even for the holy. The faithful would get up in the middle of the night and wash themselves in readiness for prayer and supplication. These were extra prayers on top of the daily five that devout Muslims were obligated to carry out. The imam would regularly say to us at the mosque that when you disturb your sleep for prayer, God is at his most merciful in the darkness of night. It is then He listens to you.

Our house had two other floors, both of which were rented out. The attic floor – where I would eventually live out my years of teenage angst, knowing on so many levels that I did not fit in – was rented to Mr McEvoy and his wife, Mary, both of whom were Irish.

There was a warm halo around Mary; bubbly and nearly round, she chuckled loudly, fizzing with vigour. The fact she couldn't have a meaningful conversation with Mum due to the language barrier didn't stop them spending time with each other. Mary loved Palwashay's cooking. They smiled a lot together, engaging through hand gestures, facial expressions and mutually exclusive languages in shared observations about the world and, of course, food. Mary was the same height as Mum, around five foot four, and her chestnut hair would bob up and down as she clomped around on her chunky heels. Her pageboy bob was a

carry-over from the previous decade, along with her seventies geometric nylon dresses.

Dad had bought Mum a similar pair of second-hand platforms with laces when she had newly arrived in England. Mum would only ever wear them when she visited someone. The platforms lived at the bottom of an old wooden chest in our back room: like the beds the rest of the furniture hadn't changed into the 1980s. On the odd occasion when Mum needed to make an impression, she would ask one of us to take them out and bring them to her. I would normally get there first, pulling open the drawer and taking in the whiff of mothballs, retrieving the plastic, perforated shoes with their faux laces. Mum couldn't understand why anyone wanted to be lifted up from the ground, saying, 'These shoes are for white women, not for us.'

By contrast, Mary never took off her platform heels. Her printed dresses hung down below her knees. Sometimes Mum would mend or tailor Mary's dresses and second-hand buys, or occasionally adjust her coats by hand, as she usually couldn't feed the heavy fabric through her machine. Mary would always pop her head around the door on her way in or out of the house, asking Mum to cook parathas. The smell of Palwashay's cooking would permeate the house, drawing Mary in: her favourite dish was spiced omelette with a buttered paratha, which she would eat sitting on a fold-out settee, leaning over a knee-height coffee table that Dad had made. This functioned as our dining table and Mum normally covered it with an embroidered cloth.

Mary exchanged her knitting skills for food. My mother absorbed all the knowledge she could from Mary, and in between

cooking and feeding us and sewing for everyone (either for cash or barter in the street), she managed to master the skill of knitting, creating her own patterns, almost always with multicoloured threads. Needless to say, we all got new jumpers.

Banafsha, my elder sister, loved following Mary around, climbing up the attic stairs. I'd follow her too but usually gave up halfway past the second landing, frozen with fear, as brave Banafsha carried on up to Mary's attic and knocked at her rooms. More often than not, she'd come back with sweets, which she would reluctantly share with the rest of us.

It was Mary who brought us Jason, a ginger cat we named after Jason Donovan (and any cat since is always called Jason). Banafsha said that Mary had assured her she had brought it especially for her, so it became Banafsha's cat. Mum had always kept cats, as mice and rats were regular visitors, and her last cat had been run over. We found it dead on the pavement, so I buried it in the back garden, lifting it up with Dad's shovel and lowering it into a shallow ditch. Banafsha and I held a funeral procession, inviting Spinzar and the other kids from our street. Mum cooked us sweet rice and I prayed over the grave and covered it with wild rose petals from the garden.

Jason was the champion mouse-catcher on our street. He would bring all his kills into the house and lay them at Mum's feet. His diet was scraps and offal from the local butcher's, and it would be me or Banafsha who ran to Mr Khan's every day for Jason's dinner. When Mum wasn't cooking or sewing she was obsessed with making everything sparkle, and she made Jason undergo a weekly Friday ritual – a bath to make him shimmer

and shine, just like the bathroom tiles and the kitchen floor. Lathered up and washed down with water, he was then towel dried and placed in front of the paraffin heater in the sitting room and left to dry on top of a pile of old newspapers.

Friday was the day dedicated to cleaning. Our ground floor would be heady with joss sticks. The vinyl flooring would shine, every surface was mopped down with Dettol, and even Mum would sparkle more than usual on that day.

I can't remember when Maryam, her elderly husband Baba, their elder daughter Humaira, younger daughter Aliza, and their two young sons moved into our house. It seemed to me they had always been there, living on the first floor. They had fled Idi Amin's brutal cleansing of Uganda. I had heard Maryam say to Mum that Amin had given them ninety days to leave Kampala. They left everything behind – their clothing factories, their fabric stores, a life of privilege, their beautiful house with servants – and were now living upstairs in our little terraced house. As teenagers, Humaira and Aliza would pick Banafsha and me up, carrying us upstairs to play. So we grew up over these two floors, eating with Maryam, and being introduced to the joys of chilli. (Our own Pashtun food was strongly flavoured, but never too spicy.)

Maryam and her family lodged with us for over seven years, into the mid-eighties, even with Dad as their landlord: he would never buy or replace anything for the flat, meeting a request for

a new settee or a new bed with a firm 'No', followed by 'I don't have any money.' However, Mum would covertly give Maryam's sons money to go out and buy a sofa for themselves, or anything else they needed. Despite my father's unwillingness to improve the flat, Maryam and her family didn't move on. She still hadn't managed to save enough to buy the family a place of their own; Baba was too old to work and their children too young – this was his second marriage.

Maryam couldn't go out to work; someone needed to look after Baba, so she opened shop in the rooms she rented from us, selling supari (betel nut) on the side. Sackfuls would arrive from India, sent by her sister who lived there. Maryam would store the sacks in the corridor and under the beds. Alongside her supari, she sold scarves, saris and fabric her sister sent over. They had their own doorbell, now Mary had moved on, which we could hear, and I would peer through our window at all those masticators, addicts of betel nut with bright-red teeth, who came to buy their fill.

Maryam's flat seemed to overflow with empowered women; they would sit cross-legged on the floor, or on chairs at the dining table, so sophisticated to us. At this table her guests would sit poised with elbows on its edge, pick up their spoons and slide the food of Gujarat via Africa into their mouths. Golden bangles would glide down their wrists, their hair wrapped in black scarves, their eyebrows threaded and darkened to match their obsidian chadors. Baba, the elderly husband, was the token male. This matriarchal group became like sisters to Palwashay: they were her support group, her promoters and protectors.

As time went on Mum finessed her lingua franca of Hindustani and Urdu, communicating well with Maryam, despite their different mother tongues.

It was the buyers of supari who became Mum's informal agents. Maryam would say, 'You must see Palwashay, the Afghan lady downstairs, she sews like a dream and is really cheap.' Mum didn't know how much to charge so she started with £2 a dress, then went up to £5. In the back room, she carved out a small section of the carpet for herself, the central space that didn't hold any furniture. This became her workroom.

I had heard Dad objecting to the constant stream of women flowing through his house. He didn't mind having the money but didn't like so many different kinds of women. Fortunately, most of the time he was at work, or the women were hidden in the back room or kitchen. Dad didn't know who was coming into the house, or who went behind the curtain, the division between the front room, the world of men, and the sanctity of the back rooms, the women's chambers. He wasn't allowed into the back rooms when we had visitors: that was the world of women.

As Mum's impromptu business grew, the house became a mecca for all kinds of women who wouldn't normally have met anywhere else: the Indian-Africans, the Ismailis and the Shias, the Sikhs, the Hindus, the occasional white folk, the Muslims; amongst them Punjabis, Kashmiris, Gujaratis, and us Pashtuns. Dad said the imam had told him that the Shias were not Muslims and that they caused mischief and segregated the *ummah*. They had ruptured God's chosen community, resulting in the big schism of Sunnism

and Shiaism in the Muslim diaspora. Still the women came, buzzing with betel nut from upstairs, and would sit and talk while their clothes were stitched by Mum, no matter what Dad or the imam had said.

I noticed that the hem embroidery on trousers was one thing on which everyone spent money. This embroidery and the rest of the trimmings required a little more expertise and were the most noticeable of details. The cuff of a sleeve, the neckline and the hem of a pair of trousers all had to be meticulously finessed by hand. It was these additional features that provided structure and a focal point to the garment and allowed the fabric to move, particularly with not-so-fitted shapes sewn in polyester satins. Some of the clothes Mum worked on were heavy winter velvets, chenilles and crimplenes, more appropriate for curtains. The winter weights kept the damp and cold out, and in the summer the women would swap them for big floral cottons, silky satins and Crêpe de Chines. No ankles could ever show for the ultra-orthodox! Mum would either create your full garment, cutting and making it, or some of the women would bring the fabric and ask Mum to cut out the pattern to their size. After she had cut the fabric she would hand it back, so the wearer could sew it themselves. Their finished seams and hems weren't as pretty as Palwashay's; so again partly-made dresses and suits were folded in plastic bags, huddled under armpits and brought over to our back room by modestly dressed women to be transformed, with Mum's deft fingers finishing off the complicated parts.

Arriving in Mum's workshop one by one, two by two, or in

groups, chattering loudly, the women would eye up the fabrics draped across the furniture. It was an unusual and independent act for our women to pick out their own fabrics and take heed of the latest trends in fashion. Many women in our orthodox community had fabrics chosen for them by husbands or sons. Women could never be seen or interact with men from our community unless they were family. There was no sanctity in the streets, outside of our homes, so the men handled all dealings, including the shopping for the women – in shops run by men, their only customers men. Dad bought Mum her fabrics; he loved to see his Palwashay in bright colours. He loved the brightest reds, but Mum's favourite colour was pale green.

Occasionally, Dad's married friends brought their wives with them when they visited our home. According to the laws of segregation, the men would sit in the front room while the women would sit in the room at the back. The back room was where I felt most free, amongst the colourful clothes, with all those exotic birds chattering away. Always, always my mother would end up behind her sewing machine altering something or making something new. Within moments, after a cup of tea, one of the women would have new curtains, a cover for her settee or a traditional salwar kameez, and if you wore western dress – with the aid of a torn-out page from a fashion magazine – you would get a new dress.

Mum came from a generation of artisans; it was in her blood. I loved the way she could pick up a piece of fabric with confidence and work straight into it like a sculptor approaching a piece of marble. She would cut it without a pattern, cut it on

the floor without a table. She would then put away her scissors in the brushed-nylon pouch she had made especially for them.

One of my most vivid childhood memories is of Mum carrying her sewing machine on her head, Banafsha and I holding on to the abundance of her dress, layers and swathes of opulent synthetics, as we marched across the railway tracks towards the houses on the other side. The railway created a natural divide between the posher large detached houses and the terraced back-to-backs where we lived. We proceeded towards Mrs Bibi's house. Mrs Bibi could afford to pay for her clothes to be made from beginning to end, and would summon Mum when she needed more.

My mother, my sister and I would spend the day there while my father was out at work. We were offered food and we played with children whose names escape me now. My mother would listen to the women talk, and occasionally would stop to chat, but she knew what her focus was: to cut and sew and, in no time at all, to transform a flat piece of fabric into a colourful dress.

Watching Mum was like watching a magician: she would piece two pieces of fabric together, cutting a neckline straight into the fabric without drawing an outline or pinning a pattern into it, then embroider it to finish it off. On the days I didn't go to school – which were many, but more on that later – I sat with her all day and watched her work. I helped her fold her fabrics or take out the creases before she picked up her scissors to cut. She would ask me, 'Which colour do you like?', and I always chose blue. I knew that her favourite colour was most

shades of light green, whether bright parrot green or a more muted eau de Nil. She had only one suit in this colour, parrot green with touches of mint. The fabric had small fil coupé iridescent flowers woven into it, and when she wore it she would radiate beauty, the soft brown tones of her skin complementing the light green, her whole person glowing like a diffused jelly-fish wrapped in her chiffon scarf. I began to love this pastel colour too: Mum looked beautiful in it; I considered it truly sophisticated.

Coming home from school, I always wanted to know what Mum had made that day or 'finished', eagerly offering to help, hoping that there was a major emergency, that she was late for an order, and I didn't have to go to the mosque. Sadly, that never happened. 'You can brush the floor of all the threads,' would be her first answer. The shiny laces that trimmed the matching shawls on the vivid salwar kameez attracted me like a magpie, and I would take the scraps of lace and any other small off-cuts as treasure, surreptitiously putting them in my coat pocket.

The curtain in the hallway sealed off the inner quarters of our floor – our bedroom, the kitchen and the front room where the men sat. To the right of it were the stairs to the upper-floor flats. Mum made the dividing curtain herself and changed it every few years. Sometimes it took on shades of lilac, in a damask with paisley woven through it, or burnt yellow ochre in Victorian flocks and florals. It allowed Mum and her guests to walk around

without their outer robes while still observing the obligatory purdah. All these women enchanted me. I was still young enough to be allowed around them. Dad would only enter when there were no female visitors other than those who were either *mehram*[1] or whose families were close enough to ours to relax the rules of face covering.

I was the go-between to these two worlds, the world of women and the world of men. The front room was out of bounds for Mum, as was answering the front door, so I would open it, puffed up with pride at my mother's popularity and skill, and show our female visitors in. One day I overheard Mum remark of me to a visitor, 'He's a woman amongst women and a man amongst men.' This filled me with both surprise and horror, but she had followed it with praise too. 'Look how clever Osman is: he has matched all the chiffons and laces together by himself. He listens to me; he is a good boy.'

One of my first memories is of crying into the bright-orange, brushed-nylon settee covers that Mum had made, and which added a vivid splash to the room. We had visitors that day. A young girl had come with her mum, in a bright-pink satin dress with matching trousers and a gold, crocheted waistcoat – a girl my age, pre-school, her hands painted with clumsy patterns of henna. I can't recall her name. It must have been around the Eid festival, as everyone was dressed in their finery. I was wearing my favourite *sadri*, a velvet waistcoat with mirrors that caught the sun. Dad had bought it for me, sparing no expense. The

[1] Close family, and more particularly someone you cannot marry.

girl's herb-stained fingers were finished off with nails painted in a rich, spellbinding vermilion. I was bewitched, my eyes feasting on those tendrils of colour. I kept looking, observing as always. We played together, and when she and her mum left, I collapsed on the settee, crying for my nails to be dipped in the brightest shades of red. I remember the following scene as if I were hovering above everyone, watching it unfold like a mirage. In front of me, Barak-Shah was fighting with Mum, who kept asking him to go to the chemist to get a bottle of nail varnish. Mum's ablutions before prayer would be incomplete with synthetic varnish on, a barrier to her obligations to God, so she didn't have any at home. To indulge me, to stop my crying, she kept fighting with Barak-Shah to force him to go the chemist. 'Look, he's crying,' she said, 'he's only a child.' He left the house, shouting back as he went, 'You're gonna turn him into a girl!'

Shortly after, he returned with a paper bag, the bottle hidden inside. I stopped crying as Mum held and opened the red bottle, and she painted my nails. I had been transformed.

I didn't think I wanted to be a girl, but sometimes I wanted to try on their clothes. They were so much more colourful than mine. I loved how they painted their hands with henna and I loved the gold jewellery they wore – the earrings in each of the customary five piercings; their golden headbands, bejewelled with discs that danced with the light as they moved; the chokers around their necks; over their tunics the garlands of gold chains, pendants hanging off them. On their fingers shone ruby-red and gold rings. There were also rings for their thumbs. On their ankles, golden bells chimed as they moved. Around their wrists,

golden bangles and cuffs rustled as they walked. To finish it off they wore matching sandals on their painted feet. They were so beautiful, with their long hair and their smooth skin. I was captivated by the way they moved, and how they covered themselves with layer upon layer of clothing.

The first time I explored wanting to be a girl was when I saw a bride at a local wedding. I marvelled at her embroidered red veil, and the way the women would lift it up again and again to offer her salutations. They would kiss her three times on each cheek and then on her forehead. To top it all, everyone gave her money, five- and ten-pound notes, which she put out her hand to take and placed in her matching red velvet pouch.

Afterwards I told Hooriya Jaan, Mum's best friend, that I wanted to become a girl – to become a bride and dress in red and wear all that beautiful gold jewellery. Hooriya Jaan smiled and said, 'Of course you can.' She devised a plan for my transition involving a dead saint, and a long journey. 'You have to go to the Shrine of Sakhi Baba, the holy man in Saleh Khana, in the Frontier for forty Thursdays, and if you pray at his shrine for each of those Thursdays, he will grant you your wish.'

I wondered how I was going to get to Sakhi Baba's shrine so I asked Mum where the shrine was, but didn't tell her quite why I needed to get there. She looked at me bemused and replied, 'It's a very special place, and we will go one day.' We never did.

2

THE CHARPAI, THE SLIPPER,
AND THE JINN

MOST DAYS WHEN WE GOT back from school, Mum would make hot dodai, place the scorching hot bread on the table for me and Banafsha, then sit and watch us eat. On one of these occasions, she seemed to be in deep contemplation. She looked directly at me, but then her gaze went through me, as if she wasn't speaking to us.

'When you were coming into this world . . .

It was time for me to go to the hospital, it was a Monday night, and your dad had come back from work. I told him that it was my time, that I wasn't well, and that I needed to get to the hospital.'

At this point her eyes shone.

'Your dad looked at me, and there was no pity. He just said there was nothing to eat, that he was hungry and I should cook him his meal and then go. So I got up in the middle of my

contractions, as you were pushing to come out, and I chopped some fresh okra, blending it with vegetables and spices, then cooked it to perfection to present it with his dodai. Then, and only then, I put on my coat and managed to get to the hospital.'

Maybe that was the reason I loved okra so much. The aroma had reached me inside Mum's stomach, luring me out.

I wondered at Mum's mood. She never talked like this. I didn't know then where babies came from. I only knew that you took the tablet the doctor gave you, and then you went to the hospital to collect your baby.

Mum kept talking: she wanted someone – anyone – to hear her. She was reciting, not prayers, but her stories. She couldn't write them down, so in case she forgot, she continued telling them out. Listing her beatings at my father's hands; beatings she said had begun almost as soon as she had arrived at her own wedding party.

Her litter had been perched high on a Bactrian camel with two humps. When the camel lowered itself to sit and let her dethrone, layers of white veils were peeled back to reveal Palwashay, aged fourteen, in her pink and green wedding dress, ready to enter her new husband's courtyard – her new home.

'My first beating was soon after – over the charpai.'

As is the custom for nubile virgin brides, she was made to sit on a charpai for seven days so everyone could see her. My grandfather was famous for his charpais, creating the perfect tension of interwoven jute ropes that crisscrossed the four sides to create the ideal mattress. People came from afar for their beds to be made by his hands, and on Palwashay's wedding day

he had gifted his daughter four cots in her trousseau. They were carried to her new house behind her in procession.

It is impossible to underestimate the importance of the charpai in the Indian subcontinent: they act as a cot, a bed, a table, a litter. They hold so much more than a body. They circumscribe births, marriages, deaths, and all that happens in between: dining, resting, sleeping, chatting, crying, recuperating.

It was the bed that she would lie on in wait for her womb to open and expel the first child that been planted inside her, Barak-Shah, and it was on this charpai that she swaddled him, lying afterwards in rest and thanking God that she had survived.

I had heard Mum say, 'It is from the charpai that the phrase came about, that a woman would leave her husband's house in no other fashion and under no account than when her heart had stopped on the day of her funeral.'

After you had departed this world, the charpai carried you to your grave, high above the bearers' heads, your body shrouded and then lowered into the brick-lined pit. Heavy slates would seal you off from the world, allowing your body to rot away from the eyes that once saw you, wandering upon this earth. Now you were in complete purdah.

Her first beating was over the charpai: Dad's mum had already served him his meal but my newly married mother stepped forward, offering a stool for Dad's plate to sit on so he could eat his food more comfortably. This is what she had learned to become a good wife. This is what she'd seen in her parents' household. It was for this act of love that he beat her – for presuming that she knew better than her mother-in-law.

The charpai, the *manji*, the *khat*, never made it to Birmingham: unlike tea, the British hadn't made the charpai their own. When Dad, then later Mum, arrived they found civilized settees to sit upon, even dining tables to eat from, along with sprung mattresses to sleep on. We were in Vilayat, 'Blighty', and we were British now.

This beating over the charpai would be brought up again and again. Mum never forgot her pain, nor would she let those around her forget. Like storytellers, she and her friends would gather and listen to each other's heartbreak, even if they had heard it before. My closeness to this world of women was to come to an end as I grew older, but for now I stayed as close as I could. It was a full-blown epic, of tragedy, pathos, colour, jewellery and clothes, compared to the drab, smoky posturing of the men, who all seemed the same, who all dressed the same.

The women were more beautiful and were all puzzlingly different. They fell into and came from two worlds: our community, from remote areas of Swabi – the heartland of the Frontier, the plateau bordered by the River Kabul and the great Indus – where women adhered to the custom of the veil and inhabited the four walls of their home, leaving the men to navigate the outside world; not stepping out without the permission of their husband; and in the same country there were freer women, across the Indus in Punjab, Sindh, Balochistan and Kashmir, who ventured out and were able to do their own chores, and make their own decisions outside of those four walls. This divide

between the two worlds, old and new, carried over onto the streets of Birmingham; through the eighties and nineties, through the continual recessions, they held on to what they knew. The pious among the women saw themselves as God- and husband-fearing, whilst those who ventured out to the streets and shops saw nothing wrong in their actions. They saw these covered, segregated women as backward villagers from the Frontier and frowned at how these tough men from the mountains controlled and 'protected' their women.

Nevertheless, there was a bond between the ultra-orthodox and the 'moderns', as I thought of them – they were close and co-dependent. They lived in the same neighbourhoods and some would shop for those who couldn't go out. They would look after each other's children, barter recipes, teach each other newly acquired skills, speak of the wonder of the world outside, tell stories of the gigantic shopping centre, and of the fish and flea markets, where great bargains could be found.

Occasionally, without their husbands' knowledge, one or two of the more orthodox women would cover up and wander out to explore the bigger world, the sparkling towers, the sprawling markets. On these very rare ventures, they could buy their own underwear, and choose their own colours.

Our own Swabi community kept to its own ways more rigidly as the urban society we inhabited became more and more alien. The men continued to view these modern women with suspicion, as corruptive forces who would lead their pious wives astray. They had even begun to drive cars, and some even worked outside their home.

The purpose-built mosque on the Belgrave Road had allocated a space for women, a balcony on the second floor veiled in thick net curtains. They could hear the prayers and sermon through loudspeakers that brought the words of the imam into their space, but they couldn't be seen. At Friday prayers they flooded the separate women's entrance like colourful birds in their regional costumes, very few black robes amongst them. They wanted to take part in the rituals and communal prayers that had only been afforded to the men. Now they had their own space.

Black robes came much later on, as Salafist and Wahhabi thought promoted a universal modern Muslim identity, and the doctrine of wearing the abaya and hijab. Nevertheless, even if a more forward-looking mosque gave women their own space, our women were not allowed outside the four walls of their house, let alone inside the mosque that their husbands frequented. Admittedly our Pashtun community, all from one region back home and guided by the imam, was a very distinct subculture.

Mum's sewing salon had no bars on letting the modern women into an ultra-orthodox space. It was good news for me as I watched the many different women who came to the salon. Perhaps it was their 'hiddenness', their necessarily secretive lives back then that enthralled me, but it was also their effect on Mum. Her friends gave her something, a self-respect and a lightness that showed in her eyes. She loved the company, the people around her. Guests were gifts from God, and you opened your heart as well as your home to them.

Her first good friend was Karen Nisha.

Years before, my cousin Payman, who lived with us, had accidentally thrown a cigarette behind the bed. The smell of smoke rose as the electrical wires burned. Payman was nowhere to be seen. Full of fear of her house burning down, with toddler me lodged safely on her hip and Banafsha holding her hand, Mum wandered out onto the street, her beauty on full display without a burqa, a five-pence piece in her hand for the phone box.

She couldn't call the fire brigade, even if it was a free call, as she didn't speak any English and she didn't know how the phone box worked. Outside she came across an Englishwoman, but the woman couldn't understand what Mum was saying. I don't know if the smoke couldn't be seen or she just thought Mum's cooking had taken a wrong turn, but she looked at Mum and moved on.

Mum then ran next door and knocked. She had already watched her neighbour, Karen Nisha, go in and out of the house through our net curtains. A lady from Karachi, Karen Nisha had married a Ugandan merchant, and after Idi Amin had thrown them out they had come to Birmingham. Anyhow, she called the fire brigade, who came and hosed down our front room. 'Water cascaded and sloshed around her own front room – thankfully the floor had lino,' Mum said.

Mum and Karen Nisha had saved our house, and after that they became fast friends, with Karen Nisha the first of many women who visited regularly.

When the women got together, they talked of the men endlessly – unlike the men, who barely spoke of the women. I still remember Mum's philosophical statement: 'No matter if a

man is made from shit, he is still a man,' at which her friends nodded and laughed because Mum had said something so profound yet so funny. Then she followed it with, 'Even if a woman is so capable and clever, she is a woman. We are never good enough!'

Some couples worked together blissfully and were the talk of the downtrodden.

'Oh, isn't her husband attentive and considerate!'

'He consults her on so many decisions,' someone would add in wonder.

Even in this misogynist, lopsided world, there was laughter, there were soulmates, there was love in some unions; men who made their wives a cup of tea, asked how they were, who went back home and looked after the children if their wife was sick. This was man as the ultimate protector, where the fairer sex had nothing to worry about. Man would provide, and womankind was the nourisher; she was the homemaker.

On the other side were the households marked by terror, tears, screams, daily fear. Fear of rocking the boat, fear of saying what you felt; knowing the consequences if you did. Fear of not having a say in who your children married, or where, fear of your in-laws, who would control and manipulate your better half. There were stories of women being beaten behind closed doors and being sent back to former homelands if they did not bear children. It was always the woman at fault; even if the husband was infertile, it was she they blamed for being barren, for providing no offspring.

The unfortunate ones would have to suffer the whims and

the abuse of the earthly god that was her arranged partner. Again and again it was said that you had to listen to your husband, no matter if he was wrong: 'Your husband is your god on earth.'

When Dad wanted to assert his authority, he told Mum that womankind is a slipper; you slip off one and put on another. Mum was prone to repeat that phrase, if only to remind herself of her position, and if she had any other ideas she knew that the slipper not only touched the dirty ground, it was exchangeable. Man was entirely in control. 'They break your back, your heart. Hell has descended on us, there is no mercy in their hearts. I don't know what has happened. The love I received when I was young! Never was there a stern word in my parents' home, and now look at me! Look at my *kismet* with the father of my children. An animal!'

These women's lives revolved around their ghetto. They would laugh, visit each other's houses, cook together whilst their husbands were on the factory floor.

What I loved was the pace of their days, which had a clarity but also a dreaminess: the ceremonies, the observances of hospitality, what to offer and what to say when a guest arrived. Life was slower inside the house, for me amongst these women; it was a life to be savoured.

Sometimes Mum's customers were not able to communicate in the language of their seamstress, so Banafsha or I would translate, or Mum would improvise, speaking with hands or the few words she had learned. Sometimes they would stay, mingling with women from our community who couldn't read or write (nor could the majority of their husbands). But inside the house,

it didn't matter; together they sewed and cooked and ate, and communicated in a universal language that only women could understand.

Outside the home was another matter. The hold of the community system was strong; the fear of shame and dishonour kept all in check. The women were afraid to open their front doors, even to bring the milk in. Doors only opened to faces they knew.

In the adjacent neighbourhood, a mother had seen her child run over by a car outside their house, yet she stood frozen in the open doorway, weeping, forbidden to come out whilst the men handled the police. The ambulance took her daughter away. She survived, but her mother hadn't been able to comfort her as she lay in the middle of the street. That story pierced everyone's hearts; the strictness of her husband, a proper Swabi Pathan who had honour. This was the extreme hold on some of these women, like prisoners, displaced and unable to navigate their new homes.

I heard another story about women who were forbidden to uncover their faces. The men of these houses were so strict that even when the womenfolk were sick, their face was still veiled. When Mum went to visit one of them in hospital she lifted her own veil, but found her friend sitting up, all in black against the white hospital bed linen, her face still covered.

There were regular gatherings as more and more women visited our house. When a mass of them got together I would try to make myself as invisible as possible so that I could watch them deep in conversation, and hear their stories and anecdotes. I memorized them all. I was a recorder, a voyeur of the *klatsch*.

There were so many, each with their own tale. The robes they wore hid all visible identity and definition, denying them silhouettes. Some felt naked if they dressed any other way. This was their space, and this was the godly attire which gave them comfort and protection. Some carried their pain under these robes until they cast them off inside the four walls of their home, away from eyes that couldn't shame and tarnish them, the double-layer chiffon-polyester veils thrown back to reveal ears, eyes, lips, hair.

Each woman's migrant experience was different. Friendships were born, solidarity organically formed, and friendships were broken, just like anywhere else. Some compelled me, rooting themselves firmly in my imagination.

In this sisterhood, there were also enemies. Mum always said darkly that 'Snakes come out in the rain.' On those days when the rain didn't stop, Zarina could not be prevented from wrapping herself in black and walking over to our house. Zarina was one of Dad's distant relatives and best friends with his sister. She often welcomed herself into our home, talked endlessly into the night, and then slept over.

I'd watch her face: she slept with her eyes open, like a lizard. It was a pretty yet pointy face, like a sparrow's, but Mum said that inside lurked a snake, a reptile you couldn't trust with a forked tongue that hypnotized you, luring you in with its honey words, but no one knew their true meaning. Mum said again and again, 'She is not to be trusted – her sweet tongue will wrap you in syrup like a jalebi, and you will let your guard down. You do not know what Zarina's thoughts are. Her schemes don't

focus on today, or even tomorrow; the game she plays is much longer.'

In Zarina walked that day, out of the rain, pushing her bosoms skyward with one of the pyramid contraptions from the market stalls. This was a good dividing marker for those women – who used bras and who didn't, who contoured their shape contrary to the Prophet's law. She was one of them, her clothes moulded to her figure, showing off her waist, and, like Marie Antoinette, her deep necklines would show off the mounds of her pushed-up breasts peeping just over the embroidery.

It kept raining, so Zarina was going nowhere. She sat drinking tea, making small talk with Mum. Mum said she always avoided this, as she didn't want to waste words that would get twisted and used against her: Zarina was a direct wire to Mum's in-laws back home. Mum may have left them behind, but here, in front of us, was their eyes and ears. Anything that happened, she told me, anything said, would be transmitted by letter, or through the gossip of friends travelling back. Zarina was their chief spy, her snake's eyes watching and burning everything into her memory.

Zarina was waiting for Mum's first customers to arrive in her sewing salon so she could look at what fabric they had bought and catch up on any gossip – or better still, scandal. No one came out whilst the rain poured, however, so Mum began to move around doing her own chores, in order to avoid Zarina. I watched Zarina watching Mum, those reptile eyes focused on . . . what?

Mum's slim wrists, which jangled with her gold bangles.

You couldn't tell they weren't pure gold: one of her East African customers had just bought them for her as a present, good quality, gold-plated bangles which didn't lose their shine. Zarina looked at her own wrists, piled with cheap plastic bangles, and then looked at Mum's again. Zarina couldn't make herself offer Mum the usual kind words, as other women did, such as, 'When did my adopted brother buy you such beautiful bangles? Let me look at them,' or offer Mum felicitations on her new purchase or present.

Exactly one month later, an airmail letter arrived. It was from Dad's brothers and sisters and it contained a long list of concerns, starting with 'We hear that you have bought golden bangles for Palwashay, and of course we send you good wishes but you haven't sent us money for over six months now. Our cow has died, so please can you send us some money?'

Dad and Mum looked at each other. Mum looked down at her bangles and laughed with heavy irony. Two years previously Mum had saved up enough from her sewing money so that when Dad went back 'home' he could buy her some gold bangles. She even gave him a plastic bangle of the right size to match, wrapped in her money. But when Dad got to the Frontier, his nephew was getting married, and that is where Mum's savings got spent: on two buffalos, and forty large cooking pots of food to feed a wedding party of nearly a thousand. He even built them a new room in the courtyard for the bride and groom.

Dad arrived home empty-handed, and explained to Mum that he had had to keep face: he was the richest sibling, living abroad, and what would people say if his sister's only son's

wedding was such a sad, lacklustre affair? He promised her that he would buy her bangles when he could.

The saddest of all the women for me was Ghamzeh Jaan. Everyone said she was possessed by jinn. Mum said she had stood next to a tree after sunset with her hair uncovered, and the jinn had fallen in love with her and taken her captive. You could see it in her hazel eyes. They would drift off into the distance as though her world was elsewhere and different – a kaleidoscope that only she could see. She spoke an unknown language to invisible people that we couldn't perceive or communicate with. Her large, panda-circled eyes added to the sense of tragedy around her, as she wailed again and again that it could only be her husband's second wife back home who had made her barren through her black magic. 'It is *jadoo* that she has unleashed on me across all those continents.'

At home, she sat constantly on her prayer mat, head tightly swaddled in a white embroidered sheet, her arms lifted up to the heavens. This was Ghamzeh Jaan's position, ready for God to throw down a child into her ready, warm lap. She didn't care what it looked like, as long as it was hers; she didn't care what sex it was, as long as she could hold it, put it to sleep, pick it up. She sat with her prayer beads wrapped around her hands, in constant motion, reading special prayers, so that God would notice her and bless her with a child.

She had sent her small savings back to her relatives, who took

them to shrines, paying for golden-flocked blankets to cover the graves of saints and holy men, and, when she could afford it, large pots of rice and chickpeas to be cooked and distributed to the poor every Thursday at sunset for forty days.

Ghamzeh Jaan's husband, Lajbar Khan, would spend a few months here and a few months back home with his second wife. She had given him one daughter, but was stuck in a village in the Frontier as Lajbar Khan was already married in the eyes of the law of England. Ghamzeh Jaan would say to Mum: 'I can feel her restless feet edging towards my home here on Edward Road. He wants to kill me, to get rid of me, to send me back.'

When she spoke with the jinn it was in strange fragments, like riddles:

'I can look through your rose-coloured face, and see the other side . . .'

'A diamond child, God has left for me.'

'Like ecstasy she is running wild, she is mine.'

'Who are you, show yourself!'

'Hell looks a lot like paradise – prune my garden for me.'

'A bouquet of stars I live in . . . Imagine . . . Come and stay with me.'

'I have diamonds and gold for you.'

'The second gives me much less pleasure than the first . . .'

'Hold my hand . . .'

When Lajbar found her talking to the phantom jinn, he would beat her with a metal yard-stick, and then her mystical language would stop, she would run to our house and take off her robes, unravel herself in front of Mum and fall apart, eyes pouring out

tears. Her arms would open and embrace Mum, and she would wail, lifting up her robes to the heavens. Her face would flood like a weeping Madonna's as she cursed and cried towards God. 'The steam from my simmering heart . . . curses you . . . that you will never rest, Lajbar, you have done this to me, and may God do the same to you. May you never find peace, Lajbar.'

I could barely sit still during these fits, and would flinch as her eyes seemed to glimpse a distant song, and her mouth sang in wails. The tears would meander down her cheeks, the sobs would accompany her heaving chest, her breath gasping until she slowed to a whimper. Then the hand movements would judder as she slapped her own face, pulled back her headscarf, untangling herself so she could be freed from her constraints.

Eventually she was banished to the Frontier for her barrenness, and the second wife came over with her child.

Many years later, on a trip to the Frontier as an adult, I came across Ghamzeh Jaan in the streets of Swabi. Her face mostly covered, she begged me for money; I gave her what I could. I don't think she recognized me.

3

GOD, JELLY, AND THE CORNER SHOP

ANN OF F. ALLEN'S HAD a dowager hump and a serious demeanour. She moved slowly in her brown work-coat behind an alluring counter filled with cream cakes and iced buns.

Her coat matched her old brown till, and she would push levers to clunk out totals with fingers that had mesmerizingly large nodes on them.

Ann was always curt. 'Can I please have some custard?' would be met with a gruff 'Over there, next to the jelly.' This one phrase filled me with deep despair. Secretly I yearned for jelly, but for us, the orthodox, the truest of Muslims, it was now forbidden – of which *much* more later – so custard was the next best thing.

I never saw Ann talking at length to anyone apart from her friend Meribel, who regularly stood on the other side of the counter with curlers in her hair and a brightly coloured scarf

to protect them. Mug of tea in hand, Meribel did most of the talking, how so-and-so was now with a Black man, and how her neighbour had sold her house to a 'Paki' and moved to another neighbourhood. Ann would nod along, repeatedly glancing over at Meribel while serving customers.

Mid-transaction Ann would suddenly say, 'I was thinking about her the other day,' or splutter an inexplicable 'Oh, God!' swiftly followed by 'That will be thirty pence,' as she clunked a coin into her till and then passed the change back to me on a brown plastic tray with a hand marked by her gold wedding band. Maybe she didn't like touching her customers' hands, or maybe it was classier to hand back your change on a mini platter. To my eyes her nodular fingers perfectly and rather eerily echoed her dowager hump. She scared me somewhat, but back then it felt nice to hang out with white folk, to have them speak to you, for them to be impressed by your manners and your English.

Ann must have been at least sixty or seventy, and I heard she had lost her husband, Mr Allen, in the war. For ages I confused this with the Great War; she seemed old enough.

F.Allen's stood on Ladypool Road and occupied the crossroads of Birmingham's Moseley, Sparkhill and Balsall Heath slums. The area surrounding the shop was evolving into a collage of abstract colours and smells, a babble of different tongues and dialects, and a bevy of women in headscarves; some fully covered, some less so.

The women from my orthodox Pathan community were the most covered and the least integrated in south Birmingham. They rarely ventured out onto the high street, let alone to

F. Allen's. Even if they happened to pass it on their way to somewhere else, they were not allowed to go and shop by themselves. Instead, Ladypool Road was the stomping ground of embroidered Hindu women in saris of bright hues under mackintoshes, and the less orthodox Muslim women in head scarves and colourful chadors; women who did their own shopping and made their own decisions. These women mixed freely, wandering amongst the men – the men who were able to go wherever, with their beards, peaked caps and tailored blazers over traditional costumes. There were men in skullcaps, men in turbans, Sikh men in vibrant colours, Muslim men in plain cotton or Bedouin check cloths that had been brought back from sacred Mecca, all mixed together like a big, heavy, fragrant biryani. There were Indians, there were Pakistanis, and the Irish – who had been there the longest and were beginning to move out of the inner-city slums – the West Indians, the Rastafarians, the East Africans, the Bangladeshis, the newly arrived Afghans: layer upon layer, we made our very own cultural Battenberg of many colours.

I only recall Ann noticing me properly once, when one day – to my huge surprise – she fixed her beady eye on me.

'Why aren't you at school?' she barked suspiciously.

It was one of my 'stomach-ache days'. Stomach-aches were a routine way for me to get out of most things, especially school. It was infinitely safer to stay at home, hang out with Mum and her visiting clients and her sewing machine, rather than face the torments at school. This was my second year, and the worst of my school years. The first had been easy: I had been entered into Class Y, where all the mediocre students had been

sequestered. Years before, Mrs Vincent, head of the Queensbridge 'lower' school, had graded us – and it had been declared that our ability was not the same as those pupils in the 'upper' forms. Our neighbouring Class Z had also been sieved through Mrs Vincent's funnel, apparently showing even lower levels of erudition. Mrs Vincent had visited our primary school to meet everyone, as she was canvassing for Queensbridge secondary and looking for new recruits. I wasn't there when she visited and was therefore judged in absentia. When I came in the following day, everyone was talking about her.

Up until secondary school, I had been one of the clever ones. There were four of us in the final year of primary school, under Mrs Briggs, who had been earmarked for the 11-plus exam. Passing this would mean a place at grammar school, where children were selected by academic ability. We were given special books on grammar and mathematics; neither came naturally to me. Every Friday, Mrs Briggs took us through a chapter of the special books. The four of us would crowd around her table and listen to her, though sometimes my head would be ruminating on the painting that I had done yesterday – judging it by far the best in the class – or the short story that had got me a gold star. I never liked trying hard at anything: if it came naturally, and I enjoyed it, then I would get through the other side. So it was *kismet* when we were given the date for the 11-plus exam. It was to be held just outside the centre of town on a Saturday. I told my dad and he said that it would clash with mosque prayers. He didn't have a car, and Barak-Shah also had plans, so that was that. The day of the grammar school entrance exam

came and went, the other three took it, while I went to the mosque and rocked back and forth memorizing words from God's holy book.

And so I ended up in Queensbridge like my older brother and some of UB40 before me. This wasn't the genteel Birmingham of J.R.R. Tolkien, or the city of major scientific advancements, cradle of the industrial revolution. This was inner-city, 1980s Birmingham: all the teachers were white, and all the kids in classes O, Y and Z were either Black or Asian. I was in Class Y. Our maths lessons were not as hard, and our English lessons not as demanding. There wasn't a single white face in my class; however, if you looked upwards to Class R, most of it was white. These were children who lived in the big houses in middle-class, bohemian, socialist Moseley, but whose parents didn't think twice about sending them to one of the roughest schools in the area. For some reason they all congregated in one class. Maybe Mrs Vincent felt they were safer together, away from the children of the immigrants, or maybe all the white pupils were as clever as each other. Whatever it was, Class R sat at the top of the school.

Towards the end of the year, and after consistently earning better marks than the others, I was transferred to Class O. Here, there were the hardworking Black and Asian girls and boys who wanted to work their way out of the ghetto, those who wanted to become doctors, lawyers, accountants, businessmen. Here I met Dabir, my tormentor.

Dabir was Yemeni, and extraordinarily tall. The tallest in the year. He had somehow seen that I didn't have the fight in me – well, not the kind of fight that he was looking for. I was determined, resilient, but aggression with my fists didn't come easily to me. We came from the same ghetto. His parents had migrated here, like mine, and they lived on Cheddar Road, where all the prostitutes sat in full glory in their front windows, just a few streets from ours. Mrs Vincent had seen intelligence in him from the start, and put Dabir in Class O, the class of British-born, immigrant achievers. Now the new boy was going to get it.

Right from the start Dabir had smelled me out. He had seen me for the weakling I was. He'd wait for me, trip me over, push me, shove me, pull my bag, laugh at me – so he could look good and stand tall.

It started in the corridor: he was standing outside the boys' toilets on our floor when I walked past him.

'What are you looking at?'

I looked straight ahead and carried on walking. It was the first time this challenge had been directed at me, but I had heard it often enough on the territorial streets of Balsall Heath. I had always felt safe; there was always someone I knew on these streets, Dad, uncles, Barak-Shah, the older boys; even the prostitutes would look out for me. I had seen the aftermath of 'You gave me a dirty look' – followed by a knuckle-duster, cricket bat or a knife. Now at school it was time to start navigating the minefield of looking after myself.

My strategy to avoid Dabir: I started taking the long road

home through the playing fields, running part of the journey to make up time. If I was brave enough to take the regular route home, I kept my eyes peeled and popped into the shops, ducking low, hiding around people or standing behind them so as not to be noticed. When I got home, I would rush in, change my clothes, don a skullcap and run to my Koranic studies at the mosque. On days I couldn't face having to run or hide from Dabir, I'd say my stomach was hurting me so I could stay home, safely out of reach. The threat subsided eventually: Dabir came to the class infrequently, and when he did come, the 'wagman' – the truancy officer – would immediately take him away for questioning.

As well as helping me avoid my tormentor, another advantage of my stomach-aches was the sympathy I received from Mum and Dad. They would constantly check up on me, force me to eat a bitter pepper-chicken soup or handfuls of carom seeds, rub my stomach and check my temperature. Inadvertently, my complaints distracted Dad from shouting at Mum, or depending how angry he was, stopped him beating her. This phantom illness of mine was a diversion tactic for Mum, who was forever trying to keep out of his way and wanted us children to do the same. Dad expected us to engage in pious acts, like reciting the Koran. This of course would increase the family's – and particularly his own – kudos within our community. The kudos would earn us all a special place in heaven and for him in particular. If I ever managed to learn the Koran by heart in its entirety, God would also gift Dad a dazzling crown to wear.

One particular morning, to ensure it would be too late for

me to turn up to school assembly, my attention-seeking formula went a bit too far. Dabir hadn't been at school for a full week, but the threat of his return was looming in my head. So much nicer to stay at home with my books. I decided that my stomach-ache that day would be catastrophically worse than usual, and after a visit to Dr Carpets (yes, that really was his name), and with his note in my hand, I was whisked by ambulance to Birmingham Children's Hospital. I was to be kept in for monitoring.

On the first day, the hospital doctor came to examine me and advised bed rest. On the second day I didn't want to say it had improved for fear of being sent home, which would result in missing out on all the books in the hospital library, and also the ice cream and jelly – yes, the forbidden *jelly*! Then there was the awful shouting and screaming so often raging in our house. By contrast, in the quiet, peaceful Children's Hospital, everyone constantly, cheerily asked how I was feeling or what I was doing. I could ring a buzzer and someone would come. It was pure heaven, so I kept up the charade. While I was in hospital, Mum and Dad would show up each day, freshly bathed, immaculate in their best shoes and coats, and wearing their most dignified look, the one reserved for doctors and hospitals.

On the third day, the consultant, Mr Thomas, came over, lifted my mint-green gown and started prodding my stomach. I was determined to keep up the pretence.

'Where does it hurt?' he asked, working across my stomach, pushing his fingers in. 'Does it hurt here? Or does it hurt more here?'

In a panic, fearing being found out, I suddenly recalled that my mum frequently complained of a pain just below her belly button.

'It hurts just below my navel,' I piped up, trying to look as agonized as possible. Mr Thomas prodded, and then pulled back my pyjamas, opened the curtains and told the nurses, 'Nil by mouth.' This, I learned to my horror, meant no hospital meals, so no fish or chips; no ice cream – and most devastating of all, no jelly. Until I gave them my appendix, that was.

So it came to pass that I found myself anaesthetized and quickly dispatched to the operating theatre for the removal of a perfectly normal appendix. There was a price to be paid for jelly, and I most certainly paid it.

Aside from A&E, the chief jelly mecca continued of course to be F. Allen's, where I always preferred to go on my errands – even after we had been banned from eating jelly. But there were occasions where I ended up at Khan's, the other corner shop. Khan's most definitely had no jelly. It was a holy Muslim shop. It was where Dad would buy halal meat, chicken, trotters and liver, and collect scraps for Jason. Khan's was located 200 yards from Allen's, tucked away on Stoney Lane, a side street, with only a drab newsagent for company. Mr Ali Khan lived above the shop with his family – his wife, son, his two daughters and their husbands. He would stand proprietorially, handlebar moustache oiled to perfection, behind the glass meat counter in

his bloodstained white coat, lamb and goat carcasses hanging behind him, halal chickens in front of him. As a young man he had learned the craft of butchery, and now in England was serving the faithful.

Mr Khan had decorated the shop with holy verses – some to ward off evil and others to bring prosperity in business. When he was not behind the counter, carving, chopping or sawing energetically into the carcasses, Mr Khan would be at the mosque.

Ali Khan's other role for the community was as the oral newspaper – butcher and newscaster. After he had read the papers, delivered the news, he would wrap your meat or vegetables in old newsprint. The shop had its fascination for Dad and other male members of our community. They would habitually sit in there, waiting for updates on what was going on in the world. Ali had help in the shop from his son-in-law, and whenever there was a lull, he would read the paper out loud, puffing himself up and preparing himself to broadcast to those gathered. Khan's the butcher's – like the barbers' shops – became essentially a men's club, where men hung around, chatting, shopping and smoking among the carcasses.

Wanting to impress this pillar of wisdom, one day I solemnly informed Mr Khan that I would be an architect when I grew up. 'I will build stuff like my Dad does, but as I can draw, I will design the buildings, which someone else can build' – my logic being that I wasn't very strong, so it was better that someone else did that bit.

I awaited his reaction nervously. God didn't allow us to draw faces, or any living figures, animal or human; this meant that we

were competing with him. Our fear was that, come the Day of Judgement, God would ask us why we had done so, and would challenge us by asking us to bring our drawings to life as a terrifying punishment. Uncle Darya's wife had told me this once and it circled round and round in my head: *God didn't want me to draw.* Mrs Morris, my primary school teacher, liked my drawings and said I had a gift, but as I grew older I knew from Auntie that God only wished me to draw flowers, so I would map out Mum's embroideries for her, avoiding any depictions that might provoke His ire. I also knew God was always very happy if I wrote one or all of His ninety-nine names in beautiful calligraphy. Drawings of buildings were, I decided, on balance, acceptable.

After a nail-bitingly long pause, Mr Khan responded, visibly inflating with sagacity: 'Why don't you become a hairdresser? You get five pounds for every haircut. These English people, all they want to do is perm their hair, dye it, everything, everything to their hair.' And he added, 'It's good money: think about it.'

Khan's was also where Dad bought the brains of sheep and goats, which were a family favourite. They tasted like dense, spicy omelettes. I loved tripe, too, though I eventually grew out of that and thankfully did not find out where it came from until much later. Cleaning the entrails was a long procedure. It meant removing the membranes and any remaining excrement that the butcher hadn't cleaned off, with two people to hold it, one pulling and the other cutting the squares off, and then the long, twelve-hour boil with salt and pepper. Mum would get up at five o'clock in the morning to put it on, the smell seeping

through the house and out the front door. The tripe would become moist and buttery, and then it would be spiced and cooked, ready for 7 p.m. dinner when we arrived home from Koranic school.

Even now, so many years later as I write this, the powerful smell comes back to me – that and the woody aroma of whole aubergines cooked on a low heat on the gas hob – stinking the house out and penetrating our clothes, our shiny, oiled, jet hair and kohled eyes, throughout primary school. It followed us as we walked to and from school, the cumin and turmeric lingering like fragrant flowers. Once I walked back with Leigh, the daughter of the landlord of the Trafalgar tavern. As she got closer to home, she ran ahead, stepped into her porch, turned and shouted 'Smelly Paki!'

Another reason to visit F. Allen's, the mecca of my heart's desire, was the regular paraffin run after school. I think it was Ann's nondescript son who dispensed the blue paraffin, the smell of which I found intoxicating. On my way out of the shop, high on the fumes, I would pass Ann's counter, the wooden shelves behind her replete with jars of hypnotically enticing sweets and cream cakes. When I was a little older, I would sometimes buy pastel-coloured bonbons, paying for them out of the change; for now I was good and took home all the change from my errands.

Yet the epicurean heaven that was F. Allen's, chief purveyors of cream cakes and sweets, not to mention jelly, was soon to come to an end. All of it became off-limits when the bar for the orthodox and the purity of halal was raised.

* * *

It was Chenghiz, one of the older boys on the fast-track to piety, who was to shatter my illusions of confectionery paradise. Chenghiz, garbed all in white, skullcap to match, with his radiant, moon-like face on a Friar Tuck frame, soft pubescent hairs sprouting around his chin, mouth and jawline. (Shaving or cutting them would risk losing the soft silky beard that was as precious as Jason's golden fleece: the softer it was, the purer you were deemed, and the closer you stood to God and the prophets in eternity.)

Chenghiz stood in the door of my classroom at the mosque. I had just walked up the stairs after doing my ablutions before class began, feeling odd and insubstantial in my blazer. My sensible blue coat was soaking in the bath that day. Dad had bought me the coat off the Ladypool Road two sizes too big so I could grow into it. God, how I loved that coat. My skinny neck, large head and skeletal body felt protected: the coat, which reached my shins, felt like armour inside and out, but Mum's obsession with cleanliness meant that I would often find it floating amongst the other dark colours in the bath.

So, on that fateful day, I vividly recall walking up those stairs feeling weirdly naked and freezing in my school blazer. When I offered Chenghiz a fruit gum, he looked at me, face full of jolly piety.

'That', he said, pointing at my fruit gums, 'is *haram*. You know where gelatine comes from?' he asked angelically, and then paused for effect. 'It comes from the P-I-G. If you look at the packet, it has the ingredients on it. I will show you where.'

Somehow it had become the norm that we weren't allowed

to say the word 'pig', but could only spell it out as P-I-G. It was almost as if your body would become unclean if you said the word. Our parents used it – the Pashto version, that is – as they didn't speak English, but why amongst us, their English-speaking offspring, it became the norm to spell it out under pain of death remains a mystery.

I reluctantly handed over my precious packet of fruit gums. Luckily, I had unwrapped it on the ingredients' side, which had come away with the inner foil, discarded on some side street. Handing it back, Chenghiz said that I should throw them away, repeating the painful refrain: 'They have P-I-G in them. You need to look for gelatine, and a list of numbers. Here, copy these.' He proceeded to chant the list of gelling agents in that high, insufferable voice of his. 'They are hidden, these gelling agents. They all start with E-numbers,' he said as I stood there, mind reeling and struck dumb. My fruit gums looked nothing like P-I-G.

But after years and years of consumption, the faithful had finally found out where gelatine came from. It was not only the swine that was unclean; it was also its hidden by-products. E-numbers had crossed into the unholy. Handwritten lists were passed around, and those who could read began scanning the backs of packages for those fatal formulas which would pollute your body and render it unworthy in the eyes of Allah for forty days. Those who couldn't read would ask everyone – their children, the shopkeepers – to read sweet wrappings, and would bring their shopping to the mosque to be examined.

I was thunderstruck. It was hard to take in. Gelatine reared

its sinful head everywhere, especially in sweets. So many were now off-limits, *haram*, forbidden!

Bubblegum
Curly Wurly
Dip Dab
Drumstick lollies
Fizzy Cola Bottles
Funny Feet ice cream
Sherbet Fountain with its liquorice stick
Bassetts Wine Gums

Fear swept through us children. Your prayers would go unanswered and your ablutions rendered redundant. Some of us obeyed and dutifully read the ingredients of the food we bought; some of us didn't. Anyway, not all packaging had ingredients on it, and what you didn't know couldn't hurt you. Not, that is, until some busybody would point out that you were eating *haram*, so you would have to throw it away or defensively insist, 'No, no, it's really not!' Everything was questioned: permissible or not?

Luker's was the local Jewish bakery in Moseley Village. Overnight, it acquired a new set of customers, its kosher white bread taking prime place on the table of the pious and orthodox Muslims. Sharia law occasionally sought help from its Abrahamic brothers, allowing its followers to consume the food of their neighbours as a last resort. Of course, only in desperate times and only if it had been correctly, ritually killed with all the correct prayers in accordance with the laws of the Torah – we

were, after all, people of the book. Luker's also sold cakes, housed in a high glass counter next to the till. But somehow the display was never as alluring, nor the gelatinous red raspberry sauce as rich nor drizzled as freely, as in F. Allen's.

Ann became frailer and slower as the years went on, but she was always there behind the counter, hair set in rollers like Meribel's, her voice as purposeful and brusque as ever. She still dispensed cakes into white or brown paper bags using stainless steel serving tongs. I found the process fascinating, and I always longed for a pair; it was something we didn't have at home, or need, as we were taught God had given us hands to eat with: the Prophet's way.

The etiquette at home was that you should only eat with the right hand and using your first three fingers and thumb (my mother would say only those who had been reared in the jungle would eat with all four or five fingers), tucking away the other two and gathering up the curry or stew with your roti or unleavened bread, eating only from the nearest side of your plate. This would make God happy and bring *barakat*, God's blessing, into your household. His abundance would flow, and keep your table full.

The sad day came when Ann, along with her cake tongs and her dreary son, moved on. No more ham and cold-meat counter, strings of sausages or those piles and piles of iced buns, iced fingers and doughnuts. No more custard and pastel bonbons. No more jelly. F. Allen's became Abdullah's.

Abdullah's shelves weren't as full as when the shop was F. Allen's. There were fewer tins, fewer options and no big-brand packaging. The ethnic food industry was not yet in full swing,

and what could be made at home didn't need to be sold in a tin or vacuum packed or come as a frozen meal. Our needs were much simpler. We were all saving money, and we hadn't fully discovered the delights that the western world had to offer. We didn't even know if we were staying in the country, or how much money we would have to send back home. It was better, all round, to stay frugal.

The meat counter became halal, and vegetables and piles of fresh fruit, including a few exotic varieties, decked out the front of the shop under F. Allen's old brown canopy. Incense burned regularly inside the shop, and a temple of holy sustenance took shape: rows of spices – cumin, turmeric, dried coriander seeds, masala mixes – rice, sacks of flour, sultanas and nuts sold in different weights and sealed in clear utilitarian plastic packages with an East End stamp. Packages of hair oil advertised by Bollywood's leading sirens jostled next to canisters of Vim surface cleaner, bottles of Zoflora disinfectant, washing-up liquid and detergents.

Sacks of supari replaced the gobstoppers. It was customary to grate and chew the supari, like our lodger Maryam did, giving her perpetually bright-red gums and teeth.

Now the counter that had once housed Ann's cream cakes was devoted to the paan vendor, who dispensed perfectly wrapped triangles of addictive and secret treats. Sliced betel nuts, fennel and flowers were layered on top of one another, then powders – sometimes mixed with nicotine – shaken on top and the triangles skilfully folded in silver foil, to be artfully lodged between cheek and gum by the more sophisticated migrant urbanites for an exotic buzz.

I saw how paan was wrapped on the television at Khair-un-nishah's house. We shared a back alley with her family, our next-door neighbours, and Banafsha and I would unlatch the gate and wander into her garden or loiter in her kitchen, hoping for leftovers. Her television was always on (only Barak-Shah and Dad were allowed to watch the one at home), and since she also had a VHS machine, she would play her rented Bollywood films daily, some of them on repeat, again and again. Dad couldn't easily wander into another family's female quarters, so we were safe. I was mesmerized by the courtesans and scheming madams gobbing out intoxicating juices from the betel nuts into silver spittoons (Maryam used empty Heinz bean cans), all whilst negotiating with an aging aristocrat over the deflowering of a nubile girl.

Of course, the betel juice, the films – these were all the devil's work. The devil was everywhere. He was in the toilet, unfolding himself when you were alone, whispering, tempting you from the righteous path. He was definitely in the TV and VHS machine. The imam had warned us again and again that the devil would take you on the path to hell, that his disciples would sing to you, offer you earthly delights, lure you in, but they could not save you from the fires of the hereafter.

The increasing number of *haram* foods and the resulting prescriptive dietary requirements pioneered new business opportunities for the holy. Bakeries were opened that supplied rusks, tea biscuits and cakes, but no more fresh-cream finger doughnuts of the kind that the imam had so loved to serve his guests, and which I had been allowed to snuffle up

if I stayed and helped clean up in his attic rooms at the mosque.

After the ban, how I missed those sweets. The biggest tragedy for me – I hardly need say at this point – was being forbidden Rowntree's jelly. It had been our number one family treat for special occasions or when guests visited. My parents had discovered it way back, soon after their arrival in Birmingham, and Mum had adapted it to make a dessert with her own exotic flavours, adding nuts and sultanas.

I had already bartered my body part for this sweet jelly, and as the Sharia commandments got more restrictive, my desires got more intense.

4

MUM, DAD, AND MUM'S
VOLUPTUOUS BEST FRIEND

M UM DIDN'T SPEAK MUCH ENGLISH, apart from:

1. 'Thank you much.'
2. 'A cup of tea?'
3. 'Age?' (which she would count on her hands, to determine the social status and position of her interlocutor)
4. 'Married?' (the billion-dollar question)
5. 'Husband?'
6. 'Son?'
7. 'Daughter?'

Banafsha would help Mum out if she needed to ask anything more complicated, and despite her limited speaking ability in English, my mother absorbed a lot of what was spoken around her.

Everyone said Mum was beautiful, more beautiful than most, even for a Pashtun. She had not inherited her mother's sea-green eyes, but her features were chiselled and not so mannishly hand-some as other Pashtun women's. God had crafted her delicately, from her high cheekbones, which sloped into a delicate point on her chin, to those large almond eyes that her mother-in-law in the North-West Frontier would complain were too big, saying: 'Take your big ball of an eye away from me,' or, 'They suck in all the light,' and 'I see them and I become more blind.' When my grandmother spoke of her own family's eyes, she would say, 'Our eyes are small, we have no shame.' Somehow these biological features justified their cruelty, as if a small oculus would shield them from taking responsibility, or showing signs of remorse.

Mum's delicate hooked nose had piercing marks on either side from the nose studs that she had taken off and left in a glass on the mantelpiece when her sister-in-law had died. After the traditional forty days of mourning, Mum looked for the nose studs but they had gone, leaving her holes empty, like little dimples on perfect, unmarked skin.

Mum would say confidently that she didn't need the aid of any potions or make-up for her skin to glow, it was her *amal*, her soulful deeds, that made her beautiful from the inside out. Her favourite saying, which she repeated to us daily, was 'Your tongue will let you ride a horse and your tongue will let you ride an ass. You decide.' These proverbs would glide out of her mouth when she deemed them necessary. She believed that joining two words could take the form of a flower, to please someone, or an insult. It was this tongue in our mouth that

ruled our relationships and our stature in the world. 'Always speak sweetly so people remember you. It's your words and actions they remember; when you offer fire to someone, they will run away.' This was born of an overriding will to always be civil, and she wanted her children to be the same. Why be disparaging when you could offer a flower? There were many distillations of advice which she hoped, repeating again and again, would guide and ingrain themselves in us.

One of my favourite parts of childhood was when she sweetly prayed to my face for my wellbeing: 'May God make your life beautiful on this earth and in the hereafter,' she would say. 'Wherever you put your hand, may it be gold,' or 'May God reveal hidden treasures to you.'

Mum was precise, matter-of-fact, her mind already made up before words came out of her mouth. She knew what she wanted. Making decisions seemed easy for her and I have always envied her this.

She especially shone in gatherings, and always wanted people around her. When the biannual Eid festivals came around – the celebrations to mark the end of Ramadan and the end of the Islamic year, or the end of Hajj pilgrimage – our house would overflow with people. On these days, everyone and every-thing shone, especially the women in their shiny satin suits with matching two-metre head scarves which covered their hair, snaked around their necks and then draped over their right shoulders – always to the right. (The imam had told us that the right hand should always lead the way; everything was offered with the right hand – food, tea, everything.)

On these and any other celebratory occasions, most women wore white socks, which peeped through their matching plastic slippers or their sensible shoes. Some made the choice to match the colour of their slippers with their suits, and then there were the less fashionable who wore their everyday black shoes and any colour of sock. Their hair was brushed, centre-parted and plaited, their hands covered in henna, some in crude, simple patterns, others with circles, like suns with dots round them, on palms that offered you sweet sherbets and piles of food, a multitude of bangles jangling on their collective wrists. I billowed with pleasure, as most of the dresses were made by Mum: my sisters, my cousins and quite a few of the women on the street wore her handiwork.

First everyone greeted one another in an elaborate gesture of welcome: those women of equal age would embrace each other, or the elders would kiss the hands or the cheeks of the younger women. Then followed the mounds of food: pilaus, biryanis, kebabs with dried pomegranate, rice puddings and halwas. Spectacular trays and serving dishes were a must, objects which took centre-stage in the gatherings of the community. The mounds of food served on Queen Anne-style tableware created sculpted installations and showed off your newly acquired wealth to your guests. First the eye would see, then the nose would take in the aromas and then the hands would take the food to the mouth for it to taste, the new life in Vilayat. Even in the most impoverished houses, it would be insulting not to put out your best – shiny stainless steel trays would be used to serve tea. People laboured over hospitality, especially my mum. How

someone left your house, and with what in hand, gave you prestige. You should always send your guests home with something: a doggy bag, some fruit, a polyester-embroidered suit or a cotton headscarf – even if it meant offering it off your own head if your visitor so desired. Overfeeding your guests was the norm, and anything less would mean that they had been slighted, and open up the opportunity for others to talk about you: 'I went to so-and-so's house and they didn't even offer me a cup of tea' was not something you wanted said of you.

Gatherings like Eid would see Mum in her element, in a bright green or red dress, her face brightly lit, her eyes shining like the moon. But at other times she showed a different side: Mum would have bad days, and would often cry, complaining she was hollowed out, emptied of everything. She had given everything to Mr Tolyar and his family: she had borne him two sons, three daughters, with no extended family of her own in England for support. Not only this, before she had joined Dad in England, she had guarded herself and kept herself pure from the lustful gazes and comments back home in her husband's absence.

Dad had come before Mum to England in order to make a new life, and eventually, after seven years, Mum followed. For the seven years they lived apart, Mum toiled in front of her in-laws and Dad worked in England, saving up to buy a house to bring her and Barak-Shah and his nephews here.

When she finally arrived, pale and thin, he said: 'When I

remember how I left you . . . and look at you now.' A camou-flaged declaration of love and concern over what had happened to his wife in his absence. It didn't take long for Mum to glisten again once she was reunited with her husband. Dad would bring her new clothes, and Mum would sew them to wear inside our home, and when she was chaperoned out, which was once every few months, she would cover them up with a coat or a black burqa. As time went by, however, in the four walls of our terraced house, her malady became entrenched. She would go through bouts of lachrymosity, recounting stories of hurt and humiliation she would never forget, as the love she was born into and the animosity she was married into was lamented again and again, so no one else should forget.

Mum's family had originated across the Durand Line, in Afghanistan, but her grandfather, a carpenter, had found regular work in what was British India, and then Pakistan, and moved his family over the border to resettle in the Frontier. Distant family friends arranged their union. Dad had been engaged twice but couldn't afford to pay the *walwar*. When there was talk of Dad and Mum's union, her grandad declined a *walwar*, saying it was 'like selling your daughter' and was against God's religion. Those who sold their daughters were infidels and would 'go to hell'.

Back in the Frontier, Mum was precious and the most beloved. When she was born, her uncle, her aunts, her grand-mother, had all been waiting for her. She was the new chapter to halt the never-ending death that had unleashed itself on her extended family. Her paternal grandfather's appendix ruptured

and he died on the spot, leaving his newborn son of less than forty days. Forty days is a significant number in Islam, a marker for tragedy and also the marker for joy. Forty days after a woman has given birth is when she can leave her house to visit her parents. Forty days is when a newborn's head can be shorn. After a death, ritual prayers and the feeding of the poor is observed on the fortieth day, and if a child survives its forty days, there is reason for hope.

On top of the premature death of her grandfather, Mum's aunt had died after the local *hakim* had cut a growth off her hand, and she left behind a young son. On her deathbed she had asked for him and fed him from her breast: when she finished feeding him she took her last breath. A few months later, the baby also died. Mum's nana had buried three grown sons, leaving her with four daughters, until eventually God gave her a son who outlived her. Out of her four daughters, two died in childbirth.

There were no more births, only deaths, until Mum was received into this world; she had pushed herself out into the open. The whole family prayed for her wellbeing and survival, for her to live, and as she passed her fortieth day, she brought hope. When she started walking, the elders baked sweet breads and distributed them throughout the neighbourhood. They pierced her ears and put pure golden hoops in them. They wrapped her arms with silver bangles with bells so that when she moved her limbs would jangle. Her nana would paint her hands in henna on a weekly basis and slide leaded kohl across her eyelids with a wooden needle. Mum's great-uncle

made her a wooden box to keep her fabric dolls in. He carved a flower onto it, and then painted it green, and Mum said that she would carry it with her everywhere. After Mum came four sisters and one brother, and her uncle remarried and fathered three sons. Mum's birth and survival had been a harbinger of many blessings of life. She had ushered in an era of survival.

Growing up, Mum was prim, upright, appropriate, beautiful and stubborn, and her grandmother would chide her, saying that if she wasn't careful she would have the temper of her aunt Sakina. If you crossed Sakina, you would definitely hear about it. Mum had found her métier as the oldest child, with the most responsibility, the one everyone was to listen to, the one that led the way for everyone to follow.

When her menstrual cycle had regularized at the age of thirteen or fourteen, she was taken from this tight-knit world of family. They came for her, dancing, with a palanquin high up on a camel's back, covered in an embroidered white sheet: Dad with his turban starched a foot high, her mother-in-law, her brothers-in-law, her sisters-in-law and their guests of the wedding party. The men danced next to Mum's house in an open space which once served as a wood-sellers' market.

Over Mum's wedding dress was a heavy embroidered shawl that draped over her head and face. Her wrists and forearms were covered in borrowed silver cuffs, a loan from her sister-in-law, and she wore ten pure-gold hoop earrings – five pierced into each ear – that her in-laws had given to her. Her family had given her golden rings, which she wore on each of her fingers and toes, along with two nose studs, a golden necklace,

a silver head piece and silver anklets that chimed as she moved her legs.

The journey from Mum's house to her new home – the home of my father's family – was an hour, so the camel carried the palanquin, followed by a parade of drummers and pipers, and the procession of guests, who kept dancing. Her mother-in-law danced as Mum's palanquin was laid down in the courtyard of her new home, and as she was guided out they seemed so happy to have her, but no one had prepared her for her new life.

'I never knew pain – I had never heard a swear word or the utterance of a bad word – until I came into this house, to this husband, to these in-laws.'

She'd raised her hands to her ears in *tauba*, penance, as she recited these words.

When she was despondent, she would recount her journey to Birmingham, to England. It began early one morning at sunrise. She was bundled out of her home, her suitcase already packed for her, and so began a five-day journey to Heathrow. It started by truck in Swabi, in the Frontier of Pakistan, then on to Rawalpindi, then a train to Karachi, where she boarded a plane, which stopped off first in Tehran, then Beirut, before carrying on to London. She told me much later that she had embroidered her own burqa in white linen, in the Afghan style. It consisted of a hat with fabric gathered into it that hung over her body, shrouding it, with a hem cut high at the front to allow her hands to move freely. The portion that hid her face was embroidered with *tarkashi*, a technique to create a *jali*, a

mesh-like screen so she could see through it. These decorated cut-outs gave her no peripheral vision – her only focus was Dad's young nephew, who she was passing off as her own, along with my older brother, Barak-Shah. Mum and Dad had given their word to their sister-in-law on her death bed. There, she had beckoned Tolyar and Palwashay Jaan through the crowd of family members. Her husband had already asked her forgiveness in an attempt to wash his sins – there were many to wash – and now she told Mum and Dad, 'My children are yours, look after them.'

Palwashay was forced to smuggle the boy, and doing so against a backdrop of paranoia instigated by her in-laws. Trusting no one, they forbade her from saying goodbye to her parents. She was given only a few hours to prepare for her departure, and she would never forget this. She would bring it up, again and again, especially when she and Dad argued.

Mum was always at some physical distance from us, seated or hovering around, when Dad was home. I never saw Mum and Dad sitting next to each other. They had never been photographed together, not even on their wedding day. That is what husbands and wives who had no shame did, it was not orthodox behaviour. Mum was in essence Dad's property. No letter ever came addressed with Mum's name; it was always addressed to my father, the head of the household. Mum did not exist outside the four walls.

For the most part Mum stayed quiet, but sometimes she answered Dad back, and on those occasions things would normally escalate. I was always dumbstruck by the fights; some-times me and the girls – Banafsha, Ruksar, Marjan – would start

crying, especially Marjan. I remember once, as a child, peering into the hallway and witnessing the scene. Dad was so mad that he locked all the kids out of the front room, putting a chair in front of the door. He roared at Mum and continued to beat her. It seemed that they were always fighting over Barak-Shah and the wedding that Dad had already arranged, to which Barak-Shah objected. Mum would scream and plead with him to stop hurting her. Eventually he would.

Dad sometimes felt ashamed afterwards and would bring home a new suit for her. Mum wouldn't cook for him, sometimes for days, and she forbade us to talk to him. She would sometimes coach one of us to go up to him and say, 'Why have you beaten my mum up?' After saying that we would run back to her double-quick.

They would fight over anything that upset him: if Mum had gone out for too long without his permission, or bought something that he thought was frivolous, or chatted to another man. She said to him once, 'So it's fine for me to open my legs, and let a male doctor pull your child out into this world, but I have to cover myself from everything and everyone? What lover do you think I have outside? Is this the way you talk to people, you have no respect or manners? You don't know how to keep a wife?'

Dad didn't have much of a reply on that particular occasion.

The first time I heard him say to Mum 'I will send you back and burn your passport', Mum cried and pleaded with him, touching his feet in the hope that he would withdraw his threat. I was terrified. I dreamt that I would wake up and discover

Mum had disappeared for ever. He would repeat it again and again, and after a while it no longer filled me with dread. I had overheard Mum telling some visitors that, back in their village in Pakistan, after they were first married, Dad's relatives had threatened her whilst Dad was away, saying, 'We will get my brother to divorce you, and you will leave this house holding your divorce papers, attempting to read them as you walk back to your parents.' This was a dig at Mum, who couldn't read. Nor could Dad, for that matter.

Mum still had that pride that couldn't be broken, no matter how much Dad beat her or her in-laws tormented her. After she had emptied her tears, her head set back to its default position of stubbornness and propriety.

It seemed to me as though everyone was scared of Dad, even at the mosque. His temper would flare up so quickly. I would dart under the big bed like a frightened cat, crunch myself into the shadows, into the furthest corner, so it wasn't easy for someone to reach in and drag me out. They were big old beds, with wooden frames and huge springs which created cavernous, dark spaces underneath. I had developed a knack of hiding in the darkest spot, so a quick glance under the bed wouldn't blow my cover.

The best thing to do to avoid Dad's anger was to run away. There were a few options. There were the Akbars, who lived two doors away and had an enormous pear tree whose

abundance of fruit was well known in Balsall Heath. This treasure, however, had a formidable obstacle to pass in the form of Warda Bibi before you ever got any fruit. Like other women in my community, 'Mrs Akbar' hadn't taken her husband's name, and was known as Warda Bibi. Her son, Fateh Akbar, was my age and cricket mad. Everyone was cricket mad or football mad or karate mad apart from me. I would have to go and play cricket with him if I wanted to escape from the cyclone that Dad would unleash: most of the time you could sense it coming, and it was those days that I needed to make myself disappear. I could just about bowl a ball, sometimes by fluke a really good one that would strike the wicket that we had built out of bricks or a milk crate: to Fateh's disbelief he would be out. *I* had bowled him out. Catching was another story, however, and I couldn't hit the ball with the bat so well either. So this sanctuary came with accompanying humiliation as a condition, and for someone so introverted, it was better that I stayed away rather than suffer the internal turmoil that came with the indignity. Not that Fateh called me names, but the looks and the giggles when I missed a catch were enough.

Then there was Hooriya Jaan's house. This was a house I could go in and out of easily, but her five sons were all older than me, and it felt odd to hang around there when Hooriya Jaan would mostly be at ours hanging out with my mum.

There was also the den that Zalmai, the local tough guy, had built in his back garden, housing the gang of street kids he had collected. It was made from old doors of different colours. Some were white and lilac, which were presumably interior

doors. Some were in full colour, electric green, pillar-box red and gloss black. This cube-like Tardis was right at the back of his garden; for inside he had found some linoleum which mimicked a grand black-and-white marble chequer-board.

I don't know how he had built it – unlike my dad, his wasn't a carpenter. Some of the doors were not straight and level, and to crown it all there was a corrugated roof on top. It was something to be admired and it captivated me, the door that didn't close properly, the shiny, glossy doors that looked like a sculpture. If you wanted to be part of his gang, initiation would involve major scrumping, smoking and instigating a theft. I had heard you sometimes had to take your top off and lie face down whilst Zalmai and his crew poured cold water on you. I had only been to see the den once and he had demanded I steal some of my mum's famous madeleines – a story I will come to later.

Another place of refuge was Uncle Darya Khan's house, two streets away. Darya Khan was a close friend of my mother's family, and would console Mum with his kind words, praying for tranquillity in our home. Once he confronted Dad, asking, 'Why do you beat your wife?' Dad replied, 'What is it to you? I'm not beating your wife!'

Darya Khan would gently insist that I should return home when it got to the evening, after I had eaten dinner. I resisted and told him my observations. 'My father's eyes go really red, and his nose flares and turns into red flames. It isn't worth going home to look at that or hear his shouts or watch my mother sobbing. I would rather stay here and play.'

And so I did, on many occasions.

Uncle Darya Khan had four daughters and no sons – though he had prostrated and prayed regularly for them. Like Dad, he was one of the builders of our mosque. He had been on many *tabligh* missions, ushering the *ummah* back to God. The *tablighis* were the equivalent of missionaries, travelling the world and bringing those who had transgressed back to the righteous path of the Prophet. In turn, God rewarded all these good deeds a thousandfold. I would hear that Uncle Darya had travelled to far-flung places, to South Africa and to Indonesia, knocking on doors, propagating his faith in new climates, breathing in different airs to those of England. Darya Khan went out into the world not in his suit and tie but in his long white robes and the skullcap that Aunty Lema had crocheted with her own hands. Uncle Darya would wrap his *kifaya* over his skullcap as a turban. God hadn't given him any sons, but he had made him content: he was always smiling.

He brought his eldest daughter, Aghala, up as a son. Unlike the other men in our orthodox community, Uncle Darya let her and her sisters go to secondary school. He undoubtedly wrestled with himself to do so, handing his daughters over to non-believers, some of them grown men, for most of the light hours in the day and not understanding what had been put in their heads when he picked them up at the end of it. At this point, all the pre-teen girls on our street were in full purdah. My older sister, Banafsha, finished Year 6 and never saw the gates of a secondary school building.

Everyone said Aghala Bibi was very clever. She loved to lead us, and we would inevitably follow. She was five years older than me. Everyone would listen to her, and on each visit she would

make us sit down in front of her to entertain us. She would read stories to us, just like our teachers. Aghala sat on upside-down, doubled-up milk crates, softened with a cushion, to read out all my favourite stories in her sparkling animated tones that made everything bigger and more entrancing. Roald Dahl was my favourite, and *The Witches* would come to life through Aghala perched high on her crate, and re-enacted through a game of tag. And then sometimes Willy Wonka would take over and she would dramatize each character, chapter by chapter, miming nibbling the chocolate bar with its gold wrapper, and recounting how the rude children fared against the very gracious Charlie Bucket.

Then, at the age of fourteen, just before her final year of GCSEs, Uncle Darya took Aghala out of school on the pretence that she was visiting her ill grandma in Pakistan. It was as if he had woken up one day and understood what it meant to live in this community, to see the prying and accusing eyes as he drove his daughters without head coverings to school – back then most Muslim girls who went to secondary didn't cover their hair so much. Now Aghala was sitting at home in Balsall Heath learning to keep a good home, helping her mum, reading any letters that arrived, and waiting to be married to her cousin back home when she was old enough. It was not only Aghala he took out – at the same time he removed her younger sisters, Balbala, who was thirteen, and Gulalai, twelve. From then on, like the rest of the girls in our community, Aghala and her sisters didn't attend secondary school. They were in purdah, and never left the house unless wearing burqas.

* * *

Just as I had my ways of dealing with Dad's temper, so too did Mum. She had a stubborn streak and in a protracted way she would normally get the better of Dad, and get what she wanted, even if it took her many years.

Hooriya Jaan, Mum's best friend, lived two doors down, and if Dad beat Mum, Hooriya Jaan was there to comfort her. Dad didn't much like Hooriya Jaan; she was brave and even answered back, assertively but respectfully. He blamed her for Mum's attempts to have some kind of freedom and independence. Often when Mum went out with Hooriya Jaan, he would shout at Mum: 'Do you have a man outside, that you are wandering out on the streets?'

But Hooriya Jaan never took any stick. Dad couldn't say anything to her, because she was someone else's wife. She would never have to ask her husband if she could pop out to see Mum, and it was her daring and backbone that enraged Dad.

Hooriya Jaan was a daily visitor in our house. She was tall, blue-eyed, dusky and broad – a statuesque presence. A mountain woman from the Dilazak people, she spoke her mother tongue, Pashto, the lingua franca, Urdu, and had managed to learn broken English from her Irish lodgers. Of her four children, one of her sons, Rahim, stood out, his light-brown hair, his mother's blue eyes and milky skin in complete contrast to his siblings. Spinzar at school said that he was the son of the Irish lodger, from whose wife Hooriya Jaan had learned English. The lodger had long since moved on, so we couldn't investigate his theory any further.

I always liked Hooriya Jaan; there was something jolly and powerful about her. 'How are you, mister?' she would always say,

flashing her blue eyes, and it puzzled me that one of my mum's friends, from our background, could speak English so well. We weren't even allowed to speak it at home. English became the code language between us siblings; it was the language that kept us apart from the 'Bushmen', which was anyone who was an elder, in authority, and mainly had a beard. Mum would shout 'Speak properly!' if our chatter became too annoying. She meant speak in our language, a language she could understand.

Often I would get home to find Hooriya Jaan sitting on the settee in our sitting room, shaking her heavy cotton-chintz scarf, opening it up, and then winding it tightly around her head and neck, covering her two perfect moles that God had placed on her heavy bosom, and now mounted in her low-cut neckline adorned in flowery polyester.

Hooriya Jaan was one of the few women to wear a bra. The resulting vista was a sumptuous eyeful of cleavage, pushed up by a padded brassiere, probably bought from the rag market. (There were piles of them on the market stands, hollow pyramids stacked on top of each other, mostly in baby pink.) For Mum, wearing a bra was considered immoral; anything fitted that enhanced your outline would lead to self-love and prurient behaviour. The fires of hell were waiting, and Mum's modesty would help her avoid them.

Hooriya Jaan would say, 'I used to be as thin as your mum. My chemise would only span the width of my hands,' and she would touch her thumbs and spread out her large hands like a wing-span indicating 'only this much'. 'And I could slide through small gaps, like in between this table and the settee, no need to

push it forward. But now look at me, as big as a buffalo,' she gestured to herself. 'All this farmed food. I don't know what they put in this chicken – you can smell it. Since I have been here I have gotten bigger and bigger.'

Then she'd stuff a spoonful of halwa or rice pudding down her throat. 'Mmm, your mum is such a good cook.'

At other times she would complain of the other strangeness of our adopted country: 'It's not natural. There is no daylight in this country, it just rains and rains. If it wasn't for your mother, my sister, I would have gone mad.' But though she complained, Hooriya Jaan was very fair. 'At least this country is good to us. Look, now there is no work and the good government is looking after us. Would this happen back home? These white people are good. Who wants to go back? There is law and there is order. Our people, they are thieves.' Another spoonful. 'The Queen is very good, she is a very good woman. It is that Margaret Thatcher, she is the worst, the worst. She is such a hard woman, like a man, and she has taken all the jobs, closed down all the factories. There is no work for our men now.'

Before Dad lost his job, on Sundays he wore his Sunday suit and oiled his hair, parting it in such a way that made him resemble Cary Grant, and then waited for his friends to come around. 'This suit cost me *fifteen* pounds, much more than any of your uncles' – all of Dad's friends were referred to as uncles – 'could pay or could afford.' He'd explain proudly: 'My wages

as a carpenter are much more than theirs. All of them work in foundries or on the factory floor. I get nearly double the money.'

When Dad had his cronies round to the house I was in charge of bringing food and hot tea from the kitchen. Before tea or dinner was served I would bring a plastic bowl and a jug filled with lukewarm water, and go round the room filled with Dad's male guests in order to wash their hands. Back and forth, from the world of women, refilling every cup or washing each hand. And they would laugh loudly and sit smoking, the latter making me very nauseous, so I would rush back to the women.

Dad had very large hands, and Mum would say, 'It is those big hands that beat me, and show me no mercy.' It was those hands that made him famous in the village on the Frontier. Dad was a strong man, and everyone knew it. Back in his village, he would be called upon to lift large boulders at wedding parties – a custom that sealed the deal and allowed the groom to take the bride home.

Dad had his own sad story. As a child and young man he had had very little to eat until he started making his own money: his father had been lost to the sea, a ship-hand for the British Merchant Navy. The boat had sunk, bombed by the Germans or Japanese. Dad's father was killed when he was eleven, leaving his mother to bring up eight children by herself. Dad never saw the inside of a school as a child; he had never sat inside a class-room facing a blackboard, listening and watching the teacher snake her chalk across it. At eight or nine years old, he shepherded a donkey; a little while later, a small drove of them. These pack

animals had bales of straw, firewood or sacks of grain mounted on their backs, with Dad sat on top.

He didn't have huge expectations for his children to don gowns and mortar boards, to hold degree certificates and pose together as a family. He had only experienced the bottom of the class system, and life hadn't been too good to him. Letters that joined to become words were indecipherable to him. No matter if they were written from left to right, or in the correct direction, right to left, as in Pashto or Urdu, he couldn't read any of them.

The clang of the letterbox would make Mum shout 'Is that the postman? Go and have a look.' As if she had been waiting for something, someone to write to her. Women's names were hidden, not to be written down for the world to see; even when Mum's parents wrote to her, it came in her husband's name. It was only her hospital appointments that came as 'Mrs Palwashay Jaan'; all the other letters were addressed to 'Mr Tolyar'. Dad carried these indecipherable letters on his person, filing them in the safety of his inside jacket pocket then waving them in his hand and asking whichever of his children were present to read them out.

He would repeat this a few times, just in case he felt one of us couldn't read the letter properly, and then for further re-assurance he would ask any literate acquaintance he met on the street for another reading. Each time a letter arrived, the ritual would start all over again. Mum or Dad would ask whose name the letter was in, then it was opened and read out, translated if needed. The sum of numbers which were the bold focal point

on some of these letters were the demands for the gas or electricity bill. How much had we spent? How much did he have to pay for our utilities?

Dad carried around with him the burden of these illegible papers in his name, and when that burden had been resolved they would hang as a reference for his interaction with the literate world, each letter stabbed into an unfurled coat hanger which lived in the cellar.

Despite being scared of him, there were displays of love. Dad would carry young Marjan and Ruksar to the mosque after Mum had bathed them, to sit with the imam. Mum recalls that when Banafsha was a toddler, Dad would parade her up and down the street and then sit proudly with her on the front wall, both saying hello to any passers-by. At Eid, Dad would take centre-stage in Mum's kitchen, displaying the culinary skills that he had learnt whilst living in England among men. He would add more ghee into Mum's preparations, chucking it in behind her or Banafsha's backs. On some Eids he would make the pilau himself, swamping it in butter and ghee. This was the life of plenty now. Food that he had dreamed of was piled high. From his shopping trips he would bring back sacks of walnuts for us to break, crates of tangerines, different varieties of apples, blood and navel oranges, dozens of pomegranates which we would open to pick out the seeds, staining our hands.

He would let me wear his watch and his Persian wool *karakul* cap at Eid. Dad had said that my wrists were too small for a watch, but when I grew up I could have the one he had bought me from Mecca. For the time being, it lived in the suitcase under

the bed, which was also filled with mothballs. Mum never had a watch. Possessing a timepiece was the ultimate status symbol in our community, and very few women had one. Hooriya Jaan would occasionally wear hers along with her bright-red lipstick and kohled blue eyes flashing, when she came around to see us.

Dad was great at telling stories. Storytelling was allowed because it didn't involve the television, where the devil and his disciples gyrated and swirled around as they watched the count-down of the charts to No. 1 on *Top of the Pops* every Thursday. Dad would often put his hand on the TV to see if it was warm, which would confirm to him that we had been secretly watching it and might have been tempted by the devil. The outside world, where women danced with all kinds of men, not only their husbands, kissed them openly or fell in love, or even danced on their own with open abandon, may have entered our house through that box. As a result of such evil, the angels would not come and bestow God's bounty on us. Dad said he was allowed to watch wrestling and Westerns only – but if a fair damsel fell into the arms of a cowboy who gave her a kiss, he would quickly switch it over to another channel.

Stories, however, could be kept clean of the devil and my grandmother had passed on to Dad an *Odyssey* of stories; ones involving toads in velvety coats with glass eyes; or witches who could trick you and carry you off; or the dwarf who saw every-thing and never slept. After dinner we would pester him to tell us one, or play one of the guessing games that he had learned from his mother. Barak-Shah was too old for stories and would either be in the front room or at a friend's watching television.

We would gather round Dad, Banafsha and me, with Ruksar and Marjan (who were so close as to seem like twins) alternating between his lap or standing at his side.

My favourite story was 'The Little Louse':

One day the Little Louse trod off westwards to visit her aunt – who was overjoyed by her visit and cooked her Four Parathas, Four Eggs and a Crowing Cock. The Little Louse gobbled it all up.

Thanking her aunt, the Little Louse left and took the path back home.

On her way, she met a camel, who greeted her, asking, 'Little Louse, how are you and where have you come from?'

The Louse replied, 'I have come from my aunt's where I ate Four Eggs and Four Parathas, and a Crowing Cock. Do you think I will let *you* go?'

And she gobbled up the camel.

Further down the road, she met an ox, who greeted her, 'Little Louse, how are you and where have you come from?'

The Louse replied, 'I visited my aunt's where I ate Four Eggs, Four Parathas, a Crowing Cock, and on the way home I ate a camel. Do you think I will let *you* go? I am going to eat you up as well!' So she also gobbled up the ox.

She carried on, gobbling one thing after another, and the ending was gory – the louse burst from greed and out came the caravan of creatures she had swallowed. Our task was to remember each one of them, reciting the list loudly.

After Dad lost his job, he started to wear a hat, and his beard started to grow. Mostly he would wear his suit jacket on top of his salwar kameez. On Fridays he would clean the mosque, hoovering, washing down the ablution areas with diluted Zoflora, sharing the cleaning duties with Guncha Khan and Makamad Lala. Dad had worked on the mosque in his spare time, building the ablution areas, constructing the concrete seats and the raised platforms, all tiled in soft Barbara Cartland pink, donated to the mosque by one of the worshippers who owned a builders' yard. Dad had done all the intricate carving around the wooden *mihrab*, which signified the direction of Mecca. He had worked into the chimney breast to create a semi-circular niche, plastering it and decorating it with wooden carvings and ready-made friezes of plastic beading to frame the paisley-patterned bathroom tiles that were part of the donation.

Slowly but surely, Dad began to look less like Cary Grant. The Sunday suit he wore with pride when his friends came around was put away, to be worn only on visits to the unemployment office to sign on.

5

THE PRODIGAL SON AND
THE VISITING HEROES

BARAK-SHAH WAS THE PRIZE BULL of our family. Thirteen
years older than me, he said he had a black belt in karate
and readily showed his flash designer clothes, glitzy Gucci
cigarette lighters and his big bouffant hair, just like the boys on
TV. He was tough but slick; I was skinny and weak. Barak-Shah
talked endlessly of sending me to cadet school to toughen
me up.

Mum had a special place in her heart for him. He was the
firstborn; she had him when she was fifteen, soon after her
marriage, and so he had found his place as a god on earth in
our home. Like Dad, his whims ruled over us: Barak-Shah could
do no wrong in Mum's eyes. She had given birth to him before
he had been fully baked. She would blame Dad for this – 'He
beat me, when Barak-Shah was still inside, at seven months' –
and Barak-Shah came out feet first two months earlier than

anticipated. Our god was born black, blue, and weak from lack of oxygen, but she nurtured him. He survived.

He was Mum's joy, and she would wait up for him if he came home late. She would cook for him and his friends at a moment's notice, wash his clothes the way he wanted. It was Mum who bought him his first black-and-white television from her savings. She repeated to Dad that 'Boys need such things.' And to top it all, Mum said we all had to listen to him, talk to him with respect.

'He is the eldest by far. Do his bidding. Never answer him back.'

'Your brother's coming. Make sure everything is ready for him.'

My mum didn't name him. In patriarchal communities it's not for the mothers to name their children, that isn't our tradition: the paternal elders name them – the uncles, aunts and grandparents on the father's side. My aunts named Barak-Shah. 'Barak' means blessed, and 'shah' means king, so Barak-Shah was our blessed king. In these societies the father keeps his distance, especially from their first-born. Dad could only play with Barak-Shah when he started to walk: carrying him or cradling him wasn't a manly act, this was the woman's burden, and by the time Barak-Shah took his first steps Dad had already left for England.

Later I understood why Mum cherished Barak-Shah so. After her marriage, she lived with her extended in-laws: her mother-in-law; her brothers-in-law, sisters-in-law, their children, and the many relatives who came to stay for weeks on end. When Dad

migrated, Mum and Barak-Shah were left to fend for themselves in this large joint-family arrangement. Even if it was Mum's husband who sent money back, she had no control over it. It was collected by someone else and spent by someone else. This extended coexistence under one roof didn't result in communal harmony. Power games unfolded about who could eat at what time, what time tea could be served, with milk or not, and by whom, who served from the cooking pot, and who got the choicest cuts of meat on Thursdays. That was the only day meat was cooked. In these domestic power dynamics, Mum and Barak-Shah lost. Barak-Shah learned how to go hungry, and Mum watched and grieved, helplessly, as she couldn't provide him with enough food. There was plenty in the house, but not for them.

Thus Barak-Shah always had this real sense of having less, of being less, as the corpulent matriarchs who ruled the domesticities in the house made a big distinction between the rest of their nephews and nieces and him. We never fully understood why they installed this apartheid, but as a result Barak-Shah had always been hungry, always had that drive to take his share and anything else that came his way.

Eventually Barak-Shah came to be with Dad in England – and now, aged nearly twenty, he started his first business; the first entrepreneur in the family. He had grown tall, and everyone said he had turned out to be a handsome young man. After a few jobs, he settled, working at the local estate agent in the slightly upmarket white neighbourhood of Kings Heath. From here, Barak-Shah and his friends started working on the side, buying and selling houses for men in the community and anyone else

who was interested. Their business boomed, they walked taller, and each of them revved up fast new cars on our streets.

One afternoon, in the bright sun, Barak-Shah parked on our street a shining red kit car with scissor doors. A red version of the *Knight Rider*. A blazing Ferrari. You could hear the commotion on the street from inside. I ran out and then I saw it, parked outside our house, surrounded by kids and men all jabbering appreciatively. Barak-Shah was seated inside like an emperor, the swing doors of his car opened up like majestic wings.

This wasn't a sensible car with four doors. Mum or Dad couldn't travel in it so easily, and nor could Dad summon his son to take him and a party of friends to visit a sick or returning comrade. But Barak-Shah travelled around the city for months in this smouldering-hot car with only two doors, conquering and gathering a mélange of friends and admirers. Windows down, the speakers bellowed out a medley of reggae, Michael Jackson, Prince and Whitney Houston. There were no brown voices to be seen or heard on the airwaves. The African-Caribbeans were our friends, we lived amongst them, and it was their voices, our closest neighbours, that fashioned some space on the radio and TV frequencies – and they were cool, we wanted to listen to them. How those darker shades moved under the studio lights in comparison to the white people, who shuffled back and forth as they all fought for the top of the weekly charts!

Full of magnanimity one day, Barak-Shah took me for a ride around our neighbourhood. He had two friends in the back who were smoking one cigarette after another. I was forced to sit between them. In the front next to him was Lewis, a

schoolfriend who was steadily becoming a Rastafarian. We rounded the umpteenth corner, and I sat as upright as I could between men who were twelve, fifteen years older than me. The smoke seeped inside, and I began to swallow and hold my breath at the same time. It was Lewis's rainbow Rasta cap that I fixated upon to stop me being ill, but the feeling of nausea surged and I bleated 'I'm gonna vomit!', pleased with myself that I knew the technical term for throwing up. Everyone turned around, looked at me, at the weak, delicate boy in the middle. Barak-Shah put his foot down in an emergency stop, embarrassed, angrily ushering me out from his car whilst his friends peered at me as though I was a leper.

There was a large Black community in our area. We all went to the same schools. It seemed Barak-Shah was friends with everyone, or that everyone knew Barak-Shah. Out of all his Black friends, only Lewis was ever invited into our private front room. He would say salaam to everyone, including my dad if he was around, and Mum would be happy to feed him. The front room was the space where Dad's visiting male friends and male members of our extended family would be hosted. It was the equivalent of a *dera* or *hujra*, a space for the men to gather on all occasions – but, as it was inside our house, it was only the select few who were invited in. Mostly we all stood outside, sitting on the wall when our friends came round.

Lewis had only recently begun to grow his dreadlocks, and

from time to time he would wear his Rasta cap. Before turning to Haile Selassie, Lewis had been touched by Malcolm X. Well, Lewis hadn't, not exactly, but his father who worked in the foundries of Smethwick had shaken the hand of the Messiah twenty years earlier. In 1965, Malcolm X had come to give a talk at the Birmingham University Student Union, and fitted in a visit to the little town of Smethwick on the outskirts of the city, where the Conservatives had recently campaigned and won a parliamentary seat, allegedly using the slogan 'If you want a n***** for a neighbour, vote Liberal or Labour'. Now they were campaigning for the 'Marshall Plan', to prevent the sale of homes on Marshall Street to any black or brown families. Asked why he had come, Malcolm X said, 'I have come here because I am disturbed by reports that coloured people in Smethwick are being badly treated. I have heard they are being treated as the Jews were under Hitler.' The press asked him what should be done. 'I would not wait for the fascist elements in Smethwick to erect gas ovens,' he replied.

Malcolm X had just left the Nation of Islam and converted to Sunnism. Embarking on a journey to Mecca, he had circled the House of God and seen believers with marble-coloured eyes and blonde hair next to onyx eyes and black hair – a spectrum of skin colours, from all walks of life, equal and barefooted, submitting to the will of the creator. He had been touched, and now his eloquent tongue would deliver his message near and far. On his recent tours he had been venerated in Africa, and now Paris refused him entry in case he roused the local Black population, sending him back on a flight to England.

Even before the liberator had reached the immigration counter, the police stood in his way. Now Malcolm X was coming to Birmingham, invited by the Indian Workers' Association, and about to touch our lives through the hand of Lewis Senior. The night before he left, he dined at a Bangladeshi curry house with Muslim students. Nine days later he would be shot dead.

Lewis Senior had converted to Islam. Well, not entirely rigorously, as he would still celebrate Christmas, enjoy a few drinks, and go to the church with Mrs Lewis on Sundays. Yet when the day of Eid came round, he would wear his embroidered cap, come to the large central mosque, and say assalam alaikum, shaking our hands.

God hadn't forsaken us in this country of non-believers. He sent us signs, strong, vivid signs. Emissaries like Malcolm X that stood up next to us and for us. A few decades later when Barak-Shah and Lewis had come of age, he sent Muhammad, the greatest boxer who had ever lived. As the sayings of the prophets go, God sends a messenger for every community – and for some reason he had been sending them all to Birmingham in England. Muhammad's name hadn't been shortened to Mo, Moe, or Mohd. He was only called Muhammad, Muhammad Ali. Here was another sign – a Muslim, the greatest fighter alive, coming to tell us we were on the right path.

No one took me to Central Mosque on the day he came, but everyone talked about it. Dad, Dad's friends, the men at the mosque, the boys at the mosque, Barak-Shah, Lewis, their gang of friends. This was a Muslim to be proud of. They turned out en masse, wanting to shake his hand, to pray in the mosque at

the same congregation he attended. He walked through the crowds, kissing babies and admirers, smiling, sparring in jest with the brave, but we all knew he was the best. He was on the front page of all the papers and he was on TV – the TV that only Dad or Barak-Shah could turn on. One of those days, I was there watching – watching the signs of this Muslim man's greatness blessed to him by the Almighty. The unshakeable belief he had! He was another messenger to tell us we were also great. Now we just needed Bruce Lee to convert and God would send him to Birmingham.

6

THE SCRIBE AND THE
HOUSE OF LOVE

I OFTEN ACCOMPANIED MUM TO OTHER people's houses, walking beside her or trailing behind her like a pageboy. One day we were visiting the home of Akhunzada the Scribe; one of my favourite destinations. Mum had swapped her shuttlecock burqa for her more practical two-piece black polyester robe. She had again embroidered it herself, this time black on black, with headscarf to match, tied over her head and under her chin. Two veils dropped over her face like Venetian blinds.

It felt like a procession: Mum promenading as if in a Spanish mantilla, an imaginary umbilical leash keeping me close by as I darted about. She occasionally grabbed my arm as she navigated the road.

I stood behind Mum as she rang the doorbell, letter in hand. She had thrown back her veil, exposing her face, and I looked up as she revealed her high Afghan cheekbones. She

looked down at me and smiled, revealing her teeth with their low gumline, and pressed the doorbell again, before Saba Jaan appeared saying, 'Sister, you have come.' And then we were inside in the warm haze, Saba Jaan telling Mum that she hadn't been feeling so well as we followed her into her back room. I noticed she had tied her long headscarf around her head, as did Mum when she was ill, knotting it directly at the back, on top of her centre plait, compressing her head.

And there was Akhunzada, seated in Saba Jaan's house, and clearly not the other way around, though I didn't at the time understand why. 'Sister, son, welcome, you will drink some tea,' part question, part command. I realized that Akhunzada was a very different kind of man. I watched as Mum sat, clearly in awe of him, and I wondered why.

'Osman doesn't drink tea,' said Mum. Saying no to his offer would have been an insult, as tribal customs of hospitality were still very de rigueur in this new orthodox community. But it was okay to say no on my behalf. I was a child.

Under his black beanie, Akhunzada had hair that was almost silver, oiled and parted in the middle, tucked behind his ears so that it curled around his lobes. In Pakistan, Akhunzada had studied all twelve classes of intermediate school, and took home a First Class in his formative assessment exams. On the day of his results, his proud mother, Bakthore, had cooked halwa sprinkled with nuts and sultanas on her open stove, in the largest pot she could find, and distributed it far and wide in their village.

Now settled in Balsall Heath, Akhunzada was living in Homer Road, just around the corner from the Victorian Balsall Heath

Baths, the most handsome building in our area, complete with a magnificent coat of arms. Theirs was a small terraced house. The front door opened into the sitting room; beyond was the back room and then the kitchen, which led out into a small paved yard. The staircase in the front room led up to two rooms and a bathroom on the first floor. This was just cosy enough for him and his wife, Saba Jaan.

To me this was always the House of Love. In here, love was not hidden. It radiated from the house, decorated, in my mind, in a cliché of reds and pinks that matched the plastic flowers in moulded-glass vases sitting comfortably on the white crochet doilies that Saba Jaan bought when she ventured out to the shops unchaperoned. The fact she shopped alone was a further reflection of the views of her very liberal husband.

Walking towards Homer Road, I often imagined I saw the house sending out warm mists of love. Inside, Akhunzada would sit near Saba Jaan on their embroidered black polyester settee covers, not immediately next to her but close enough that it seemed to me their auras would intersect and rise up like a joined-together candyfloss love heart and escape out of the chimney. It formed a message that travelled out to the world, of love existing in full bloom, all year around.

Akhunzada was one of the few in our transplanted commu-nity who could read and write proficiently. He had studied Persian and Urdu at school along with his mother tongue, Pashto. At the drop of a hat, in any gathering, he could recite Khushal Khan Kattak, Rumi, Ghalib, Shah Shuja, Maulana Jami, in a chanting recitation, or rhyming patriotic couplets from Sufi

poetry whose profundity would go straight to the heart. Everyone would applaud and ask for an encore as the chillum bubbled and was passed round like a peace pipe, filling the room with smoke. I was alone in hating that pipe; it would make me retch, my insides swimming, and the smoke would make me want to throw up.

As a consequence of his literary skills, as well as his day job at the foundry Akhunzada was our local and trusted scribe. The respect he received was huge, and I recall seeing hands forever thrust forward in his direction, greeting him on the road, at the mosque or at the local grocery store. Through his work as their scribe, Akhunzada had built complete trust with the older generation: he was the keeper of their secrets, their joys, tears, losses and feuds. He was the oracle, the vehicle for correspondence with those left behind at home, the keeper of the bonds that couldn't be broken. He wrote messages in poetic swirls, messages that were sent separately from the monies that travelled to loved ones through the black-market *hawala* system. What to do with such money? Where to buy new land? What to say to your foe or friend via your brother, cousin or in-laws? What to do about the hatching of plots? Whose wedding to pay for? Whose death rituals to subsidize? To whom to give congratulations when God blessed a relative with a daughter – or more importantly, a son? Promises of betrothals, enquiries into health and sickness, notifications of arrivals, admonishments and upsets . . . all were scribed by Akhunzada with his powers of tact.

He also was the first to tell of joyful news from the homeland or from Vilayat: of new offspring, of grandchildren and nephews

and nieces born, of the names of those being christened. Or he would transmit suggestions for naming a child. And of course, he was also the first bearer of sad news.

So, there sat Mum, mesmerized, as Akhunzada moved gently, navigating the utensils in the kitchen. He had put the pan on the gas cooker, all in open view through the bevelled glass door which led to the small kitchen. His movements were so precise and purposeful. It was then I twigged at what Mum was marvelling. We had caught him in the unmanly act of making tea for his wife and himself.

In fact, on almost every visit my mother made to Akhunzada and Saba's, I would sit in awe as we watched Akhunzada making a cup of tea, offering it to his wife and to Mum, and offering a glass of Ribena to me. On this occasion, we both stole glances at Akhunzada's eyes as he looked over the letter mother had handed to him. His eyesight was gradually getting worse, and he had taken to wearing thicker and bigger glasses which reminded me of Elton John. Dad had mentioned that the *ustad* at the mosque had prescribed Akhunzada the best collyrium from Isfahan every night, and Saba Jaan confirmed this later to Mum: 'In each eye three times per day, starting from the right eye and then moving on to the left eye. Three times exactly, reciting his prayer, asking for his sight to improve or at least not to get worse.'

I examined him closely. Through the heavy concave lenses you could see his clear blue eyes, small, scarab-like, smudged with kohl. He sat down and began reading out loud. I couldn't work out quite what it all meant but it seemed that my father's

brother had upset my mother's family by going and asking for the money my dad had sent for my maternal great-grandad's funeral. When Akhunzada finished reading the letter, he peered over his glasses at my mother, who was extremely shocked, and Saba Jaan came over to comfort her.

I noticed how Saba Jaan's cream and pink complexion always shone, along with her long, luscious plaited hair. I never saw her in anything brightly coloured. She always dressed in shades of peach, ivories, dove greys, soft shades of parrot green and magnolia. She wore a headscarf to match and a practical acrylic cardigan, which not only kept her warm but also seemed to keep her breasts from moving too much. To finish it all off she wore black shoes or slippers and always, always bright white socks.

I remember Mum saying Akhunzada and Saba Jaan were childless, that the stork had never brought them their bundle of joy, and this was probably why she often took a fancy to any goody-two-shoes child that ran an errand for her. I was more than happy to be one of those children. It was Saba Jaan who had written down the word 'brandy' on the corner of a cereal packet a year before and asked me to run along with a five-pound note to the off-licence on the edge of Balsall Heath, away from our thoroughfare of prying eyes. Mr Singh had wrapped it in a brown paper bag and then a plastic carrier bag. I took it straight back to Saba Jaan.

On my frequent subsequent errands for her, I usually arrived holding a yogurt pot – this was the prevalent receptacle used to carry gifts of food from house to house. Women in the

community would share food they had cooked, and we children would carry it around like couriers. This particular yogurt pot had a lid, and using it was far easier than trying to carry a stew or curry on a plate – a real challenge, for it would slosh away as you plodded along, the gravy licking the rim of the plate and spilling over the side if you weren't focused or didn't keep it absolutely horizontal.

Lollipops and Mojo chews a-plenty were my reward, and five-penny pieces were dished out on occasion if you smiled, said your pleases and thank yous, and stood around long enough to answer her pleasantries.

'How is your mum?'

'She is very well.'

But I was aware that to please her, it would be wise to offer more information.

'She has a headache, she is lying down.'

Better still was my response on one particular occasion: 'Oh, very busy. We have relatives from far, far away staying,' I bragged.

It was always worth mentioning when relatives or family friends visited from outside our city, exotic Bradford, Bolton, Luton or Dudley, aunties or uncles or cousins come to pay their respects or celebrate a birth or a long overdue visit (everyone was a cousin, an aunty or uncle, even if no blood was shared). Saba Jaan would plug me for more details and I would stand there, all puffed up with my own importance as the neighbourhood gossip.

Easier and even more exciting was the hand-delivery of finished garments my mum had sewn or mended. I would watch

entranced whilst Saba Jaan inspected her delivery in front of me, just in case it needed to be returned. I loved the fresh embroidery of the hem, the thickness of the buckram – even the off-cuts. These could be made into children's wear, and could never be treated as unwanted. Returning what wasn't yours was always important, a sign of an honest tailor; even keeping scraps was *haram*. Anything sizeable had to be returned, though the very small scraps went into a black bin-liner, eventually to be transformed into patchwork throws and duvet covers.

Mum always told us never to accept a present from anyone on our errands, but sometimes it was difficult to say no, especially to Saba Jaan. When I couldn't refuse the gifts, I would take them home to Mum, and she would store them and keep a tally of who had given what, as some day it would have to be given back tenfold. A headscarf, a sweater, dates and Zamzam water; a prayer hat or beads from Mecca; a pair of slippers, cut lengths of crimplene, polycottons, lace to decorate necklines or edges of scarves; tea sets, jugs. These were esteemed presents to bestow, and were met with gratitude, but generosity had to be returned. As a result, gifts would circulate in a complex web of social etiquette.

But back to that day, and the reading of this particular piece of bad news. Mum finally composed herself. Akhunzada gave me a kindly handshake but looked gravely at my mother. Saba Jaan kissed me and hugged Mum. Afterwards, as we walked away, Mum wondered aloud, 'How did I ever manage to get married into such a house of hornets?' I secretly agreed.

Sometimes Akhunzada would visit us at home and I would

find him in the front room as I walked in from school in his Crombie coat and 'campus' acrylic jumper over a pinstriped shirt, his girth held contentedly in by his gold-buckled black leather belt, and on his head the perpetual beanie. Armed with his pen, which lived inside his jacket pocket, Akhunzada would come and practise his vocation as community scribe at our home, and at the homes of many others in the community, over endless offerings of tea, sweetmeats, pilaus, dodai and curry. His sessions were usually fitted in 'after hours' from the foundry work, or on Sundays.

He was confined to writing people's instructions, all one's heart's sayings, in the four segments of the old-fashioned pre-paid airmail letter. The letters would open out like a concertina and were made of the lightest Regency blue sugar paper. Pre-creased, with gummed flaps and a minimally festooned front, with red and blue chevroned edges where the address of the receiver was to be written, it was forbidden to add any additional weight – no banknotes slipped in or photographs, no matter how much you wanted to.

It was my job, always, to go and buy the airmail letters from the Post Office. When Akhunzada had finished, it was also my role to lick the flaps, carefully press them down and skip across the road, past the big oak tree and straight to the post box so the big steel bird could carry the messages across the deep seas, vast deserts and snow-peaked mountains to the birthplace of my father and mother.

THE BUTCHER, THE BUTCHER'S MUM, AND THE BUTCHER'S WIFE

NOOMYALAY HAD BUILT A PALATIAL bird-loft for his beloved racer pigeons right at the back of his garden. He would let them out, and they would circle up above, then miraculously find their way back, some of them taking tumbles as they headed down to a breakfast of corn, yesterday's bread and cold dodai. He had fifty-seven exactly, all pristine shades of grey or white. A few feet away from them were the caged chickens, which couldn't roam, and were there to give him an additional income. Noomyalay lived three streets away from us in Ivor Road. There should have been a 'halal chicken' sign above his front door, signposting his dispensation of fresh chicken to most of the Muslim houses in the neighbourhood. He was equally adept at making the caged birds halal in his back yard as he was at beating his wife, Janan.

His love for one bird over the other was shown ritualistically

through the slaughter of the bigger birds in his open yard in full view of the pigeon palace, where his beloveds lived. The blood from the chickens would drain into the gutter, staining the back-bricked yard, and the freshly halal birds, decapitated, struggling and darting around, were caught, plucked and skinned by Janan and her two elder daughters. On the rare occasion he would slaughter a pigeon, Janan would cook it for him. Pigeon curry was a remedy for asthma, Dad said.

Mateen Baba, Noomyalay's father, had been famous back in the Frontier for beating Noomyalay's mother, Makmalbakt, with her eyes blindfolded, and now − like father like son − it was Noomyalay's turn to beat Janan.

Makmalbakt visited our house regularly. Sitting with legs folded, her chador wrapped over her head, she would eat, drink, nap and chat to my mum and dad, reminiscing about life back in their village. Somewhere along the way, from her marriage to Mateen Baba, who was long dead, to her life in Birmingham, she had lost two fingers.

Mum always said she only ever remembered Makmalbakt having a hand with five digits, but her pinky and her ring finger were stumps now; they had been rounded off − no nails grew now. Yet still she wore a large ring of lapis lazuli, and a silver band on her short, diced fingers. She didn't seem to want to hide her incapacity, and would put both hands in full view with golden bangles jangling from each of her wrists for everyone to see. She would sit there, golden hoops, golden bangles, golden rings and golden lockets like the booty of Blackbeard, her sparrow face watching your every move. I was mesmerized.

Dad had known Makmalbakt when all her digits were intact. He'd seen her wedding from the village rooftops when he was a small boy. He had seen her taken out of her wedding palanquin, the embroidered sheets parting as she put her feet on the ground, her red robes shimmering. She had been guided by her mother- and sisters-in-law, and also sat for seven days, like a doll, with her hennaed hands and borrowed jewellery, keeping her gaze low to the ground as all the relatives, neighbours and friends visited again and again. They came for the wedding feast, for the henna night. On the day before her departure from home, as is customary, Makmalbakt's hair had been plaited seven times by seven married women preparing her to become a bride. They returned to eat once again to look at her virginal-blood-stained sheets on display in the courtyard, proof that the marriage had been consummated.

It seemed impossible to imagine this wedding day, as Makmalbakt sat before me with her three-fingered hand, a tiny old woman. But she was a gifted storyteller, and as I listened to her she seemed to grow bigger and bigger, like a genie, as her stories came alive. Her audience — sometimes my parents, some-times my siblings and me — was transfixed by her tales and infamous guessing games. One of these games was a series of riddles, which took us ages to work out.

'Across the river came two burly men, of same colouring, wearing green hats.'

We would guess and guess for what felt like hours — with little luck. She never gave anything away, not even the tiniest clue. The answer, it turned out, was a pair of aubergines. 'A golden urn with two colours of water?' An egg.

One day, Makmalbakt was sitting in her usual place next to the paraffin heater. She had eaten her fill and Mum was clearing the plates away. I had just got in from school and was en route to the mosque when I sensed the familiar black cloud hovering over Makmalbakt as she got ready to tell a dramatic story.

'The holy day of Friday was the day that I became a widow,' she told us, raising her palm and solemnly fixing on me. Then to my huge confusion she began lamenting, 'It is better to be beaten than have your cover of respectability taken from you,' and said that she would rather have her hair 'PULLED' (here she pulled back her scarf, unveiling her thin grey hair), 'or be SLAPPED' (here she touched her cheeks) . . .

'KICKED . . .

'PUNCHED . . .

'SHOVED . . .

'and be PUSHED to the ground, than face a life of finger-pointing, hiding in the shadows, keeping visibly pious and stain-free as a widow.'

The onus, I learned, was always on womankind; once she was widowed it was she who must guard herself, keep herself shrouded, divert her gaze, turn her back, speak in hushed tones so her voice would not reach beyond the four walls of her home.

So it was, Makmalbakt told us, she found herself alone with her four young children. 'Oh, what I had to endure to bring Noomyalay and Farang up. I worked from dawn to dusk to feed my two sons and two daughters.' She had no man to protect her and had always to be watchful to keep herself and her young daughters pure and untarnished. She would say, 'I gave my

daughters away early for dodai.' Later I understood she meant that she had given them away so that they could get a regular meal at their husbands' houses.

'I begged from behind these four walls,' Makmalbakt continued, her lament accelerating. 'I took in work at home, embroidering pieces for dowries: bedspreads, pillowcases, table covers, mantel scarves. I ground pulses, peppers, grains, herbs and dried chillies. The spray from the capsicum, springing from the two flat circular grinding stones which sat one on top of the other, would sting my eyes.'

She put her good hand close to her eye and rested it on her cheekbones.

"They were two pools of red, where the tears would then flow.'

She paused dramatically, and I held my breath.

'I managed to put Noomyalay, the eldest, and Farang, the youngest, through school. Noomyalay had been hungry to learn, and then he got himself to England and brought me with him.'

But Noomyalay, it seems, fought regularly with Makmalbakt and one day she walked out, her trunk in hand containing her few simple belongings, which she counted out for us: 'Five suits, four acrylic cardigans and seven pairs of socks, some new and some worn, two chadors, my pension book and a new pair of plastic slippers.'

As she left, she opened the door to Noomyalay's pigeon loft in the hope his beloved birds would leave with her. She walked up Willows Road to Mary Street, to her younger son's, whose wedding she had arranged with the daughter of a distant cousin. Their family were already settled in England with their precious

passports, and now her son had joined his wife. They had one of the largest houses on Mary Street, and Makmalbakt took up very little space.

'And I threw myself at his mercy.' Noomyalay, as the eldest, was always her treasure. '"But I can't take it any more, the words, he behaves like a woman, not like a man, God has tied a dog to his mouth – he barks, your brother," and he took me in with open arms.'

It seemed that Noomyalay had forgotten the Prophet's saying, 'Heaven lies under your mother's feet', and had let her walk out. Now Makmalbakt was creating havoc by talking in any salon she cared to visit of her eldest son's neglect. She would repeat her lament, again and again, of how she had brought him up, the sacrifices she had made, those pools of blood in her eyes, the countless hungry nights, how she had signed him over everything, everyone's inheritance, and his harsh words. Her eyes would fill with tears, and once again those beside her would encourage her to be strong, to have patience, that God would punish him in the hereafter.

Mum would console her: 'God did not have a stick to beat you with in this world. No one has come back from the other side, but yet we know that it is fraught with trials and the worst of punishments, where snakes and scorpions await you.' Mum was never happier than when she imparted advice of this kind, which helped put her own misery and hardship in perspective – her belief that all our sorrows in the present would be rewarded in the hereafter, or at least the bad deeds of those that wished us ill would be punished.

Once I heard Mum recount to Dad that Makmalbakt had confessed that she didn't know how to use a toilet. She had always squatted on the ground to defecate. In England, she had worked out that the same needed to happen but perched up high on a glistening white porcelain toilet bowl. So she would stand, parking her tiny feet on either side of the black toilet seat, and expel from a great height with perfect accuracy – just as she did back home. Then she'd wash her bottom with a water pot in the bath and use the toilet paper to clean away the imprints of her plastic slippers from the seat where she had stood. Following this ritual, she flushed everything away.

Mum and Dad laughed endlessly over this story and Mum said that eventually Makmalbakt had worked out the correct way to use the toilet by walking in on Tabesh, Farang's eldest grandson. At this Dad laughed even louder.

Makmalbakt the gifted storyteller also landed the wettest kisses, taking my face in both hands and moving it left to right as she planted one on each cheek. Most days I was welcomed back from school with a dribble down my face from Makmalbakt's toothless mouth, but it was a small price to pay for her stories.

With Makmalbakt removed to his younger brother's home, Noomyalay settled on another distraction: he would beat his wife Janan regularly, upon the slightest of annoyances – the shift of an eye, paying too much attention to one thing or another, her walk, her laughter. Anything that irritated Noomyalay would

result in an attack on Janan. And it wasn't that Janan couldn't make a home or wasn't beautiful, people said, it was because she hadn't borne him any sons, only two daughters. Grace and gratitude hadn't touched Noomyalay, for he would eat all the rich food that Janan prepared and laid out on the table each day for him, but not extend an offer for his wife and daughters to join him. When Noomyalay was at the foundry, Janan would slaughter the chickens herself, read the relevant prayers and catch the chickens that were darting around her back yard, either to kill or to put them back into metal cages at night so the foxes couldn't prey on them – the same care and duty she gave to Noomyalay's pigeons.

When Noomyalay beat Janan, he was careful not to hit her face; he hit her on her back, punched her in her belly. Dad wasn't so careful, and would hit Mum on her face, and then Mum would cover her bruises with colourful headscarves, the reds and blues matching, and somehow merging into her wounds.

Janan wasn't like my mum, who mostly suffered in silence. Janan had fire in her belly and her mouth and she would look through Noomyalay without fear in her eyes – straight through him. This would regularly result in prolonged beatings. She would scream, and then show her bruises to everyone who wanted to see, thwarting Noomyalay's efforts to hide his actions. Her neighbours were always the first to come round, but everyone who came to shop for halal chicken also saw her fresh bruises. Once I saw her lift up her chemise to my mum when we visited, bearing her scars in full view for us to see, showing her back,

which looked like a map, with gradients of blue, yellow and red marked across her shoulders.

Janan's body had slowly padded out over the years, and her half-dozen solid-gold bangles dug into her milky, fleshy wrists. Like Mum, she wore the traditional five 24-karat gold hooped earrings, stretching from the centre of the lobe to the middle of each helix, as well as two miniature gold and emerald nose-studs, one on each side. Her frizzy locks were always contained in some way: brushed down, heavily oiled, centre-parted and braided into one long tail. Janan loved jewellery, which the faithful would only wear in the form of soft, 24-karat gold – no impurities, this was wealth on their body. Everyone turned up their noses at English gold. Mum would say, 'They have contaminated it – it's not proper gold!' and Janan would chime back, 'You can tell proper gold: you can tell from its colour.' Gold was gold, and it had to come in the reddish, Indian variety. English and *vilayati* gold were found wanting when compared with gold from the Indian subcontinent. *That* was proper gold. The rite of passage for any Pashtun woman, or for that matter Kashmiri, Punjabi, Gujarati – any woman from the subcontinent – was a set of golden bangles on her wrists.

For the love of jewellery and the dread of her husband's beatings, Janan was one of the pioneers of the 'Committee' on our road. The Committee was an innovative, rotating savings and credit association, wherein Janan, Hooriya Jaan, my mum and several other women would meet every Wednesday for a period of three months or more at Janan's house.

I had accompanied Mum a few times to Committee meetings

during the school holidays. Each signed-up member brought with them five pounds or any other agreed sum. And every week, one person would take the whole pot, and this rotated throughout the group. In this circle of trust, everyone contributed and everyone benefited. There was no documentation, as none of them could read or write. No need for security boxes or safes, as each week someone took home all the cash.

The Committee was made up of women who knew each other and could vouch for each other, who grouped together to save for their children's wedding trousseaus, or their own gold bangles, gold necklaces and lockets. Mum was saving for a set of golden bangles for herself and a set for Barak-Shah's future wife, as he was the eldest and nearly ready for marriage. The lucky women who didn't need to hide anything from their husbands saved together for new settees or carpets.

When everyone's turn had come and each member had received her lump sum and there were no more financial requests or demands, the Committee would automatically disband, to be restarted, with the same or new savers, whenever it was needed. This was the co-operative bank for the orthodox women on our street.

8

MISS ALBERT, MRS MORRIS, AND MY LIFE AS A DODGY BOOK COLLECTOR

FOR A WHILE, I WASN'T sure if it was Miss Albert who had grown up in a concentration camp or her mother. It sounded like prison, so I didn't want to ask any questions, but I couldn't imagine her doing anything bad. Dad just said it was all to do with The War, and that Hitler was a bad person. He had lost his own father in the war when my grandad had sunk to the bottom of the ocean.

Anyhow, now Miss Albert and her mother were safe, living together and very firmly rooted in Moseley Village. Like Mum, Miss Albert carried something inside her, something which set her apart. You could tell from the modest dignity with which she carried herself that sadness and loneliness had been stirred into her blood. You would never see Miss Albert throw back her neck and really chortle. She had been made for a purpose, and that purpose was scholarly: the acquisition and dispensation of knowledge.

No matter what season, she would always take her morning stroll through Moseley Park's magical garden. Miss Albert had bought membership, just like you would for a gym or a club I suppose. Only this was just a park, open to the elements, with no shelter apart from the big oaks that lined its path and willows that bowed to the oasis in the middle. She had a daily mission when she got there, to feed the moorhens with her bag of stale bread. I would sometimes climb over the fence into the park and watch her strategizing how to outwit the more aggressive waterbirds, who saw her coming and rushed over in a big gaggle. Miss Albert was only interested in the underdogs – all those shy birds.

I wasn't sure where she was from, or if she really was German – although her English was perfectly posh, if a little exotic, she did look different from the rest of the English teachers. From her big dark frizzy hair, which she tried to keep in place with clips, to her strong nose hung on olive skin that looked peaky, starved of sunlight in the unremitting rain of England. She seemed to me an ideal concoction of Albert Einstein and Anne Frank: Einstein for the wiry hair and Anne Frank for her features; Miss Albert was surely as clever as both of them. She had a penchant for corduroy trousers worn with checked woollen vests over a little blouse. Miss Albert always wore browns, the kind of shades that trended in the seventies, brown shoes, brown trousers. She was still wearing the same wardrobe a decade later. She had made those careful choices, clothes that were probably better made and lasted longer than the more synthetic, mass-produced garb of the eighties.

Miss Albert was our locum schoolteacher and teacher's assistant. (Our usual teacher was Mr Kinnock, who conned me out of a George V coin I had found and which he wanted for his own collection.) It was Miss Albert who introduced me to Greek mythology and old Bible stories. When she took the class in Mr Kinnock's absence, she would gather us round, sit right in the middle of us and read, holding up her book to show us the pictures that translated the words into images – images that forever stuck in my head, images that afterwards she would get us to draw. I painted the Trojan Horse, the ship from 'Jason and the Argonauts', and Zeus, the King of All the Gods. But my eternal favourite was Medusa, the woman with poisonous snakes for her hair. I was entranced by the scariness of the story, but not enough to stop me drawing her again and again, each time adding new patterns to the snake tresses and giving her a different shade of badass, bleeding lipstick.

I had learned English without noticing through Reception Class and Year 1. I had turned up to school the year before with no English on my tongue: Mum and Dad didn't speak it, so we didn't either. Now Miss Albert, with her piles and piles of books and mythical stories, had allowed me a deep look into myriad universes in this new language, each one containing worlds that you could step into, with Miss Albert holding your hand. When she read stories aloud, with that faint hint of a posh, clipped German accent, I sat hypnotized; when the stories finished I would go away and try to capture some of that wonder in my own writing.

Miss Albert had held out her hand and pulled me into a

world of dreams, very different dreams to those of the rest of my family. My escape route began with her. Many years later, I bumped into her in the village pulling her trolley filled with shopping. I helped her home and then visited her a few more times later on, when she moved into an assisted-care home. Her warm bungalow was simple, with no photographs, but lots of shelves of books. She seemed lonely there, too.

As time went on at school, Miss Albert spoke about the war with Germany, and how she had had to run away with her family; how they were nearly caught; how they had to hide; about her hunger and not having enough food. It was like the stories Dad would tell of his childhood, admonishing us to finish our food, lecturing us on how lucky we were when he had starved nearly every day growing up.

Miss Albert began telling us other stories of her family: of the cakes they would bake; of how her father was taken away and never came back. She said they probably put him in the gas chamber and killed him. She conveyed this with such calm and composure, but I realized she had survived terrors worse than Medusa. I asked her if she had come across Medusa in Germany, and if she lived there, and was she scared of her when she met her? Miss Albert calmly reassured me that Medusa lived in Greece and not in Germany.

She had survived along with her mother, and they joined her grandmother in England. Miss Albert's grandmother's sayings were intelligently amusing. When she first saw football played on TV she flapped her hand dismissively and said, 'Why are they all chasing after one ball?' and 'Why don't they give them *all* a

ball?' I couldn't help but agree with her – during football games I carefully avoided running after the one ball.

Sometimes Miss Albert fed the moorhens with her mother in tow and I'd see them both making their way to the park, Miss Albert upright but her mum shrunken, wearing a floral headscarf, wrapped in an old-fashioned faux Astrakhan overcoat.

Miss Albert bestowed her hunger for books on me. Every book she opened I wanted to read and then keep.

Illegally: Sometimes filching them from Balsall Heath Library under my zipped-up parka, and sometimes borrowing and not returning; and once . . . Well, I'll save that for later.

Legally: From jumble sales and school summer fairs for a penny, or from the giveaways at the neighbourhood Community Centre on Ladypool Road.

Pride of place, in order:

Shelf One: Quite pristine, nearly new books: *The Fantastic Four*; *The Children of Cherry Tree Farm*; *The Lion, the Witch and the Wardrobe*; *The Adventures of Pinocchio*; *Puss in Boots*; *Rumpelstiltskin*; *The BFG*; *Matilda*; Dr Seuss; and *The Golden Goose and Other Stories*.

Shelf Two: Piles of dog-eared Enid Blyton, maps, picture-books of icebergs and Antarctica, annuals from the *Beano* to *Jackie*, books on gardening, and books on flowers – on pansies and marigolds in particular; Dad liked marigolds.

There were also heavily thumbed editions of *Reader's Digest*s and *National Geographic*s – both particularly easy to come by at the Community Centre. I took whatever was on offer, carrying home six, seven, ten at a time. I didn't read much of these, but they served to fill out my collection. A library needed volume and choice – you never knew who you'd need to impress.

Then the hoarding became indiscriminate, a greedy yearning, very nearly on a par with my jelly mania.

Dad built my bookshelves but my parents didn't read, so there wasn't a notion of extra-curricular stimuli, and certainly they would never have brought books into the house unless it was the holy kind: the only book worthy of reading in their opinion was the Koran, but no one could understand it since it was in Arabic. In some respects we were considered lucky to be attending school, because neither Mum nor Dad had gone, and they thought the school day should have contained enough reading for me. And once the school day had finished, Koranic school started. Everything had its time slot: you couldn't pick and choose your own reading menu.

By the time I was nine, Mrs Morris's report card for me stated:

Art, A+
Craft, A+
English, B
Maths, B
Writing, B
Reading, B
History, B
PE, B

A sea of Bs. My brother Barak-Shah went to see Mrs Morris at Parents' Evening at the end of the year. He was unimpressed with her judgement, and quizzed her indignantly: 'Osman reads all the time, what does this mean that he has a B in all the most important subjects, and the only As he has are in Art and Craft?' It bewildered him and he was outraged.

But Mrs Morris continued to encourage me, looking at my drawings, assigning me special projects, separate to everyone else's in the class. Whilst everyone copied and followed what was on the blackboard, I was working in the corner – my very own studio. I made an animal pen for her, with animals and fences made from pipe cleaners, the floor made from silver paper, and a house of cardboard that I had painted, adorned with a sloped roof made out of corrugated paper. She picked it up and walked down the corridor so that it could take pride of place for a term outside the Assembly Hall, my name written on it in black marker, my class year, Year 5, on a card, folding it so it stood next to it.

Each week there would be another project especially for me.

Everyone else worked in groups, but I always had my own projects, my own collages, my own cut-out stories or chain men, assembled and mounted by myself, my own series of masks, my own tapestries. Once, while walking to swimming lessons side-by-side with Mrs Morris, holding her hand as the most perfect teacher's pet, I pointed out the sign of the abandoned Moseley Art School opposite the baths. 'What is that?' I asked. 'That is an art school,' she responded. 'That is where you should go.'

This charmed creative life, with my own gently supportive artistic patron, came to a sudden and unwelcome end when I moved to the last year of primary school and Mrs Briggs became our class teacher. She was sports mad, so it was all games of rounders and lashings of warming up and extra gymnastics. My feeble attempts at gliding gracefully over the gym horse became her Mission Impossible. There she would be, in her antiquated maroon Adidas tracksuit, a long whistle round her neck that she'd blow to stop proceedings after every one of my efforts. 'Never mind, try again, Osman.'

Back I'd go, and '*Jump*, Osman! JUMP! Go on – do it properly now, Osman. Try harder!' Then eventually, 'Look, I'll show you.'

She would stand there, sizing the horse up as if she were at the Olympics, before going straight for the kill. It always amazed me, the way she lifted her capacious bottom up and over the horse like a ballerina, whistle flying high up above her head.

Arts and Crafts would have to wait, but I kept up the book collecting. My next issue was that I became frustrated by a terrible craving to have my very own, personal, clean copies. The selection in the children's section at the library was never

nearly as pristine or up-to-date as in the WHSmith's in Moseley Village, and anyway it was useless: with library copies you had to give them back. With the ten pence I received for pocket money I could never save up enough to buy a new copy, and the books were so expensive – pounds not pence. My pocket money only stretched enough to feed my insatiable sweet tooth. Saving meant sacrificing the Wagon Wheels.

On a visit to WHSmith, I hit on a simple but brilliant plan for some new acquisitions to bring my library up to date. I would grab *Malory Towers*, several Famous Fives, and run. Infallible.

But it would require some care. I looked around, reading a few pages, putting one book on top of another, looking around again, scouting the joint. There was only one person at the checkout tills near the door. Good. Next step was to hide the books, which I did standing behind the magazine rack, pushing the books under my jumper. Easy. Just a few short steps before I became the proud owner of pristine, perfect, sharp-cornered paperbacks for my library!

As I walked forward and pushed the big glass door open, however, I heard a great shout behind me: 'Oi, you! Stop!' I didn't turn to see who it was. I began to run at high speed, holding my precious stash close to my chest, across the pelican crossing, past Tesco's, then past Lloyds Bank on the corner, past the Jewish bakery Luker's, and straight down Woodbridge Road, taking a sharp left down Trafalgar Road.

My huntswoman was a determined young teenager in her checked WHSmith coat. Her flat white pumps took broad strides across the bricked pavements; it was just like *Cagney & Lacey*.

My little ten-year-old legs ran as fast as they could. She was *determined* and put her arms out to grab me as she got closer, just as my legs lost their strength and I wound down to the ground in slow motion. She slapped me across the back of the head and grabbed one of my arms. Now I was clutching the Enid Blytons in my other hand. She claimed them swiftly back, tucked them in her checked work-coat pockets, and marched me back, tears streaming from my kohled eyes, to WHSmith to be:

LOCKED UP.

They locked me in the room at the back, which had a mirror window that you could see out of but not into. I was made to sit on a high stool, with my feet unable to touch the ground. The huntress stayed next to me, watching me while drinking her mug of hot coffee: I was her catch. It seemed like ages and ages until the police turned up. They asked me why I had stolen the books. I said I hadn't stolen anything; it wasn't me who had taken anything, that they had caught the wrong person. Both officers looked at me, confused. They wanted to know what my address was, and I told them, and now I was travelling home in a police car. Mum opened the door, but couldn't communicate with them, so they gave her a chit.

Mum gave Barak-Shah the chit to read when he got home. It said it was compulsory for me to attend the police station with my parent or guardian the very next day. Barak-Shah took me to the police station in the morning. There were three of us in the sergeant's office, me and Barak-Shah on one side and the police sergeant behind his desk on the other. He was

impressed by Barak-Shah's facility with form-filling and his strong grasp of English, and sent me home with a caution, warning me that I could be sent to a detention centre if I did anything like this again.

Worse was to come when my dad found out. The wrath, the thunder, the shouting was titanic. I had seen him whack his wife and my older brother quite regularly, of course. Occasionally, if my sisters and I found ourselves in the way, we were pushed aside. So our survival tactic had been to dodge and avoid incurring the brunt of his rage.

Now it seemed that I was the only person in that front room: I had his full focus. The slaps came down on me in a cascade; my tears kept falling; my brother and mother tried to pull me out of his way. When Dad was like this, nothing could stop him: his brute force was Hulk-like.

'I have never seen the inside of a police station, in all my years in this country,' he said between breaths. 'Look at you, you were born yesterday, and you have turned my honour into dust.'

The blows kept coming, until finally Mum and Barak-Shah managed to pull me out of the line of attack and Dad left the room.

9

THE BLACK CLOUDS AND DEPARTURES

Up until now, it was only Dad who had gone back home to Swabi in the Frontier, never Mum or any of us children. He had returned alone to pay for his older brother's second marriage, and to do the same for his nephew. But most importantly, he had returned to rebuild the family home, which was made from mud and straw. Dad now assembled it with his own hands, one brick at a time. New red bricks mortared on top of each other.

He had chopped down the thirty-foot jujube tree that had given shade to the whole courtyard, and whose heavy fruit had rained down on him year after year as he grew from child to man. Now the tree had become exquisite doors which he had carved himself with floral motifs. This tree, that everyone used to sit under for shade, was now the portals to their new *haveli*.

There was no doubt that Dad was now a *vilayati*.

The Urdu word for 'foreigner', *vilayati* had been corrupted

in the mouths of the new rulers of India to become 'Blighty'. By a certain irony, Blighty became the patriotic term for the British motherland, for all the goods that were imported from its green pastures and rolling hills, for all its dreams of making Jerusalem in England. For the native subjects in turn, 'Vilayat' became the name for Great Britain, where all the wealth of the Empire had been stored, and the *vilayati* were the lucky immigrants to that land.

All the Empire's colonial subjects yearned to become *vilayati*, to get to Blighty, the land of opportunity. Tolyar had sold part of the family field to get here; Palwashay had helped by selling her silver wedding arm-cuff and some golden rings. My uncle had sacrificed many goats to the tombs of many holy men, and prayed at their many shrines, just so my cousins would flourish and take root in that faraway promised land.

These migrants who had managed to be naturalized and been given their British passports were *vilayati* now. Like 'Blighty' for the rulers, *vilayati* was a term of great pride to their colonial subjects, an envious compliment signifying the admission to a new life. Mum said that, back home, relatives were always making snide, envious remarks to those who had made it into the fortress of Vilayat, returning with the riches it promised:

'Look at you now, you're a *vilayati* . . .'

'Your walk is different; you eat on silver plates now?'

'You take off one suit and put on another . . .'

'What are the few rupees you send back to us? Remember we grew up together; naked, barefoot, when there was no food to eat.'

'You are my brother, my sister, you have gone before me, now give us your children, your sons and your daughters for ours in marriage so we can keep our bonds closer. You can't forget us . . . We are stronger together . . . We can all share in this dream.'

Our parents were naturalized and we were born here, looking up to the Queen, her coat of arms embossed on the cover of our hardback black passports. We had become British now. Dad kept our passports safe inside a bag, inside a suitcase, inside a wardrobe.

Dad had grown accustomed to walking on the solid pavements in the land of the Queen, leaving behind the dirt tracks of Swabi. Now he was back to make things anew. The jujube tree had been cut down from the middle of the courtyard to make way for the new buildings. Dad built three rooms next to each other: one large, grand room, where his mother would sleep, and two smaller rooms on each side. All three had verandas facing into the courtyard. Honour, appearance and standing deemed it would be shameful for his family to continue living in a mud house, even though they were ventilated better in the summer and retained heat in the winter. People would talk . . . He was earning in *pounds* now, not rupees!

Dad scrimped and saved to send money back home regularly, and then on each visit he turned up with bundles of notes sewn inside his vest. Mum had added extra patch pockets to his undergarments for when he travelled. He couldn't turn up

empty-handed: he had just about made it *in* before Vilayat had closed its doors to any more immigrants from the Commonwealth.

When Dad left for his journeys he took everything, leaving Mum empty-handed. Her laments would begin, bitter complaints, which grew longer and longer. Hooriya Jaan was always there, ready to listen with a sympathetic ear.

'He only left me fifty pence and an old bag of flour that someone had donated to the mosque for the poor . . . All he thinks of is himself, and his money. Not about me, or his children. He performs his prayers, his rituals, his Hajj, his *umrah*s, and off he goes, only thinking of himself, he doesn't think how they will grow up, or what they need. What are we going to eat? What am I going to cook? A dog's head?'

Something had broken inside her and her laments would come in waves. Sometimes no words would come from her mouth, but then: 'He never was mine. He never will be, no matter what I do. His sisters, his mother, his brother, his nephews, when he sees them, light shines in his eyes, the darkness recedes and they cool his heart.'

Darya Khan was Mum's distant kinsman. When Mum wanted solace, she would find him and his wife, who both tried to comfort her. 'You know, Palwashay, my dearest, he knows that you have no one close. No mother. No sister. No brother to look out for you. That's why he treats you like this.'

Mum compulsively repeated herself. I guess that was a sign. A sign I was too young to understand. When no one was around, I would become her listener, her consolation. There was one incident which she recounted several times, in order not to

forget. It was around the time I was born. My forty days hadn't passed, but Dad had decided months before my birth to join a pilgrimage group heading to the Holy Lands. Following that, he planned to go and see his family in Swabi for a few months. Dad's friend Inayatullah Khan, and his wife, Warda Jaan, came to say goodbye to him the day of his departure. They had walked down several streets to see him, not hand-in-hand but with Warda discreetly behind her husband, never a sharp word exchanged. This was yet another harmonious relationship that Mum looked at in awe. Inayatullah Khan and Warda Jaan seemed always to be dignified and only words of decency were uttered between them.

Mum recalled the occasion to me: 'I was still sick after your birth, and Inayatullah Khan and Warda Jaan offered protestations to your father, saying, "Brother, why are you leaving? Look at Palawashay Jaan, she isn't well. She needs you here." And do you know what your father turned around and said?' She shook her head. '"If she dies, bury her." And he looked at me, without saying a word, and walked off into the big van outside waiting to take him to the House of God.'

The hurt swarmed through her body, and she would sit with her eyes streaming. Her headscarf was tied tight around her head, and before the confluence of tears met at the cleft of her chin, she would wipe them away with the corners of her scarf. These stories repeated themselves again and again. That repetition led to a numbing of the affliction.

Something about his departures to visit his family unnerved her. He never asked her to go with him: he always went alone.

When Dad returned from those journeys, Mum said mischief had been planted into his brain, revving up and exploding onto her, lashing out from his mouth and tongue or through a beating with his fists. The waves of pain continued and the story of her journey to England was repeated.

It had been twelve years since she had been bundled out to the UK in her white burqa in great secrecy. She had worn the same burqa to go to the British High Commission in Pakistan to get the entry stamp on her passport to join her husband here. It had been an arduous, tortuously drawn-out affair and it seemed like the decree would never come for my terrified teenage mother. Her in-laws had initially added four other children along with Barak Shah on her application papers. Not surprisingly, this set alarm bells ringing at the High Commission in Rawalpindi; she looked far too young to have borne all those children. But it was her only means of escape – she had no choice but to keep trying.

Meanwhile, back in Birmingham, Dad fought for her to come over, continuously paying for lawyers to appeal the rejected visa decisions so he could live with and enlarge his own young family. Yet his relatives, her in-laws, wanted to keep her in the village and only send the sons. Her mother-in-law had protested, 'If she goes, who will look after the animals or draw the water? Who will do the cooking, or the cleaning, or the grinding of flour and spices? Who will look after me?'

'They would look at me – just *look* at me – to make sure I was working. They would watch me work. None of them helped. All these chores had fallen on my young head. I would pray, and have hope in God, that He would open up a path.'

No bridal price, or *walwar*, had been paid for her but she was still deemed the maid. Her mother would visit her regularly to a reception of frost and disdain. Dad's mum once said to Nan dismissively, 'Take your daughter home, I have no use for her.' Mum would tell me with pride that Nan had replied graciously, 'Your son is still alive, and may Allah grant him a long life, but if he dies, I most certainly will take her home.'

Fearing Mum would sabotage their plan to smuggle her brother-in-law's children into England, Dad's family began to withhold information, and cut her access to her family. She wouldn't be able to say goodbye. Once her visa arrived, a flight was booked in secret. They informed Palwashay of her departure only hours before she was due to leave.

Mum would never forget how her grandfather and her grandmother had died, how her uncle and her aunt had died, and how she wasn't given a chance to say farewell. She learned of their deaths via a telegram.

'It stabs me in my heart not to have seen their faces before they were committed to the ground. When I got the news, I cried, but there was no one to cry with.'

These memories plagued Mum so much, she got sadder and sadder, more and more withdrawn and wretched. One day she collapsed, and Dad had to call Dr Carpet.

Dr Carpet was from Bombay. I knew he wasn't a Muslim as some of the men from the mosque mentioned he drank a lot of whisky and had lost a lot of money gambling. They said he was a Parsi, a Zoroastrian, whatever that meant. He drove a big car, a Jaguar, and was on wife number two or three, but despite

all this, everyone trusted Dr Carpet and spoke very highly of him. 'He is such a good doctor,' they would frequently say in unison.

He'd visit at the drop of a hat and take the £5 for 'petrol' that the men from our orthodox community would slip into his hand for visiting their secluded sick wives and their hidden daughters.

On one of his regular £5 private visits to Mum he looked meaningfully at Dad. 'Mr Yousefzada, your wife's *aab o hawa* [climate] is wrong, it needs to be changed. Her *pani* [water]; she needs to drink her own water, and she needs to breathe her own air.' He spoke in Hindustani as Dad's English wasn't very good.

'She hasn't acclimatized, and she hasn't become a proper *vilayati.*'

He paused for a long time before continuing. 'You have to take her back, otherwise I have no help for you. This could be her last . . .' – and at this he glanced across at Mum – 'if her malaise settles in . . .'

He sat down, dropping his stethoscope from his ears for it to sit around his neck. Using his briefcase as a desk on his lap, he scribbled out two prescriptions and a hospital letter. I stared. His skin was very fair, and I noticed his curly hair only grew from the sides, leaving the top of his skull like an egg with a milky white peak. As he handed the prescriptions to Dad, he said, 'Otherwise you will have to take her back in a coffin. She needs to see her parents, change her environment.'

I looked over at Mum, who sat there with her head bowed low, covered with her headscarf.

Now Dr Carpet had decreed that Mum had been drinking the wrong water, she would have to go back to the Frontier. The water there would ensure she would get better and stronger, more able to cope with the foreignness of Blighty or Vilayat.

Until then there were two prescriptions in Mum's name, one for her medicine and one that wasn't for her. Not only was Dr Carpet taking the fine sum of £5 for each home visit, he would often write prescriptions for other patients in the names of those who received free medicine. Mum was one of them, as Dad was unemployed. Dr Carpet asked for them to be dropped off with Mr Singh, his secretary.

The next day it was my duty to get Mum's medicines. The chemist was across the road from the surgery, where Mr Singh sat behind his wooden desk with piles of papers, rows of filing cabinets behind him holding everyone's personal details. His waiting room was always full, with no ticket system; you remembered who entered the waiting room behind you to keep your place in the queue. If you didn't have enough time to wait to see the doctor, Mr Singh was at hand armed with pre-signed prescriptions. He would write down something for your headache, some amoxicillin for your flu, some indigestion remedy to dissipate the gas that had built up in this new land. Maybe Vilayat gas was different, and its remedy of bright Pepto-Bismol pink hid inside a brown bottle.

Mr Singh needs a full story of his own, but let me tell you about his obsessions. He would wash his hands every twenty minutes, getting up from his chair and using his elbows to open the toilet door like a praying mantis. On his return he would

use his hidden pile of kitchen towels to wipe his hands and all the surfaces around him. When you approached him, he wouldn't touch any of the medicine bottles you had brought back for a repeat prescription. He would use his pen to move the bottle to read the label, and if the manoeuvre was difficult, he would ask you to turn it over or hold it closer to him. Anyone coughing in the surgery was told to cover his mouth and sit in the far corner. I had heard that once Mr Singh had washed all the prescriptions and they were left to dry on the radiator behind him. Aghala had told me that the best present for Mr Singh was a bar of soap. She would often take him such a present so her family stayed in his good books.

When I walked in with my mother's prescriptions that day, Mr Singh was wearing a crisp white shirt, a huge bright-red turban, and braces to hold up his trousers. As always he looked very important; they said he was one of the Panj Pyare in the local gurdwara. I found a space to stand in front of him at his desk. He was already attending to someone, writing 'Amoxicillin' on an already-signed prescription. After he had finished he gestured at me, raising his eyebrows, and I gave him the bag of medicine I had collected from the chemist. He opened it, took out the boxes of tablets, kept one, and gave me back Mum's tablets in the bag.

When the time came for us to leave for the Frontier, I was taken out of class without much grumbling or concern from

the school. (They were used to such things in our community back then.)

This time the whole family received the ritual farewells from the neighbours and community usually reserved for Dad's departures. Meanwhile, Mum's black clouds began to disperse as she threw herself into getting ready, allocating gifts she had been collecting since she had arrived, packing and unpacking suitcases. This was her first 'return home' since she'd set foot in England.

Birmingham airport had no flights to Pakistan, so Uncle Raheem Baksh took us in his twelve-seater van to the big airport in London. Mum had helped his wife make the seat covers in a damask upholstery fabric in yellow ochre, which provided a warm glow against the rain that day.

We all piled in. We were all in our traditional salwar kameez; Mum was in her burqa. Ruksar and Marjan had identical frocks on. To finish off our smart look, Mum slid lead kohl along the inner edge of our lids. This was to protect us, warding off the evil eye, repelling it with the black marks of imperfection. She had become preoccupied with it since her illness. By the time we arrived at our destination it would have smudged to lend us truly decadent rock-star *vilayati* looks.

Mum was taking her offspring back to the land where she grew up, to the earth she had walked on, to drink the clean mountain waters of her country. Her long exile away from her own family was coming to an end, and we could feel her trepidation and excitement.

Uncle Raheem Baksh drove for what seemed like days. He

liked to take the smaller roads, the country lanes that took us through villages and past rolling hills with narrow paths and the occasional herds of cows and flocks of sheep. Here was the beauty of Vilayat in full, quaint glory: its meandering streams, its bales of hay sitting in empty fields and miles and miles of green – nothing remotely like our local parks in Balsall Heath.

Eventually we arrived at the vast departures terminal at Heathrow. Dad led the way; he knew where to go. It was all madness, a throng, everyone in convulsions with hurry, as if the world was coming to an end. I had never seen so many people together in this kind of rush, as if their flights were going to leave without them. Back then, taking a whole family on an aeroplane to Pakistan was a costly affair – maybe that was the worry: the chances to go home were so few, the voyages so mingled with joy and melancholy, seeing what had changed whilst they had been away.

Inside was a shiny metropolis of counters, behind which sat glamorous, onyx-skinned check-in girls, along with milk maidens and dusky desert queens. I watched them beckon people forward to weigh their belongings, tut-tutting or shaking their heads in stern disapproval as they went on the weighing scales. Everyone's eyes would rest rigidly on their faces, waiting for the final judgement.

People had no restraint when packing, eager to take just one more token of the New World back home to share with relatives. While we waited in the queue, a desperate man with his family tried to ask the people behind them in the line if they had space in their luggage. One of the older-looking aunties looked frantically around, found a smart man travelling with

only hand baggage and pleaded with him, shedding all dignity. 'We have too much weight, too much luggage; everyone back home expects a present. May God bless you, son, please help us. Look, look! You have nothing but hand luggage.'

He was going back himself at short notice for a death in his family, and was happy to help, hoping his good actions wouldn't go unnoticed by God, and would make the final journey of his deceased brother easier. He asked them to pray, and they did, standing there in front of everyone – and those nearby lifted their hands and joined in.

Our turn at the check-in finally came. Mum had wrapped nearly a hundred gifts throughout our luggage (none of us possessed our own individual bags back then), each one lovingly labelled on masking tape in Pashto. Many of the recipients or givers couldn't read in any language, but my cousin had written out the labels for my mum; I didn't know who was going to read out the names on the other side.

I noticed our check-in girl's name tag: Sylvia Morris! The very same surname as my schoolteacher. I felt sure that they must be related, even though she had bright-red manicured nails, bright-red lips, a pointy nose, pointy cheekbones and frizzy hair that sat like a Toulouse-Lautrec chignon on her head. To finish it off, she wore a red pill-box hat that sat high on top like a crown. She clucked slightly as she moved, her head swivelling back and forth on her tiny, spring-like neck, in rhythm with the conveyor belt that chugged forward, heaving the gift-laden cases.

As our brimming suitcases went on the luggage scales, I saw Mum praying quietly. We all held our breath. The whole place

seemed to go into tense slow-motion as we scrutinized Sylvia Morris scrutinizing the scales, frowning a little bit. I kept smiling at her until my mouth froze completely.

Then she looked up like a benevolent Queen Solomon and with a little wave indicated she was letting ours through without demanding excess-weight payments. Dad thanked Allah aloud.

Sylvia Morris had let through an extra suitcase of gifts! A victory for all of us.

On the plane, I heard Dad discussing it with Mum and telling her to be vigilant, because when he normally arrived back in Pakistan everyone would crowd round him as he opened his trunks and suitcases. Mum would later find out the whole truth: when Dad travelled alone, Dad's sisters inspected each gift and switched the names around on the presents so that they got what Mum had sent for her own family.

IO

THE FRONTIER I:
DEATH AND MR ROOSTER

'Y OU WILL SEE NOW FOR yourselves the way true Muslims live,' Dad told us during the plane journey.

The visit to the Frontier was supposed to be for six months, which seemed like a thousand years to my mind as we flew through the thick grey bank of English cloud. I gave no thought to my school or the friends I'd left behind. Now I would be living out all the stories Dad had told us of his homeland. For years it was a mythical place to us children, but it had been all Mum could dream about.

The flight seemed endless after the initial few minutes of excitement. Finally I fell asleep and Mum woke me as the wheels thundered down on the runway at Islamabad. Once inside the airport, I managed to pick out all our luggage on the conveyor belt – Mum had tied red ribbons on the suitcases to make them stand out. It was disappointing when the last one came out; I

wanted to keep going. I then had to pee in loos so disgusting I held my nose for at least four minutes thirty-six seconds, especially at the urinal.

On we went to the arrivals gate, Barak-Shah leading the way with the multi-stacked, wobbling trolley. Dad had picked up Ruksar and Mum picked up Marjan, who was nearly two years old. This place beat Heathrow for noise: the chaotic hollering of the waiting crowd stood at least ten deep. Amidst the crush of people, we were eagerly spotted by Dad's youngest brother, Dostam Khan, who began shouting at us hoarsely, ran towards Dad and embraced him repeatedly. Just behind him was my eldest uncle, Khushdil Khan, the patriarch of the household with a *real* gun slung across his chest. Even Barak-Shah couldn't stop goggling at it.

Compared to our departure, our arrival seemed to go by in fast-forward. We were bundled into another twelve-seater van − a very dusty one this time, like a Scooby Doo van with the safety tyre at the back − and we were off to Dad's village in Swabi. The suitcases were stacked onto the roof and tied with blue and red ropes. Mum lowered her head in front of Khushdil Khan, who placed his hand on it to bless her before she climbed in. Mum was in strict purdah; she couldn't lift her veil as there was a non-family member present, driving the van.

Dostam Khan sat at the back and put his arm around me, pinching and squeezing me till it hurt to breathe. I had heard many stories of Uncle Dostam from Mum, Dad and Barak-Shah. Things like, his brain didn't work properly, that he was slow, that he would tremble and pass out with epilepsy, that he would

always get into fights, that he'd once tried to join the army. My mum said he'd parade around in a long army coat, marching through the dusty labyrinth of the neighbourhood with the children following him around making fun of him . . . *Left, right, left, right.* And then he would raise his hand to his head and salute. But I thought, my, he cut a dashing figure, with his white turban.

Years back Dad had taken him along to Karachi so both could get a passport to come to England, but for some reason when Dad went back to the village he left Dostam Khan in Karachi. Months later he recalled him, and Uncle Dostam Khan turned up with the various army uniforms he never stopped wearing.

We travelled endlessly through dusty terrain towards the Frontier, crossing the mighty River Indus, once the divide between Afghanistan and British India. Dad pointed out that this very land had been taken by the British, the colonialist Sir Mortimer Durand creating a new border, closer to the Khyber Pass, in 1893. It remained a thorn in the conflict between Afghanistan and Pakistan. 'The border split one people into two, half facing Kabul and half facing British Delhi and now Islamabad,' said Dad mournfully.

We entered Dad's village, the van only just making it through the narrow streets. I looked on, amazed at the fortress-like walls on either side, walls so high, like the sides of a canyon whose shadows stopped the light touching the ground, a puzzle of alleyways in permanent shadow. Everything was inside out; these buildings had no windows on the outside to let the sun in like in England. The portals into these cube-shaped houses were

huge doors, metal and wood, intricately carved affairs, and behind these closed doors were open courtyards, with rooms around the perimeter. Each room opened outwards into the courtyard, with a veranda where you could sit in the shade. There was a well in the corner of the courtyard, and either a mulberry or jujube tree in the centre to provide further shade and fruit. Open steps led to the roof, which again had its own high walls, and all this architecture was painted with bright colour: indigo, lime green or terracotta salmon.

The crush of relatives ready to embrace us was overwhelming. They stood together, a multitude. Brother Tolyar and Palwashay Jaan have returned, and look: they have brought *five* children. Mum cried when she saw her mother and clung to my tiny, green-eyed nan. A waterfall of tears poured down as they looked at each other's wet faces, brushing away the streams before embracing again. Then came her aunt and her sisters, who had been given just a few hours' notice of our arrival. They all embraced for so long that Mum's sister-in-law, smirking, let out a caustic remark: 'Look at them, it's as if someone had died' – meaning, 'That is quite enough now.' They parted, and Mum moved on to the rest of the visitors that had come to see her in her new role as a returning *vilayati*, the wife of someone who had found fortune in the promised land, however small.

Days later, we headed for my mum's parents' home in the adjoining village, near Topi, to see my grandfather and the rest of the family. My grandfather's thick beard was long and flowing and engulfed his small frame. Mum saw her father and they both wept as he spoke in sweet tones. 'We looked for signs of you,

Palwashay Jaan, every day after you went. I'm so proud God has given you five children; he hasn't left you unprovided for.' And he wept again. 'Be careful, my dear daughter – you have come back to that prison.'

Then he ran around his courtyard pointing at chickens, asking us which one he should kill for our evening welcome feast. 'Do you want this one? Or that one? Or that fat brown one?' he asked, darting towards the confused birds. This was, after all, a man who kept his own goat, which he milked himself for his tea.

The kisses came thick and fast. Everyone wanted to plant one on my cheeks and on my forehead: big sloppy ones, long dry ones; they all smelled of warm spices. Mum's skin illuminated with happiness as she led us through a whirl of introductions: 'Say hello to your aunt, and this is your cousin, Shapara' – a girl, my age – 'and this is your nan's mum, this is my nana.' Nana was a wrinklier version of Nan. I had heard much about her. Mum had talked of how beautiful her family was, how some of them had very fair skin, unlike Dad's, and that her nana's hair was blonde just like Helen of Troy's from Miss Albert's stories. I was excited to see my great-grandmother's hair, but now it was completely white, and she had lost all her teeth. After their greetings, they put strange-looking notes in my hand that didn't have the Queen's head on them. These were rupees – apparently it was money here! So where was I going to spend it? Where were the shops that sold halal sweets and jelly?

If Dad's family were formidable and not scared of anything, my mum's family seemed the more exotic. Here the people had

luminous green and blue Afghan eyes, with auburn and blonde hair. You would notice them from afar, and in their extended family houses in Topi, towards the hills, I would sit and listen to the stories they would tell.

Both Mum and Dad's villages were not far from the banks of the mighty Indus. We crossed its tendrils regularly, and each time I couldn't believe it was real – wide, majestic, its fast waters a transparent, clear ice-blue. Dad told us its source was high up in the mountains, on the Tibetan plateau, and it snaked down south towards Sindh, swallowing up its tributaries, becoming wider and wider before it merged into the Arabian Sea. 'This is a river fed by the snows and glaciers of the Himalayas,' Dad said. 'This is our source of water, our giver of life. It is a river of gifts, a river of myths. I remember when my friends and I would bathe here.' Dad looked very thoughtful. 'Look at this beauty, have you ever seen a more beautiful view? Is there anything so pure in England? You can drink from this river. I miss this: this is where to live. When I have made enough money, we will come back and build a house here.'

The government's decision to build the Tarbela Dam over the River Indus in the late seventies ushered in the destruction of many villages, all submerged under the resulting reservoir – the mosques, the schools, the graveyards, the houses. Some of Dad's older relatives worried that the dam would break and flood them, advising those that would listen to buy land on higher, less fertile ground.

We had relatives on Dad's side who had been displaced by the new dam and it was from them that I later heard many

stories of the legendary Indus, how the Kabul river dances towards it, the latter's black waters merging with the former's blue; how the people washed at the river. To this day, when the reservoir's waters recede, the people flock to its banks, many to visit their ancestors' bones.

Everything felt foreign in this country: the houses were inside out, and although the faces seemed familiar, and the Pashto words, there were many other dialects being spoken in neighbouring villages. Every household lived with their livestock – goats, cows, buffalos, chickens – inside their homes. The big creatures would be tied up near feeding and water troughs. Sometimes the women of the household would hold their hands under the animals and catch the dung as it was being pushed out. This they would dry into patty cakes, which they stuck onto the wall, to be used later as fuel.

Like in England, everyone was an uncle or aunt it seemed, though here some were connected by blood. Mum's family had connections over the border into Afghanistan. Once when visiting my grandparents, there was a woman whose dialect I couldn't understand. She was Nan's niece who had come from far, far away. Nan and Nana were sitting there transfixed by her: she was leaning forward for emphasis, with great seriousness, her legs crossed, her hand gestures gyrating constantly. Sometimes she'd stop suddenly and her eyes would open wide and one hand would hang dramatically mid-air to reinforce what she was saying.

Mum told me she was speaking another tongue of Afghanistan. I didn't understand and my mum didn't either, but we both listened politely.

The niece paused to adjust her headscarf, wrapping it around her head and tucking it behind her ears so it wouldn't fall off. Then those hand movements carried on and the non-stop talking and the nodding of the head. I wondered if Mum and Dad felt like this back home in England, mystified and fascinated, bewildered by the English and the sound of the language that came out of their mouths. The niece's monologue ended dramatically when she began crying, holding her head in her hands. Nana went over to comfort her.

Later I learned that she was a distant niece who had turned up asking for help. 'She has lost everything.' I tried to imagine what this 'everything' meant; had she lost her house, or the people in her house or the whole village? Where was her house, had it drowned under the reservoir? I couldn't really get to the bottom of *everything*. I didn't know if she had lost all of her chickens, her cows, her money, her keys, her clothes, but I knew she had lost it all.

Back at my dad's village, there was Baksh Kaka, another of Dad's brothers. He and his family lived next door to us, sharing our open courtyard, though they had a huge mulberry tree in their garden which bore fruit a few months after our arrival. Baksh Kaka let us climb up and pick the berries. The longer you left them the sweeter they got, he explained.

Baksh Kaka was full of many stories and opinions. He said to anyone who'd listen that years ago, the Pakistani Army had

killed Zulfikar Ali Bhutto because he was bringing too many white women into the country; and also, because he drank. That is why General Muhammad Zia-ul-Haq, a good Muslim, a good military man who brought Islam into the country, had to kill Bhutto. I had visions of these women, singing, dancing and drinking, multiple blonde facsimiles of Madonna hanging out with Bhutto on some grand palace poolside.

In Pakistan the women sparkled with their jewellery, so many bangles and anklets and piercings. They reminded me of peacocks as they pranced around their secluded courtyards, with only other women and their husbands as their audience.

Up and down the banks of the River Indus and the Kabul there were weekly funeral rites and many seasonal weddings from both far-flung and nearby villages. The weddings in the Frontier were celebrated with huge firings of Kalashnikovs, which shot out a round of ammunition to a thumping melody. This signified that the groom's family had come to collect the bride, and they were happy and could defend themselves. On days with no festivities, there were always kaleidoscopic sunsets, and always – *always* – there was jewellery: golden headbands, trinkets laden with emeralds and rubies that fell to the side of women's temples, nose rings, so much of it. These adornments were like tiny, shiny creatures glinting in the sun, yet all hidden in the sanctity of the secluded courtyards.

Every Thursday was the turn of the dead. Mum would go to the resting places of her ancestors with her mother, aunt and myself in tow. Here lay her uncle who had referred to her as his son and would take her around his fields showing her when

a melon ripened, and breaking off sugar cane for her to eat. She cried quietly as she caressed his grave. She had never had the chance to say goodbye to him, nor to any of those who had left for the other side when she had left to become a *vilayati*. As she stood over the grave speaking to him, my heart was inside hers: finally, I understood the crying. Next to her uncle was her grandmother, who had painted Mum's hands with henna and who had cared for her so tenderly. Mum began her address: 'Oh Grandmother, you have taken your love away . . . No one comes back from the other side. You have taken your kind ways . . . You never had a cross word for me.'

This became a weekly thing, this visit to the land of silence where the dead were taken, their bodies lowered into the ground, their heads facing Mecca. Dirt was poured over them to create a mound, and their graves looked like protruding bellies that the earth pushed out after it had taken back what it had created, gobbling up its fill. At the head of these rectangular mounds were slates pushed into the ground – horizontal to denote a man and vertical for a woman.

Death became more vivid to me when I went to my first funeral. It was that of a distant relative who was well loved by everyone. Zarsanga Mai lay dead in the same courtyard where she had walked, cooked and pulled water from her well, where she had entertained, celebrated her children's weddings, brought in the palanquins of her daughter-in-laws' wedding processions.

This same courtyard now hosted a flock of female mourners to see her face one last time. My first dead body looked very normal; I half expected her to snore.

'Now Zarsanga is taking no more breaths, she needs to be ready to be sent into the next world,' explained Mum. Her female relatives had washed her body, perfumed her, prepared her for burial, closed her eyes, tied her toes together, plaited her hair into three braids. And here she lay in state, bathed in a white shroud made of three sheets with the mulberry tree for shade over her charpai. I looked around, taking it all in in silence, whilst everyone around sobbed, screamed and beat their chests without stopping.

Her daughter would ask her to wake up in between sobs: 'Look up, Zarsanga. Look up, Bibi Zarsanga.'

'You have taken the light.'

'You have left us in the dark.'

'Who will I come and talk to?'

For many reasons – curiosity, heat- and grief-exhaustion included – I also badly wanted her to wake up. Eventually the women's hearts became too heavy to push out any more tears. We had all been sitting there since morning, receiving the female mourners, who linked together, bosom to bosom, sometimes in silent tremors and sometimes in loud laments of weeping.

In fact, the crying had started much earlier, when Zarsanga let the angels of death pull out her last breath and the *nagara* drummers had gone from *gali* to *gali* and pounded on the stretched cowhide announcing her death. They didn't use

Zarsanga's name, only the names of her husband and of her sons, declaring that the wife and mother of these men had died.

Now the male mourners began pouring into the *hujra*. Every neighbourhood had a *hujra*, an open courtyard looking out onto the street which had been gifted by one of the richer families and to whose upkeep everyone in the neighbourhood contributed. The men would convene here daily, especially on important occasions: births, deaths, marriages, circumcisions, conflicts, tribal feuds and jirgas, or tribunals. Dad sat here with many elders of the clan, who smoked the chillum and then passed it around and gossiped. On one side of the *hujra* was a series of rooms, like a caravanserai, where visitors and unmarried men slept at night. Dad had slept here with friends in his youth: behind these closed doors when the sun set they would sing *qawwali* accompanied by the tabla and harmonium. The words 'Har Kala Rasha', meaning 'You are forever welcome', were calligraphed in black in the niche above the door.

The *hujra* had swelled; guests had come from afar for Zarsanga's funeral. The men sat outside receiving guests in silence from the street, raising their hands every few minutes, and reciting words I didn't understand – God's words. They held their hands over their chests or near their beards, praying, praying, in unison for Zarsanga; the cadaver of Zarsanga all the while lying on her bed. My *first* cadaver, which looked a lot like she was sleeping to me.

To my relief I discovered that Death also meant eating well. Rice cooked with chickpeas, along with sweet halwas, were on the hospitable menu of all funerals. The cooks had found themselves a spot in the open field next to the *hujra* and had lined

up two big pots. Underneath them the fires kept burning, and from these big pots the family and servers would rush forward with earthen plates piled high, continually feeding their guests. 'Let it not be said that you came to our funeral and you were not looked after or not fed' was at the front of the minds of Zarsanga's family. This was their day of honour. Once everyone had eaten, they were ready for the funeral procession of Zarsanga.

The female mourners had been left to grieve all morning. Finally, at 2 p.m., the men of the family entered Zarsanga's courtyard and asked for the ladies to step aside. Some of the women grabbed onto the charpai, not ready to let her go. I worried her body might fall. When they finally did let go, they held on to each other instead.

The body was lifted from the courtyard of its house, and then covered and taken out into the open streets by the men. I looked up and Zarsanga's body was hovering high in the air on the charpai, which kept moving forward on a sea of hands like a conveyor belt. We left the women mourning inside, and now we were heading to the funeral ground, where the imam recited the prayers. There was no bowing or prostrating; the ceremony was conducted entirely standing up. Rows and rows of men followed the family pallbearers straight to the burial ground, where Zarsanga's body was finally lowered into a freshly dug grave. It was lined with bricks; there was no coffin. The bricks created an inner chamber, with slabs over the top to create a contained space which was then covered over. Here, the earth fully took in her body.

<p style="text-align:center">★ ★ ★</p>

After Zarsanga's death, the world of the Frontier taught me another lesson. Until now, it had proven to be an excellent education in the many, varied rituals of the adult world. It would now teach me that even those I loved, I could be powerless to protect.

One day my mum's great-uncle, Kaka Khan, bought me a cockerel, which he carried locked under his armpit, his gun slung round his back. He brought it into our courtyard and left it there. It was a very bright black, with a red wattle and vivid red hackles. Mum assured me it was mine, and said to thank Uncle when he next came, and recite him a prayer in my beautiful voice.

Sure enough, just before the call to prayer, the cockerel would crow every morning without fail, head honcho and chief stud among the chickens. I was scared of him initially, of that proud stance, but most of all those beady psychotic eyes. But he was mine, my cockerel, and I could beckon him whenever I liked. They had clipped his wings, so he couldn't fly so well.

Mum helped me so that, after a few efforts, I could pick him up and lock him under my arm. I called him Mr Rooster, and everyone else would try to pronounce it in English, making me giggle hilariously. After a month he got so used to me he'd allow me to pick him up and put a rope around his neck without too much of a fuss.

One day I went off to visit Nan with my mum and my sisters and we all stayed over. We returned for midday lunch at Dad's house, to a delicious chicken curry. Mr Rooster wasn't around but I thought he might have drifted over to Baksh Kaka's courtyard as there was no gate between his and ours.

After lunch I went looking for him everywhere with no luck. I began to feel nervous: had they sold Mr Rooster? I asked everyone, and no one said anything. Growing frantic, I kept asking and asking the same people until my aunt, my father's sister, let slip that they had had guests the night before. 'He was the main dish,' she admitted. Then worse: I had just had some of him for lunch.

My screams reached the surrounding houses. Baksh Kaka's wife came to see what the ruckus was about, along with some of our neighbours, who shouted from the rooftops, asking what happened. Had someone died?

'Bring back Mr Rooster, bring him back to life!' I wailed, rocking back and forth.

Everyone gathered around, my little cousin Gul Pari laughing and mimicking me, 'Bring back my cockerel to life.'

Mum promised she would get me another one, but a new one never arrived. They all thought I would calm down, but for weeks I would keep getting myself into rocking trances, sitting on the open stairs to the roof, repeating, 'Bring back my cockerel to life.' It didn't occur to me that I might have picked up the idea from Zarsanga's mourners.

And to be scrupulously honest, it didn't put me off chicken curry, not even the day after the dramatic lunch.

11

THE FRONTIER II:
THE WELL AND THE FEUD

IN THE CORNER OF OUR courtyard was a brooding, enchanting well. It was about twenty metres deep, and I'd peer and peer down into its earthy, dark depths as if it were a living thing, to glimpse the magic creature's eye: the thin sliver of illuminated water, which moved like mercury, beckoning you in.

Every day in England you would turn the taps and water spouted forth, but here you had to go to the well. For all the effort it took, I loved the whole magical business of opening up the closed doors guarding the creature's mouth and seeing the spindle unreel the buffalo-hide bucket. I'd wait for the thrilling sound of the smack and crash as the bucket made contact with the water. When the bucket drank its fill, the handles on the spindle would need turning, recoiling the rope. I'd watch the bucket rise to the top, sloshing its magic water, and my mum would let me pour it into the lined-up pots.

That day, however, something was amiss. The girls were all hanging around the well looking concerned. Banafsha was there, along with all of Baksh Kaka's daughters. I got closer to them; they all looked half-crazy with anguish. Banafsha explained quickly, 'The well can't be used; it has been polluted and the water is unclean to drink. Gharsane's slipper has fallen in.' It seemed she had taken her slippers off, as it was much easier to cling to the wet ground with bare feet when one was turning the spindle.

Gharsane, Baksh Kaka's eldest daughter, was looking sheepish, guilty, and wearing only one slipper, very much wanting to leave the scene of the crime, but not really able to without her missing slipper.

Afreen, her younger sister, kept on peering down the well, saying 'Yes I can see it, look, there it is. Look!' I could just about glimpse the blue plastic slipper floating in the dark, damp circle.

Afreen explained – maybe for us, the *vilayati* in the group – 'You know when the slipper has been retrieved, you will have to draw ten buckets of water from the well to purify it.' She reeled off the rules of purification: 'You have to drain the full well if an animal falls in and dies. The *ustad* at my school told me that if the well doesn't empty, then four men should keep drawing from it from sunrise to sunset and then the well water has become pure.' She paused for breath then continued. 'If a dog falls in and it doesn't die then you only have to draw seven buckets of water. If a sparrow falls in, it's only one bucket of water. And if your chicken shits her droppings into a well, then you have to draw five buckets of water to make the well pure. And if by any chance you get urine in the well, then it's seven buckets of water again.'

Their father, Baksh Kaka, appeared from next door and quickly solved the problem by suggesting I go down the well to retrieve the slipper. I tried not to tremble as I peered into the depths. He kept smiling and nudging me in the back, saying, 'Go down, don't worry, it will be fine, just hold on to the rope and I will lower you down with the bucket.' I was reminded of Mrs Briggs in the school gym.

I suppose I was more embarrassed to be considered a sissy than anything else, so after taking a few deep breaths I decided to go for it, to go down to my probable death. I was taking off my slippers when Mum ran out with impeccable timing. She started screaming at Baksh Kaka, 'Why would you want to send a child down? My child! Are you mad?' Mum threw her full scorn at him as she led me away. 'Why don't you go down yourself, instead of sending a kid?'

He replied, with a reasonable smile, 'But I'm not as small; it's very easy, you see, if you are small. I used to do it all the time.'

In the end a professional diver from the village was lowered down the well to rescue the slipper.

Mum's miraculous intervention had saved my life but she grew very paranoid about Baksh Kaka's actions and imagined everyone was trying to harm her children in 'this lawless no man's land'. She seemed to be getting ill again after the initial joy of her arrival. I had got to know my new hood pretty well, but now Mum wouldn't let us be out of sight or alone in case we were kidnapped. Her excuse, as she always warned us, was that the Karkars would come and snatch us away and hold us for ransom. It was a real threat – there were child-labour

camps hidden in remote areas of the Frontier where they cut out the tongues of children, tied them to donkeys and forced them to break stones.

Maybe there was something to Mum's paranoia: having no sons of his own, we had no *tarburs* from Baksh Kaka. The word *tarbur* has two meanings: 'male cousin' and 'an enemy', the meanings interchangeable. These blood links could be treacherous, bound up with inheritance and the carving up of family land. Maybe Baksh Kaka wanted to kill his brother's son out of jealousy. Or perhaps he wanted to test the bravery of the son of legendary strongman, Tolyar. My dad had been one of the strongest men in the region. Maybe this was Baksh Khan's way of mocking the weak *vilayati* boys.

The day after Mum saved me from the depths of the well, the sun grew hotter and hotter and my head began to hurt. She said I had a fever and put me to bed. In the evening, I got up to empty myself, and my wee had turned a bright orange. I had pissed in a potty that Mum had brought with her from England for Marjan and Ruksar to use, as Marjan was still potty-training. The potty had a sticker of Bugs Bunny on its front, reminding me of my past life.

After I had finished, Mum looked at my wee and started getting worried. She told Dad, who told his older brother, Uncle Khushdil, who went out in haste. There were several *hakims* or herbalists, as well as one Dr Walid, in our village. Since we were from England, Uncle had brought back with him the doctor and not the *hakim*.

Following Dr Walid's visit, Dad declared that he was not a

proper doctor like our Dr Carpet back home. Dr Walid had just worked as a 'compounder', a pharmacist in the big city of Peshawar, which I think meant he had been working in a hospital, grinding the doctors' prescriptions and counting tablets into bottles, dispensing them to the sick. Now in Swabi he had come back and set up his 'surgery'. There was no certificate on the wall of his shop, just God's words in calligraphy, which was all the paper he needed. Uncle Khushdil said he had healed man, animal – everyone. He was an expert in the health of buffalo and donkeys, and had even brought the dying back to life. I was in good hands – Allah had given him the power to heal.

I was lying down when Dr Walid arrived, enjoying the attention that Mum was giving me. He looked at me, then at the orange wee, then at me again, and we all looked at the orange wee together. As there wasn't any electricity that evening, Uncle Khushdil took out his torch and shone it on my pooled urine, which also gave out a yellow light. Everyone was staring at my piss and its neon colour. Questions raced through my brain:

Was I going to die?

Were they going to bury me like they had buried Zarsanga?

Would everyone come to *my* funeral?

Would I have to lie very still?

Would Mum cry?

My distraught mind wandered over to Ruksar. I had fought with her the day before, and she had got Dad to 'slap' me: Dad would often pretend to hit me on my back, clapping his hands to make a big sound, and I remembered Ruksar grinning, saying, 'Give him some more slaps! More!' So Dad slipped in a few

more, winking at me. I'm sure she would be sorry now that I was surely going to die! Everyone from the village would come crying to see me in my white shroud! She would be jealous and no one would speak to her.

Dr Walid took out a sachet of crushed white powder wrapped in newspaper, and instructed Uncle Khushdil to mix it with water and give it to me, before both of them left. Mum made me drink this sherbet, all of it, and said I should go to sleep.

I woke up the next day feeling better, and disappointed: there was to be no funeral for me.

Mum always said that money corrupted. Where there was plenty, there was mischief; yet where there was little, honour and love could still be found. The bag of notes that Dad had brought with him to Swabi had been depleted in front of his eyes. As the story goes, he had fallen out with my uncles and aunts, and though pounds had greater value than rupees, it was Barak-Shah's decision not to marry his uncle's daughter that truly added fuel to the fire.

The eruption of this family feud had made some things worse – and others better. Mum was relieved that Dad had seen the mischief of his brothers and sisters with his own eyes. Khushdil Khan, the gunslinger, had been spending envelope after envelope of the money that was regularly sent to the Frontier from Birmingham. Dad felt that his sacrifices at the altar of the *vilayati* dream had been in vain. His ambitions for the family to buy

land in the new capital of Islamabad, to build a row of shops there, had been squandered by Khushdil Khan's profligacy. Men in the *hujra* would say to Dad, 'You know your brother never works.'

'Oh yes, he is always wearing pristine white suits.'

'And hires a tonga carriage all to himself to go to Saleh Khana to eat kebabs.'

'He has even invited me!'

The three brothers – Dad, Dostam Khan and Khushdil Khan – decided to part officially. (Baksh Kaka had already separated his share much earlier.) Collectively they owned two houses – one with water and one without – as well as some land, gold and silver jewellery, and a bundle of rupees. Two buffalo, seven chickens, one cow and two goats were also to be split. A council of elders was invited to assemble a jirga of dissolution to oversee this splitting of assets through a process of throwing stones. The estate was divided up equally into three lots, one for each son. A line was drawn through the sand – half for England, half for Pakistan – and whoever's stones landed on a particular pile three times, those assets were theirs.

In the horse-trading of throwing stones that ensued, Dad received the ancestral home and Khushdil Khan the house without the well. In front of the elders, Khushdil Khan refused to move from the house that was now rightfully ours. It was therefore decreed that Dad be given some money in exchange for taking the house with no water. Dad refused the money proudly, and we moved into the smallest house. Mum and her sisters-in-law fought over bedspreads, pots and pans. They had

always bullied her, but now Mum would throw back her own cutting remarks. Her fear had gone.

Even though our aunt lived directly across the path from our new home and had her own well, she would not share her water with us. The irony that Dr Carpets had told us to take Mum back home to drink her native water, and that there was no water at all, was not lost on me. For weeks, Barak-Shah had to go to fetch it from the mosque.

Mum's family would stay over regularly now, since none of Dad's were on great speaking terms with him or us. Dad began to defend my mum in her constant fights with his sister, who lived opposite. They would accuse her of putting a spell on Dad, controlling him with magic, but Dad saw for himself how they treated us differently. As he grew closer to Mum, her paranoid thoughts lifted; she was happier than she'd been since her arrival, and her family was now closer to her. Dad decided there and then to have a new well dug.

It was four months into our stay when Dad realized I was missing most of the school year and, as I'd be going back to Birmingham soon, I needed to catch up, even if the curriculum was different here. He made enquiries about where I could go, since there were no English-speaking teachers in this far-flung village, only schools that taught in Pashto and Urdu.

Though Banafsha had been going to the local girls' madrassa, finishing off her Koranic studies and learning how to read and

write in Urdu, the time had come for her seclusion. Mum and Dad decided that when we went back to England, her school would be told that we had left her behind in Pakistan. This would save us the admission that she had been taken out illegally.

Barak-Shah had finished school in Birmingham, and here in the Frontier spent most of his time riding his bicycle or trying to learn how to shoot a Kalashnikov. My other sisters were too young for school and stayed at home, getting under Mum's feet. I remember my mother yelling and scolding one of them once, and my nan telling her off for doing so. 'I never hit you or scolded you,' she reminded her. It was true what she'd told me: Mum really had never seen violence until she had entered my father's house and lived among his family. The story of her lament, how her soul and body had never rested from the age of fourteen, had become clear and real to me.

Eventually, a school was found for me to attend. It came highly recommended: the son of the village chairman had attended, and he was now flying planes in the air force. Barak-Shah said I could do with toughening up.

Every morning I had to rise very early and travel very far to the district of Hazara, where the school was located. Mama, as we called my maternal uncle, took it upon himself to pick me up each day, take me there and bring me back. We would set out when it was still dark, taking a tonga to the bus terminal, which took half an hour. The bus terminus would be heaving with buses, all of them honking madly for attention – some going to Kabul, some to Rawalpindi, some to Karachi. Everyone

would pile into them, and we'd head to Ghazi, nearly another hour's journey, before following the great Indus and crossing it over the infamous dam.

Besides the headmaster, the teaching staff were all women. They were to be addressed as 'Madam'. There was no painting, no storytelling, no equivalent of Miss Albert and her odysseys. Here, the floor was dusty, there were adult-size tables and chairs, and we learned by rote, from a book, repeating a lesson at a time, again and again so you would remember it. I was glad this whole adventure only lasted a month.

After we had been in the Frontier for seven months, Dad decided he needed to go back to England. I don't know if he had run out of money, or whether he had fallen out of love with his old homeland, or in love with his new one. Maybe it was because Mum was better now and able to return to drink the water of Vilayat. In any case, we all prepared to go back and secretly we were hugely relieved. Even Dad was relieved, despite having settled the family feud when Barak-Shah eventually consented to marry Afreen – she of the well.

Packing didn't take nearly as long as it did for arrival, but saying goodbye – especially to Mum's family – was painful. I said goodbye to my grandad's goat, to all the animals, to all the extended family. We all wept and hugged and wept again and hugged again. We were given a thousand goodies to take back to England, and things they had made for my mother – shawls embroidered for her, bedspreads and tablecloths. Later we heard that Shapara, my cousin and playmate, didn't eat for three days after our departure.

* * *

Back in Birmingham, I had to go back into the class I had been pulled out of. Barak-Shah accompanied me to the secretary's office to fill out a form to register again. The secretary didn't even ask where Banafsha was, but I knew: she was now confined to the house, helping Mum and looking after our younger sisters.

On the first day of class, we were asked to paint a picture and accompany it with a story. Fantastical stories about my adventures back in the Frontier poured out of me. My hero brother was the star of one: 'How Barak-Shah Killed a Deadly Snake with a Sickle'. It goes without saying that the snake was so huge that it was as tall as him, like a king cobra. It was on the point of attacking us when Barak-Shah turned up and chopped its head off. But the snake wasn't ready to die, its head kept bouncing around, barely hanging off its body, hissing away at us, until Barak-Shah had to give it a final fatal whack, killing it for good.

Another of my stories was titled 'My Highly Dangerous Descent Down a Well to Retrieve Mr Rooster'. My sisters tied ropes around my ankles, lowering me down to rescue my poor drowning cockerel. In I went, into the deepest darkest well I'd ever seen, suspended by only a few ropes but with a brave heart. When one of the ropes broke, I looked up and everyone was looking down at me, their breaths held. I managed to hang on, reaching the waterline in the bowels of the well where Mr Rooster was flapping his wings, swimming badly and very relieved to see me. Dad shouted down, 'Hold him tight!', and I scooped him into my arms while he and Barak-Shah pulled

me up. When I got to the surface they both declared how heroic I had been, to go and rescue my pet from down a well. Barak-Shah picked me up and put me on his shoulders to loud cheers from all the bystanders, who shouted in chorus: 'Osman is so brave!'

Osman the Brave!

12

THE RELUCTANT BRIDEGROOM

BARAK-SHAH'S AGREEMENT TO BECOME ENGAGED to Afreen prior to our return to England saw words of honour spoken, gifts exchanged, pots of food eaten. Mum's aunt had teased and laughed with him: 'You saved yourself from the rain, and now you've found yourself in the gutter!' (She was referring to a childhood engagement Barak-Shah had managed to get out of.) Barak-Shah replied that if he had not agreed to the engagement it would have been apocalyptic. He would not have been saved. This was his compromise.

When Barak-Shah's fiancée came of marriageable age at sixteen, letters were written by scribes sat cross-legged on the dust floors of the Frontier and delivered across the seas by airmail, demanding that a date be set, demanding that the groom come for his bride, complaining that the groom and his father had forgotten their commitments.

Barak-Shah's commitments had been agreed under duress

during our visit to the Frontier. But he had his own ideas. He was beautiful and adored. After our return to England, he had met and fallen in love with a girl whose displays and declarations of love were written on cards and stuffed bears saying 'I love you!'

Mum and Dad couldn't read, so it was safe for these cards to lie around in his room, testimonies of new and forbidden love. I opened them up, trying to decipher the symbols of love: balloons, hearts, bears, bows, couplets reading 'A little birdie told me / You will be mine'. Accompanying the cards were bottles of cologne that smelled awful, Fiorucci and Replay clothes, box sets matched with designer cigarette lighters. This is where the lighters that Barak-Shah ignited so frequently came from. Of course, as for any upstanding younger sibling yet to infiltrate the world of adolescent love, any such displays were disgusting and incomprehensible. *Yuk!*

The messages scratched into those increasingly aggressive airmail letters kept coming. Dad would wave them in front of Mum, and wave them at Barak-Shah, and repeat their contents with volcanic rage. He had got the scribe to read them out to him, and memorized chosen lines.

This is when the beatings started again, and this time it was Barak-Shah who found himself in the firing line of Dad's fury. Dad had given his word; Barak-Shah had agreed; Mum had given his fiancée an engagement present, five metres of pink Japanese moonlight crêpe with a matching scarf, and four solid-gold bangles. The rituals had all been completed! Mum had kissed her new daughter-in-law three times! But now there was an impediment, which hid inside the secret gift boxes and lingered

in the heady mix of eighties colognes that Barak-Shah sprayed, marking himself as the territory of his secret beloved.

More airmail letters kept coming. They would be filed together on the untangled coat hanger in the cellar. The latest from Baksh Kaka asked, 'Are you a man or is your woman controlling you? Your wife has separated you from your brothers and sisters, and now she wants to do the same thing with me.' Dad went to the scribe to send a reply, explaining his strategy: 'If your daughter comes to the UK, I will be able to make the marriage happen. Send your daughter. I will arrange a fiancée visa and we will get them married here.'

Our cousin Shamash replied, and Akhunzada the Scribe was summoned to read out the correspondence. He sat in our front room. Mum was there, so was Dad. He put on his glasses, focused, took a swig of his milky tea, and started to read. Then he paused, and you could see the change in his body language as he digested the full meaning of the words. Sweat glistened on his forehead as he looked up at his audience.

He cleared his throat and read: '"What have you taken me for? Children are the parents' taking – you can sell them or slaughter them for your own honour. Where have you seen this before, that a girl comes to a boy to get married? What is honourable is that a boy comes and collects the girl. What sort of disgrace is this? Can you not control your children? Is this your wife's doing? What has happened to you in that country of non-Muslims? You have no honour."'

Mum was quiet most of the day. Her face looked worried, but she sent us out to play onto the street in front of the house as

usual. Evening came around and we had our dinner, followed by hot halwa made from semolina and jaggery that Mum's mother had sent. Dad was sitting in the back room, and Barak-Shah had come in with his friends. Mum made them all food and I took it in to them. They were all smoking. Dad then left for evening prayers, and Mum also started praying. Tonight this involved longer than normal prostrations, her hands raised in prayer and her eyes filled with tears. She was crying to God. Asking for something.

When Dad came home, it was clear that his time at the mosque hadn't given him the tranquillity that prayer should provide. By this time Barak-Shah's friends had left, and Dad sat on the settee in the parlour with his prayer beads in hand. Marjan and Ruksar were throwing themselves all over him, asking him to tell a story, so he began telling them 'The Cat and the Jackal'.

There was once a molly cat called Bulbul, who asked her husband Gul Khan to go get some tea leaves, some fresh milk, and some jaggery. When Gul Khan came back with all the provisions, Bulbul lit her stove and cooked some delicious tea for them both, and when it was ready, she gave some to her husband Gul Khan and then she drank the rest herself.

They both sat around for a little while, and then Bulbul asked her husband to go out and get some meat for dinner. When Gul Khan came back with the meat she cooked it into a spicy curry and then made some dodai to go with it, and they both sat down to eat the dinner she had made.

After eating, Gul Khan curled up and went to sleep. Bulbul cleaned up all the dishes and did some housekeeping, then curled up and also went to sleep. When she woke up in the morning, she looked over and tried to wake her husband. Gul Khan wouldn't move. He had died in his sleep. Bulbul started wailing and cried out, 'Everyone, everyone, my husband has died!' All her neighbours came round, and after Gul Khan had been bathed they took him away to the burial ground and interred him. She had ordered a large pot of halwa for her neighbours and the mourners to eat.

So Bulbul would visit Gul Khan's grave regularly, and one day, she saw a jackal sitting next to the grave. The jackal had urinated on Gul Khan's grave. Of course, when Bulbul saw that she got upset and beat up the jackal black and blue.

Everyone started laughing when Dad described the cat beating up the jackal. He continued:

When she finished beating him up, Bulbul said,

> 'You don't defecate on the right
> nor on the left,
> but right on top of my Gul Khan's tomb,
> you dastardly jackal thief.'

There was more laughter, and then Dad continued, 'The jackal replied:

'You didn't hit me with your hand
Nor with your foot
But you struck me with an iron rod
You dirty, dastardly pussy.'

Everyone laughed again, including Dad. Then all of a sudden Dad got up, putting his prayer beads into his pocket, and went upstairs into the room where Barak-Shah was sitting. You could hear Dad shouting, and Mum rushed upstairs, all of us following close behind. The door was open and Dad was on top of Barak-Shah. He had pinned him down, shouting at him. Spit coming out of his mouth, Dad screamed: 'I'm gonna tear you in two, you bloody bastard, why did you say you were going to get married and now you're not? You're not going to let me show my face to anyone! Are you going to get married to a Sikh or a Hindu? Are you a Muslim?'

Between Mum, my sisters and me, we eventually pulled Dad off Barak-Shah, who escaped into the night, jumping out of the first-floor window (at that time the front of the house happened to be scaffolded). He ran to our cousins, and Mum put on her burqa and ran down the street after him, sobbing.

Despite setting the city on fire with his flash cars and heady scents, Barak-Shah couldn't relinquish the codes of honour. He couldn't escape the bond that had been pledged in the family name. Dad went ahead, back to Swabi to prepare for his wedding.

Barak-Shah reluctantly followed. During his long absence, his girlfriend, the purveyor of lighters and scents, turned up at our door not knowing where he was. My mother spoke to the mysterious Sikh girl, and told her that Barak-Shah was getting married back in the Frontier. For all her declarations of love, the fire amulets, the talisman scents and the stuffed teddy bears, they couldn't break these codes of honour.

13

GANGS AND PIETY

BY THE TIME THE MID-EIGHTIES came along, our community boasted its fair share of prominent hardmen. Asian gang culture grew in tandem with the Anti-Nazi League, protecting our communities against White Power skinheads.

Some of the boys began carrying pocket-knives. Their swagger was influenced by the Rastas and Jamaicans: emulating their street-talk was all the rage, cussing while sucking their teeth and calling everyone 'blud' or, if you were annoyed, 'bumbaclot'. We were seen as a weak race, as easy targets, so we copied the toughest kids on the streets. These were boys coming of age in crowded Balsall Heath, living with a newfound sense of bravado. Any opportunities were further afield, away from our side of the tracks, towards the bigger Victorian houses in tree-lined streets and boulevards in uptown Moseley, Edgbaston and Selly Oak.

There were always three of us at school, Bobo, Spinzar and me, sitting around the same desk. Bobo lived on the Ladypool

Road over the family luggage store. He had become my best friend in our final year of primary, but he was not from our community. Bobo was Punjabi, so I didn't see him outside school or at our mosque. Mrs Briggs had taught us how to play chess, and Bobo the eager student had mastered the game, outwitting both his own teacher and me on the chequer-board. Everyone thought he was very clever.

It was near the end of Mrs Briggs' class one morning during this last year in primary school when Bobo came rushing in mumbling a rhyme: 'Ding Dong, the lights are flashing, we're goin' Paki-bashing!' He was beside himself with excitement. 'Hey, you know what happened, last night? It was wicked, I saw everything. There was a big fight outside our shop and the skinheads were singing this chant, "Ding Dong, the lights are flashing, we're goin' Paki-bashing!" There was a fight between the skinheads and the Lynx or the Panthers! I saw everything! Everything!'

His voice rose; he was nearly shouting and his eyes grew bigger and bigger, wider and wider, nearly popping out of his head. He looked at me and Spinzar. We all knew to keep well away from the skinheads and the National Front, but here was Bobo, whose room looked onto the street, with prime viewing, front-row action.

'It was one a.m., man, and the noise woke me up. There was a tribe of skinheads on one side, I think there must have been thirty, fifty, or maybe even a hundred, there were so many, and then our lot on the other side. They all had dustbin lids with sticks and cricket bats, and one of them had a chain, he

was swinging it round and round. Me and my brother were just praying they wouldn't crash into our shop!' After a quick gulp of air, he continued: 'It was wicked, they just kept charging each other, back and forth, back and forth, and then police arrived.'

Spinzar asked, 'So who was tougher, the skinheads or the Lynx?' This was Lynx territory, not the Panthers, but Bobo wasn't one of us; he didn't know who he was talking about, he didn't know who was in the gangs. Spinzar went on: 'Was Barlass there or Zalmai?'

Spinzar and I agreed they must have been. The youngest of four brothers, Zalmai had plenty of experience of fighting like a warrior, and he thrived on it. He was nearly six feet tall, and strong, with defined muscles, and he had grown a thick moustache despite his young age. The police pounded on his door regularly, but he was rarely caught. 'They have nothing on me,' he'd say. From his early kingly domain, the den he'd built in his back garden with its different-coloured doors and chequered linoleum, Zalmai began to build his empire, graduating to become one of the most feared young men on the street.

Our dads were friends and had grown up together in Swabi. All the gangs were involved in petty crime, small-time stuff, before some of them started hitting the big time. Not all of us were certified gang members or runners in their rackets, but just for one summer, the summer in between primary and secondary school, aged eleven, I drifted ineluctably into Zalmai's influence and gang.

Gang initiation rites usually involved gladiatorial trials in front of Zalmai, for some to prove how strong you were, for others

to prove your cunning and demonstrate what you could steal, laying what you'd taken before him as an offering.

My own initiation was easy by comparison. My mission, almost Proustian, was to steal my mum's homemade madeleines, which had become famous throughout the hood.

Cake was still a novelty in the 1980s; not part of the diet back in rural Pakistan or Afghanistan but introduced as part of our new, richer English life. After all, the Queen ate lots of cake, and these treats added a little sunshine under the perpetually grey skies of England. Slowly but surely, along with the change in lifestyle, all the confectionery, the sodas, the cheap, mass-produced New World food wreaked havoc. Middle-aged women and men with high blood pressure and chronic diabetes became common.

Mum would bake forty to fifty madeleines in one session. Her secret was adding extra eggs and extra butter; the more she added, the softer and sweeter the texture. Her batter would rise and scent the house with the heady, vanilla smell of madeleines.

The piles of soft yellow sponge-cakes were kept in a large pot in the back room of our house, on the floor just behind the door. In I went, armed with a plastic bag I'd taken from the kitchen trolley. The pot was filled to the brim with a recent bake. In a state of trembling terror, I took one handful, then another, before quickly closing the lid and running down the alley into Zalmai's garden. There, I was in two minds whether to hand Mum's madeleines over or not, but it was too late; Zalmai had spotted the blue plastic bag.

'Have you got them?'

I nodded and walked towards him, holding out the bag.

He grabbed it, taking a madeleine and biting into it. His eyes went dreamy. 'Mmm. Yeah, this good, blud.'

From this, I stepped up to stealing crisps, biscuits and chocolate bars from the newsagent's and then to carrying out one of Zalmai's more ingenious scams: sponsorship forms. We'd take these to people's houses, asking them to sponsor us for school marathons, spelling challenges and other fêtes. It was simple. You knocked on the door and held out the form. They were easy targets: white people who knew what sponsorship was. Our families didn't understand why they should give money to someone running up and down the street – they gave weekly donations to the mosque on Fridays. Walking down the wide pavements and up their manicured garden paths, I rang doorbells and gave the white residents of the big houses pleading looks. Here I was, a respectable immigrant child, trying to fit in. While I wasn't white, I had an innocent charm; I was average in height, stick-thin and big-nosed, shy, smiley and bookish. I didn't list all the Enid Blyton and Roald Dahl I'd read as an introduction, but I wasn't exactly gangster material and was totally plausible.

Zalmai, impressed by my success, handed me more photocopies of the school's sponsorship forms. I set off to where those with money lived, where the hedges were perfectly trimmed, and began asking politely for people's names and addresses which, without fail, they wrote down on my prepared sheet. I began to get good at this – so much so that I began to consider my situation.

Although I was good at scams, my disposition was too weak to be part of this rough world; it didn't involve books, or libraries.

Zalmai just wanted half the money, he never asked for the forms to check. I gave him his share and started to devise an exit plan.

One day I told Zalmai, 'My mum and dad said I should tell you: I can't do this; it's *haram*.' Anything different, anything out of the ordinary was *haram*, the way of the infidel. Sponsorship for running up and down the street was an unfamiliar thing, as was collecting money for anything other than the work of God, for the destitute or the sick, and would surely have been considered tantamount to gambling. And gambling was bad. In any case, my brother was one of the toughest older kids on the block. His numchuck moves could knock anyone out. So, I was safe.

I didn't turn up to the den again and there were no repercussions. However, I did go into business by myself, photocopying the forms that Zalmai had made, knocking on doors, presenting my very good manners, pleases and thank yous: it was a very profitable summer.

Meanwhile, others went further astray. Mustafa played on the same streets as me and was my age. He and his older brother Tabriz went round picking fights with anyone. When Tabriz got into an argument with someone younger, he would say, 'I'm not going to fight with you – you're too short', 'You're too young', or worst of all, 'You're too fat', so then Mustafa would be summoned to fight the opponent. Before it all began, Tabriz would say, 'Mustafa, you better not lose, otherwise you will bring shame on us, shame on our name, shame on our family, shame on the tribe of Musa Khel. Now punch his head in!'

In this way, forced to fist-fight nearly every week, Mustafa toughened up and learned the hard way. His mother would pop round to our house in despair and ask everyone in Mum's salon to pray for Mustafa's and Tabriz's goodness to shine. She'd heard about the pious boys from the mosque – learning the Koran by heart, giving beautiful recitations – and dreamed aloud about the day to come when she would be congratulated for her sons doing the same.

The biggest coup for any mother was for her sons to lead the faithful at the mosque during Ramadan prayers, which lasted well into the night. You would prostrate *forty* times, and finish each of the *thirty* chapters of the holy book, one for each day of the month of fasting. Those were the longest prayers ever, with each prostration preceded by many long *Ayat*. It is said the devil is locked up in the month of Ramadan, allowing the faithful to absolve their sins, whilst amassing good deeds in their place. Some of us – even the most pious-seeming – slipped off from time to time during prayers. The older boys sneaked off to smoke after showing their faces to their fathers, who would be standing erect or prostrated in the front rows upstairs as their sins were washed away. Meanwhile, we were beneath them, with our own devils, in the bowels of the mosque.

In the world of the streets, Barlass was just as important as Zalmai. He was the most compelling and handsome boy on the street. He took long strides, his body taut and upright, his green

eyes hypnotic and ablaze, his free dark locks bouncing as he moved. He was a distant relative, not by blood, but by other bodily fluids: his father had been suckled by my grandmother in Swabi so our dads were 'milk brothers'. Though I wasn't in his gang, I liked to hang around him. Barlass had true, pure charisma, a halation of coolness that hung over him. He was someone who had started taking charge early on, and all those signs of greatness and leadership were clear to see. He had his own den on a nearby street, an abandoned garage that he had settled in with his own initiation ceremonies. He and Zalmai left each other alone.

No matter how our fathers felt or how strongly the elders tried to guide us, thanks to the likes of Zalmai and Barlass, we all developed a sense of fearlessness. No one could mess with us. Many amongst our Pashtun boys were formidable and well-trained fighters: we were defeating the Russians in Afghanistan, pushing them out, and the pride bubbled in our blood. We also watched a lot of Bruce Lee films. Here in our neighbourhood, we were the toughest. And then there was me, whose hand–eye co-ordination failed miserably in any attempts at fighting, or at cricket or at football or any other particularly physical exertion. No matter, there was safety in numbers with Barlass and Zalmai on your side. We all came together in times of invasion or infil-tration against anyone that wanted to harm us – from the pigs to the skinheads. In return for this feeling of pride, occasionally I'd be a freelance lackey and watch to see if anyone was coming.

Barlass had Droon Khan as his partner. The former was a few years older than the latter, but they had shared experiences; both

had been in and out of youth detention centres. Droon Khan had become famous for his dashing police helicopter chase through the streets, across the back gardens and over the railway tracks. The wagman was always knocking on Droon Khan's door. Their fathers turned to the imams, both at a loss and in utter turmoil as to how to save them – but that being said, they were also a little proud of the machismo and the protection they felt their sons' gangs gave to the community. Although in need of saving, these were real men who protected their own. They'd take on the skinheads and give like for like.

If you spotted a skinhead and you were by yourself, you needed to run lightning fast. Everyone knew about my poor Uncle Parwiz, who lived down the road. He was going home late from the factory one night, waiting at the bus stop. A group of neo-Nazis found him there on his own and beat him up so badly that he was found unconscious, nearly dead. Mum said the *gora* boys, a generic word for all white people, had kicked him repeatedly in the skull. She didn't know the word 'skinhead'. After that Uncle Parwiz never came out of his room. I was forbidden to go into the centre of town until I was several years older and then only for quick errands; no loitering or my day-dreamy meanderings. I'd see Mum sighing with relief when I got back.

There were quite a few like Barlass and Zalmai, those that had been lured into an alternative route, a different occupation, away from the pious path. There were others that put their heads above the fence and wanted to get out, to see a different world – like me. We had all sprung from simple, pious families, with

fathers who had toiled in the hot foundries and factory floors, and then when they came home caught up with their prayers. Here, in this land of opportunity, our fathers had sacrificed their bodies and now their children, but no matter. I don't think Barlass's father ever beat him. It seemed almost implausible that someone so gentle could have fathered such a notorious figure. Once, right in front of me, his father, puzzled and hurt, narrowed his eyes and, concentrating on Barlass's fine, chiselled face, asked him: 'Why can't you be more like Tolyar's boy? He goes to the mosque every day. He is a good boy, you can see it on his face, he reads his scriptures . . . He doesn't bring the police to my home every day.'

Barlass had his head down in respect and deference during all this. When his dad looked away, he shot me a smile, showing his pearly white teeth. He had no interest in being like me; he was a trainee Al Pacino. Leaders of the pack like Barlass were not scared of their fathers, or of the pigs or anyone else for that matter. They were

TOUGH,

FEARLESS,

ANGRY,

Barlass could take on anyone.

As boys and young men in our community, the available role models were either the men at the mosque with their newly acquired beards – the Bushmen – the tough, cool Rastafarians, a few schoolteachers, or the gang leaders.

Altogether they created a maelstrom of choice, leaving us brown boys

NO DIRECTION,
ALIENATED.

We were sandwiched between our parents' Frontier and the streets of Birmingham. Like my dad, Barlass's father couldn't read: their generation was full of men and women who wouldn't – and couldn't – integrate, linguistically, culturally or economically. It was best to recreate what made them feel safe, to look inwards, to keep everyone under control to navigate this new space. So, an *eruv* developed and if you wandered out of it you would be questioned. If someone happened to see you too far from your home . . . they would tell your dad.

The parameters for the children were: to and from school, first Park Hill Primary then Queensbridge Secondary School in Kings Heath; errands to the butcher's, grocery stores, fabric stores, then home; and, of course, the fountain of sustenance for the soul – our local mosque. My first ever trip to the centre of Birmingham was when I was fifteen, on the number 50 bus, to buy frozen fish.

When school trips were not strictly compulsory, our parents didn't sign us up, and even though I could easily forge Dad's signature, I rarely dared risk it. Anyway, school trips made you late for the mosque.

Those who rebelled and followed their heart just couldn't understand why their parents thought the way they did. They clashed like any teenagers coming of age and not being under-stood, though the distances between the generations were so great that you lived two lives. Honour and respect for the elders and the codes of *Pashtunwali* were key. The elders didn't want

the world to change so fast from how they had grown up, nor for their offspring to be absorbed in the ways of the devil, the ways of the infidel. For the elders, keeping face was paramount. 'There must be no stain on your beard for the world to see.' You held your head up high without averting your gaze, confident and respectable in any gathering, or at the mosque, so that no one could point a finger at you, no one could say anything about you.

Little wonder that the gangsters oozed a version of this pride. It was an offshoot of our upbringing. Our parents had endured hardship; they had worked endless hours, slept ten to a room, and were ready to give their children everything from their houses in dowries. 'We are only doing this for you, to make your life better' would ring from the mouths of the fathers. They all said the same. It was for us that they had sacrificed themselves – yet there were certain fixed conditions. In return, we had to be pious, stick to our community, keep the family together, respect and look after them when they grew old, follow the path of *Pashtunwali* and righteousness.

But our parents were no longer in their small villages, panopticons of sand and stone, where everyone and everything could be seen, where all eyes were omnipotent, and gossip guarded against shame and dishonour. Horse-drawn carts and donkeys had been upgraded for Datsuns and Capris. Whole rural communities had been transplanted into inner-city slum dwellings, but with enough infrastructure to allow people to move up the food chain. You worked and slaved and saved until you could buy your son his first car. In return he would have to transport

everyone around town – to the butcher, the doctor, the hospital, the barber, the mosque, the grocery store, to the homes of Bushmen to pay your respects when someone died or was ill. But there was only so much that could be contained, and the world beyond that we could move in with relative ease was still foreign to our parents.

In our British-born generation, Sikh girls were marrying Muslim boys and converting to Islam. Muslim girls were running away to marry out of their community. Bollywood epics from the screen were replayed in reality – tears, screams, terror, forced marriages.

There was a distinction between the boys and girls. The boys were always given more freedom. There was the same attitude as you find everywhere: boys will be boys, and all that. Even if you were a girl who went to school, unlike my sisters, you still served your father and brothers, and followed your mother's example. There was servitude, and there was male dominance.

While the boys and men fought, the girls had to be wary of their every move. The streets were not for the girls, who were even more peripheral to the business of the gangs than the sensitive readers, geeks and misfits like me. The fairer sex was easily stained, and being seen with a boy, even a friend, was enough for gossip to spread through the community like wildfire, tarnishing her as unworthy of marriage. It never struck me that Banafsha's confinement after returning from the Frontier was wrong. It never struck us as anything but normal, at least not me, not back then.

It was all different after marriage: once a girl – now a woman

– had been shrouded with respectability, once she had been bonded to her husband and her in-laws, once she had been deflowered by her legitimate other, only then, ironically, would she have a right to develop her own personality. With each year of marriage that passed and each child that she bore, her position was strengthened: she was a mother of children; she had done her duty. She was respected.

The Sikh girls were a little freer than their Muslim counterparts, sporting the latest trends, tapered jeans and brightly coloured jackets. They caught buses home, went to libraries that opened late outside of school hours, and did so on Saturdays without being questioned by their parents and community. They called themselves 'Sharon' for Satwinder, and 'Karen' for Kulwinder. They were here to absorb and integrate, and some of them didn't want to marry boys with turbans, worn to cover their long hair that was never to be cut. Some of them fancied clean-cut guys without turbans – which made us Muslims a threat to the Sikh boys.

Shere Punjab, the Sikh gang, clashed with the Muslim Panthers over girls they thought were being courted. In order to save those that had fallen in love with Muslim boys, or were in danger of doing so, they warned them to stay away. The Shere Punjab would turn up outside schools with their orange scarves poking out of their jeans or tied on their heads so there was no mistaking who they were. These were the protectors of Sikh honour. They patrolled the school gates, stopping girls getting into cars. But they couldn't stop them all: there were still those who ran away, converting to follow the one true God for their Muslim lovers before marrying them.

There were other, bigger battles: often over disrespect. Sometimes even that look in the wrong direction could escalate into something more serious. Turf-wars ensued, spreading from the north to the south of the city. Most of the protagonists ended up in juvenile detention centres, and many went on to hit the criminal big time.

When they weren't fighting each other, Muslims and Sikhs sometimes ganged up together against the skinheads: the common enemy.

On the other side of the coin, those who followed God were clocking up good deeds so heaven's angels would perfume them. We were shrouded by a veil of piety and safety. God would call and we would be ready.

Chenghiz, the one who had spread the message of the forbidden gelatine far and wide, was one of the pious boys. His like became pillars of our community, leaders, beacons of the faithful. Having recognized that gang life wasn't for me, and wanting to avoid the bullying boys from school, I took the pious route in my early teens for a while.

I went to the mosque every day; on weekends I would go at least four times. The madrassa, the Islamic seminary from back home, was resurrected on the ground floor of the mosque. It was rote-learning every day of the week after school, and on Saturday and Sunday mornings. No day of rest for the pious.

There was more to come, a bigger, shinier world for the lucky

few: a purpose-built seminary, a shining beacon of light which sprung up in Dewsbury in West Yorkshire. It had pristine grounds and perfect lawns among rolling hills – a green and pleasant land where the faithful would learn. This House of God was funded by booming petro-dollars from far away, which travelled with new doctrines that would fire a generation in the heart of northern England and beyond. A few of the parents who could afford it, lured by the abundance of praise they would receive in this world and in the hereafter, sent their sons to Dewsbury. For the boys it was a one-way ticket to purity, away from all the distractions; away from the prostitutes at the bottom of the road with their big fur coats, their big hair, their bright make-up and action in the alleyways.

In Dewsbury, secularism and its allures were firmly denounced, and religious piety, the Holy Grail, was within your grasp. The boys in the seminary could carry the light of faith on their faces in scholarly pursuit. Dewsbury was a plenary refuge away from the gangs, a place for breeding leaders. Upon completion of training there, the chosen few travelled to seminaries in Cairo to get closer to God's language, and the rest returned to the community to lead prayers, the pride of the next generation.

Spinzar, Ulfat and Noor Zad were the first recruits to Dewsbury, their new school uniforms so different to mine. They were swathed in billowing, shiny white polycottons, Reeboks peeking out under the chic, ankle-cropped tunic trousers. Never had a blade or razor touched their faces. Their sprouting, silky hairs grew into compliant fistfuls of luscious, pious black locks framing kohled eyes.

All three of them looked like gods, like angels. My own uniform was an itchy blazer and scratchy jumper, and a very thin tie.

Spinzar had come back for the holidays. I saw him in the mosque and went over to say hello. He was standing with Noor Zad. Their new look intrigued me. They looked like little devout imams – and all of them living away from home, in a dormitory, like the adventure books of Enid Blyton. I shook Spinzar's hand and gave him a hug: 'Tell me all, what's it like?'

'It's amazing there,' he replied enthusiastically. 'We pray, eat, sleep and pray again, and I still do my four subjects, science, maths, English and history, and I'm learning the Koran by heart. I'm on Chapter 11.'

I regarded him. He was definitely going to get to wear a crown in heaven, and a direct ticket in for his whole family.

Barak-Shah was too old to go to Dewsbury, since it only opened in the eighties, and as for me, Dad didn't want me to leave our home – though we couldn't have afforded it even if he had.

The anointed few were pointed out as they walked past, or as they prostrated in prayer with their heads wrapped in cottons bought at street stores in Mecca. Their parents were congratulated, their hands shaken regularly, and told they had made the right decision, sending their children away. They were the parents of the pious, their sins forgiven, welcomed ahead of all parents into God's glorious country wearing blazing crowns that would blind. Everyone in heaven would regard them and ask, 'Who are they?' The angels would answer, 'They are the parents who guided their children on the right path. They are the first in line.'

Noor Zad, who I didn't know so well, explained it further. 'It's the only way to live and prepare for the true afterlife. We are living in a *Dar al-Harb* in England, a land of war. They have killed Muslims, thousands of them. We ourselves should say what is right and what is wrong, and live under Sharia law, but we are surrounded by non-believers. It's our job to convert them, bring them to Islam the right way, bring them to the light of true knowledge.'

Noor Zad had grown eloquent, and I was struck by what he said, though I couldn't quite digest it all. He was right: white people had always taken everything from us. They had even turned Jesus white! A fast ticket to heaven waited if you converted a non-believer, and all your sins would be forgiven. We all needed one quickly, especially if you didn't go to Dewsbury.

14

THE HARLOT
AND THE HOUSE OF GOD

JAMEELA, THE MOST BEAUTIFUL LADY of the night, began to feature frequently in my life as I was growing into my virtuous phase. I'd often bump into her when rushing to the mosque, and she had begun to greet me differently.

'Come and see me when you get older and I will make your hat fly . . . right off your head,' she told me.

I wasn't quite sure why my hat would fly off, but I'd always get a warm glow seeing her at the bottom of the road. At other times she would ask me to run to the shops while she stood with the others on the corner.

'Hey, love, get us some fags and I'll give you 10p.'

She was vivacious and pin-sharp. But prostitutes were supposed to be evil, so she was something of a conundrum for me.

I made my way to the mosque one day, trying to banish all thoughts of Jameela as I walked under the holy scriptures

inscribed above the door on the transom windows. It was the calligraphy of God. As required, I took off my shoes, and headed downstairs to the basement to do my ablutions. The front and back sitting rooms on the ground floor were the school rooms, the madrassas, each with low benches facing each other. Korans were stacked in the coves on either side of the chimney. The faithful gifted Korans to the mosque, so God's word could be continually read in their name. You could never have your back to the Koran, that was a sin. It should always face you.

We students bought our own, in colourful covers that those mothers or sisters who could sew had made for us; in lamé, in brocade, in hand-embroidered fabrics, in patterned cottons. Nothing was too precious to cover this book. I was lucky to have Mum. The shelves in these coves held each edition of the Book of Truth, covered in a mosaic of many beautifully coloured off-cuts, stacked, swaddled and wrapped on top of one another.

After ablutions you would unwrap your Koran, rest it on those low benches, and sit on the floor as you learned how to read from right to left. These sacred scriptures learned by heart, rocking back and forth, were words that you didn't understand, as they weren't of your language, but you knew you were uttering God's ancient words.

We were lucky: our mosque, a converted house, was situated perfectly in the direction of Mecca – but this was potluck. Rented houses had been converted into mosques as the Muslim population grew. Some of these were eventually purchased when enough of the faithful had put their hands deep into their pockets. Enabling a House of God to be erected on earth would be

rewarded plenty in the hereafter: in exchange, God would make you a house of gold and silver bricks, encrusted in corals and rubies. Giving to the House of God was on an entirely different level – there was keeping up with the Joneses and there was preparing for your final resting place in the hereafter. Who wouldn't want a house made from gold and silver bricks?

The walls of our mosque were squared and faced the *qibla*: no wastage, no awkward corners, perfect rectangular rooms facing Mecca head on, which allowed everyone to fall in neat lines, regimented, feet washed and nearly touching each other; some of them light, some dark, some fungal, quite a few hairy, some feminine and soft, some large and solid. All these feet of the righteous lined up to submit to the one and only. Man was equal before God – regardless of wealth, foot-size, hairy toes or athlete's foot.

On his way to preach to the elite of Dewsbury, one imam, head of the missionary movement Tablighi Jamaat, visited our mosque accompanied by his fifteen disciples. They travelled and preached the word of God in the far-flung lands where believers had settled. He had been to Belgium, to France, to South Africa, and was soon to be leaving our shores for America.

Standing at the pulpit that Dad had built, a long gauze over-coat draped over his spotless white robes and with a tightly bound turban to match, the visiting imam spoke about evil innovations. He looked straight into the congregation and recalled the words his own teacher had spoken to him, applying it to our community: 'When the radio was invented, each house had the voice of a harlot piercing through its walls. Now, thanks to

television, not only can you hear, you see her, she has *entered* into your home, into your front living room. Repent, my brothers, repent, my brothers.'

At this point he stood up, and in melodic rapture sang,

What will you answer to your God . . . you believers of
 the Prophet,
When the Day of Judgement comes?
You walked on the path of the devil and forgot your God.
God sent you his beloved. His Prophet.
You were warned yet you did not follow.
The life in the hereafter will never end.
The hereafter is the life you need to prepare for.
This worldly life is the ephemeral life, do not be fooled.
Jesus will return, you can see the signs of the end clearer
 and clearer.
Gog and Magog will break out, ravaging the earth,
 drinking all its water.
The sun will rise from the west.
The Second Trumpet will sound, and the dead will
 return to life,
A fire will start in Yemen, spreading all over the earth,
Gathering mankind for the Day of Judgement.
Are you ready, my friends?
Are you ready, my friends?

He went on in a trance, his voice going through the range from bass to baritone, his pulpit vibrating as he moved into a tenor.

Then, raising his pitch to mimic the panic that would be unleashed on us on the Day of Judgement, he pierced us and the rafters as a holy soprano, threatening and reminding us of awaiting death and judgement.

When the Angel of Death, Azreal, sits on your chest,
And brings out the soul from your body,
Your journey to the hereafter will start,
And when your relatives leave you in your grave,
And as soon as they step away, the Angels Munkar and
 Nakir will arrive,
With dark faces and blue eyes, making you sit up . . .

I was already sitting up on the mosque's carpet. I began to daydream, making shapes into the pile. He continued:

Who is your lord?
If you answer correctly, my friends, a cry will come from
 the heavens,
That my servant has spoken the truth,
And the doors of heaven will be open to him,
Perfuming your grave, sending him to a blissful sleep
 before the Day of Judgement,
And the same question will be asked of the unbeliever,
And he will reply, 'Alas, I don't know.'
The cry from heaven will come that he has lied.
'Let the door of hells open up its burning heat,'

And hot winds will enter his burial chamber,
 compressing it, crushing his ribs.
His screams will be heard by everyone, from east to west,
And he will be ripped apart from mankind till the Day
 of Judgement.

It occurred to me that there was a simple solution to finding out
what really happened when someone died. We would know every-
thing, and there would be no mystery: why didn't we put a tape
recorder with a wire in a grave when they buried someone? The
wire could trail out to a speaker, and we would all hear and know
what went on down there. That was the only way to get to the
bottom of it all. You would hear the angels question the dead.

I was pleased with my plan and wondered why no one else
had thought of it. I told myself I would propose this at the next
burial I attended.

The imam interrupted my thought: 'Now, my friend, what
sort of life would you like? Think, my friends!'

His voice took me away from my thoughts, and transported
me – well, all of us. I was nearly twelve and, anxious to be
virtuous, I prayed extra hard to be good, and that God would
take away the arguments from our house. It was well known
in the mosque that if you went one step towards Allah, he would
take seven steps towards you. But my mind kept wandering off,
lurching from my ingenious solution to finding what was really
going on in the graves, to wondering who, out of the people I
knew, was going to die next. The imam switched to Arabic,

which I didn't understand, so the sound transported me further. The devil had entered my mind, leading me astray to thoughts of the fleshly pleasures of jelly and Jameela.

Back in their homeland, on familiar terrain, where the rivers from the Hindu Kush ran fast and clear and the sun shone brilliantly, the mullahs like our visiting imam were respected, but they ranked low in the pecking order due to their poverty. In a subsistence, tribal society, they were occasionally teased about their profession, going too hungry to survive only off the honorariums that they received in exchange for bringing guidance and performing rituals for the faithful. (But they knew that if they were patient, God would of course reward them a thousandfold in the hereafter.)

Pashtun society back in their homeland was deeply conservative; the *Pashtunwali* code they lived by pre-dated Islam and bore similarities to Mosaic Law. It provided a framework for daily life and kept everyone in order. The ten codes of *Pashtunwali* were:

Melmastia: Hospitality
Badal: Revenge and Justice
Nanawatai: Asylum
Tura: Bravery
Imandari: Righteousness
Isteqamat: Belief in God
Ghayrat: Courage

Namus: Protection of Women

Nang: Honour, Defending the Weak

Sabat: Loyalty

I never could remember them all, but these were the social codes that made true men.

The Pashtuns trace their lineage back to the ten lost tribes of Israel. Our folklore has it that King Saul had five sons, not four as some historians claim. The fifth was named Jeremiah, who had a son called Afghana. He was orphaned at a young age and brought up by King David. Afghana became the commander-in-chief of the army when King Solomon was crowned, and founded a martial race.

Legend has it that Afghana is buried in the Sulaiman mountain range near Zhob, and in the summer months goats are still taken up and sacrificed there. Way down the descendant line, a man called Qais, hearing of a new prophet, travelled to Mecca and brought back the final Book of Truth, the Koran, to his tribe. Qais was given a new name upon conversion and became Qais Abdur Rashid, the modern-day father of the Pashtuns, who now stretched across southern Afghanistan and northern Pakistan. The British colonials called them Noble Savages and couldn't tame them. Instead they divided their lands, creating the Frontier, and used them as a buffer against Russian expansion.

The Pashtun diaspora, a fragmented people of the book, began to arrive in England in the sixties and seventies, subjects of the Commonwealth, and were pushed together and barred from integrating by cultural and linguistic barriers. Most arrived unable

to read the notices that stated: NO COLOUREDS, NO IRISH, NO DOGS.

They were forced to huddle together in Birmingham's post-war slums with other 'undesirables', in crime spots and red-light districts. Their white hosts wouldn't let them rent in the areas they themselves lived in; and then came the opportunist landlords, who made them pay extra to live in houses with only outside toilets, no bathrooms and plagued by rats, mice, cockroaches and damp. Balsall Heath's dilapidated streets, with cavities left over from bombing during the war, were hardly in sync with Birmingham's new utopian planning. Bright new concrete blocks were replacing Victorian brick houses. Whole streets were pulled down to be rebuilt, clearing the way for that utopian vision. Gaps in terraced rows and clapboarded houses were all too common results of an act-first, plan-later government mentality.

As a result, mosques were regularly housed next door to brothels. At the peak of the eighties recession and into the nine-ties, Cheddar Road and Edward Road were known in the press as the 'wickedest streets in Britain', with upwards of 350 sex workers living and working in their bordellos.

After the imam's stormy speech, I was walking behind Dad and overheard his friend Angar, all fired up, saying: 'The Yorkshire Ripper isn't a bad man. He killed prostitutes, and now they have locked him up there is no one to deal with these prostitutes here!'

I glanced over to see if Jameela was around. I didn't want her dead. The Yorkshire Ripper had been caught a few years earlier, but Spinzar (who wasn't yet at Dewsbury) and Chenghiz, walking

with me, agreed with Angar: let him out and he would get rid of the problem. A somewhat unconventional solution. Chenghiz never stopped ranting about it. 'This Ripper, he must have been a Muslim; a very good man. He has a beard just like mine, and they said he heard God telling him to kill all those prostitutes.'

A huge leap in logic, I thought, but kept my mouth shut.

Sensing that something had been unleashed by the visiting imam, our local imam continued sermons for the good fight, frequently inciting the faithful to rid ourselves of this polluting vice. 'How can you live with such filth and vermin around you? How can your children grow up looking at this? In Vilayat even their devil dances naked!'

He had finished his oration but now he took off with real vigour, hollering a call to rise, to take action: 'You need to go out and drive this *filth* away. You need to *stop* these cars from coming to our streets and the women need to be taken off them.' The pulpit trembled, and his entourage sitting near him raised their voices in chorus, 'Yes, yes, Inshallah!'

He was on a sacred mission (God must have been building him a very expensive house in heaven) to hypnotize everyone to do God's work in these infidel streets.

'Tell me,' he bellowed at us, 'what will you do about it? What will you answer to God on the Day of Judgement? God will ask *What action did you take*? And what will be your answer, my friends?'

He looked round fiercely, a glimmer of sweat on his face.

Inflamed by the fire of indignation, and seeking a remedy, Angar took it upon himself to take the fight to the streets and asked a group of men outside the mosque: 'Who will come with me and gain the *sawab* that the imam is talking about?' He continued, 'Not *only* are these vermin unholy, they affect our house prices. Our houses are worth nothing!'

At this point the men perked up and raised their own voices. It became their crusade.

The men came home and told the women to keep their wits about them: there was going to be trouble. The news started to spread when the women got together. 'This is the shameless world of the non-believers; they *kiss*, *drink*, *dance*, do bad things in cars or out in the open, in front of our eyes, they have no shame! FORNICATING for money.'

What on earth was *fornicating*? Never mind, I kept listening in.

'Oh, so much filth here, it's not good to bring up our children, look what filth the children pick up.'

(I knew this was a reference to the condoms and needles that the women waded through in their black robes.)

'I pray to Allah they are successful.'

'They are surely going to hell,' Hooriya Jaan concluded. She touched her ears, uttering the word *tauba*.[1] The following day, when evening prayers were over, a huge vigilante group formed near the Oldfield Road mosque. Spinzar and I decided to follow

[1] 'I keep my distance from them, I deny them.'

them as they trooped forward. We marched behind and dodged in between them as they moved towards the busiest corners where the prostitutes stood. I was relieved that Jameela was nowhere to be seen that evening; maybe she had got into one of those cars.

Angar then divided everyone up into groups of five or six and we separated to take down kerb-crawlers' number-plates. To our surprise, our presence had immediate results. As we took their numbers down, car-tyres squealed as they drove away fast. These numbers were then later handed over solemnly to the police.

This went on through the wintry, cold nights. We lit fires in dustbins to keep ourselves warm on these vice stakeouts. My own excitement had worn off on night two in the freezing cold. The elders realized this, and after a week or so we were told to go home. 'Thank you for your help, but leave this to us elders. This is no place for boys.'

Now our news updates came from listening to the gossip of the older boys at the mosque, who were allowed to go out on the patrols. The pimps had begun to fight back. We were taking away their livelihood after all. The fight between the faithful and the devil children was *on*! The older boys got into fights with the pimps. Barlass, with all his awesome might, had punched a pimp hard in the face; the prostitutes all screamed and shouted back: 'You dirty Pakis, just go back home!' and 'Yeah, I know your kind. You'll be here first. You want this white pussy, don't you? Take your fucking smelly curries and fucking go back to where you fucking came from – to your fucking tinpot country.'

This was God's work, and I was missing out on all those special extra points that God dished out to clean our streets. I was disappointed. The men had told the women not to go out in case they got attacked. A local TV news team arrived with camera in tow to witness the vigilante group and the drama in full flow. I was jealous when Spinzar came into school the next day. His brother had told him everything, but from the way he spoke you'd think he'd been there himself. 'Angar was on TV, he is famous now. He has been on TV shouting, "We don't want any of this filth on our street. These are our homes, we are respectable people."'

After a few months of nightly patrols, the prostitutes gradually began to move away from our area, towards Edgbaston. No more loud shouting at night, no more clicking of heels on the pavement into the late hours; no more Jameela, and her beautiful smile.

The truth was that the fringes of Birmingham society were ineluctably mixed with all those who had arrived in England with hope of a new life. The Irish, the Indians, the West Indians, Pakistanis, Bangladeshis, Afghans, Travellers – all arrived over the post-war decades to provide cheap labour to the foundries, the railways, the textile mills, car plants and factory floors. Britain was booming and needed cheap labour, and the Commonwealth had many who were ready and willing to swap meagre rupees for the glinting, hard British pound.

As the slow trickle of funds sent back to family bled all financial gains, the original dream of coming west, making a quick buck and heading back to the homeland dissipated. Everyone was here to stay. Talk of being thrown out of the country and sent back still hung over many in the community, though, and was the background chatter when everyone got together. When the elders' worries surfaced, we always said that we were born here, and of course the government couldn't send us back. But that wasn't the case for the older generation: they didn't know where they belonged. They had only come here to work.

Ironically, in expelling Jameela & Co., we were expelling something else in ourselves, something intangible and exotic about our arrival and history. I missed Jameela and I suspect I wasn't the only one. I regretted not having warned her about the vigilantes. Our community lived side by side with those women, our worlds eliding quietly as they formed relationships with the Muslim and immigrant men (away from their wives; they still had urges). The women found solace and company in the arms of the so-called 'savages' and illiterates. Somehow, it seemed the ghettos were more beautiful before, the transgressions turning into acts of transcendence. However, God's work was done and the house prices began to rise.

A few months after the expulsion of the prostitutes, I took Mum to the dentist because one of her molars was hurting badly. I gave Mum's name at the reception, and we'd just settled ourselves on the waiting-room chairs when out of Mr Patel's surgery door walked Jameela. I looked again: it was definitely her. That hair

was permed so tightly it moved in unison with the tassels on her leather jacket. I was elated she was still alive – Mr Angar and his vigilantes hadn't killed her off.

Mum had removed her veil; some of the women from our community would pull it back in certain situations, and a hospital visit or dentist's surgery was one of them. She was sitting there looking at the tank that Mr Patel had stocked up with goldfish to keep his patients calm before they faced him in the chair. I nudged her and whispered, 'That's one of the prozzies. Isn't she beautiful?'

Jameela had her hand holding a tissue over her mouth. Her heavily made-up eyes darted around, looking for someone. Opposite us sat a tall skinny Black guy in a sheepskin coat, solid gold rings on both hands. Her lover or pimp or both.

He got up quickly as he saw her and stepped forward. 'Hey, babe. How did it go?' Very gently, he pulled her hand away from her mouth. 'Open up, open up . . . open your mouth, let me see.'

He looked inside, and then lifted his hand and held her chin and kissed her tenderly on the lips. She laughed and they walked out.

I don't think Jameela had seen me, so absorbed was she in her pain and her lover. Mum looked shocked at this open display of love, affection, power and shamelessness all in public.

As we walked outside, Mum looked down at the ground and said: 'Thank God there are no more syringes or junkies.'

She was probably thinking of the days when Jameela was a regular sight in our area, and the condoms and needles too. It's

true the streets were now cleared, but I missed them as well as I remembered my freer, younger days, the days before my teens, when I could play with the girls. We would pick up those abandoned syringes and use them to play doctors and nurses. We didn't know the word for syringe, so we just called them 'injections'. Roxana across the road had the biggest collection, and a few needles in a Bird's Custard tin. And when she felt like opening up her surgery in her garden shed, she would take out the custard tin and invite some of us round so she could administer her cures.

She knew not to pierce the skin with the needle, but she would fill her syringe with a little water, holding it up to the light, then place it near your skin, push the fluid through, and then dab your skin with pink toilet roll. We all used the same toilet paper. The rest of the cure involved Nurse Roxana telling us to lie down.

'You will be better in five minutes,' she would say reassuringly. And she would put a blanket over you, and a few minutes later put her hand on your head – her patient's head. 'I'm going to check your temperature now.'

Then she would administer another injection just to be sure she had killed any infection that was lurking inside you, and resurrect you back to wellbeing. 'You see, I'm going to make you so much better,' she said.

That had been her last summer at school. Roxana could have made a great doctor. However, just like Banafsha she was at home now, learning to cook and clean, read and write Urdu and Pashto, and learning the Koran in the holy language they

couldn't understand. In a year or so they would don the black robes of a burqa, and no one would be able to know who they were. They were to be protected, escorted, a chivalrous chaperone always present. You never knew what dangers could befall them; back home they could have been kidnapped, anything could have happened. When the girls went out, Mum would only breathe a sigh of relief when they were safely returned.

I developed a knack for recognizing which girl was which from their height, their gait, the shape of their feet and the kind of footwear they wore. I would chaperone Banafsha, walking in front of her, and occasionally by her side. Sometimes I wished I could also cover myself in black and walk around unseen. I tried on Banafsha's burqa at home, pulling the veil over my face. When I walked into the room she was sitting in to show her, she looked at me, screaming, 'Take it off! Take it off, it's mine!'

Behind these veils were girls who possessed a luminous beauty that they were to hold close and precious until they got married. The imam said that man needed to protect woman, to keep her honour; they weren't as strong as men. He would repeat again and again that a woman's place was at home. He said Womankind was different to Man, that God had created Eve out of Adam's rib, and wanted him to protect her. Even Jameela had her own chaperone to protect her – her lover and pimp.

MRS THATCHER'S HAIR, AND THE
ARRIVAL OF THE BUSHMEN

GUNCHA KHAN WAS THE PUREST of the Bushmen, and like Dad he would easily get angry. He was over 6 foot 2, and when he walked he pushed his chest forward, standing very straight, elongating his spine, his high *karakul* always fixed firmly on his head. Dad wore his cap only on special occasions, but I was sure Uncle Guncha must sleep in his; I never saw him without it and I was sure it added another half-foot to his stature.

From this towering height he would take long, deep strides like Orion the Huntsman, scanning the horizon as he moved around the mosque and its surrounding streets. This was his domain: he was president of the mosque; he had marked God's territory for himself. Mr Guncha wore attar of saffron blended with musk in the winter and attar of jasmine in the summer. His scents lingered powerfully: he always appeared to be there, even when he wasn't.

Guncha had manoeuvred himself into being president, lobbying the faithful so his already strong crowd of supporters voted him in *unchallenged*. He was the man in charge of the mosque finances, collecting donations and making sure everyone and everything was kept firmly in line.

Not only could you smell him, you would also hear him coming half a mile off. He jangled as he walked: a long chain dangling from his waistcoat breast pocket and snaking into the side pocket of his kameez carried all the keys controlling the doors to his domain.

Watermelons were Guncha Khan's favourite offering for his weekly meeting with his comrades and the imam of the mosque. The shops would pile the melons high on the Ladypool Road when they were in season, and from then on it was all he talked about, priding himself on selecting the ripest and juiciest, feeling them delicately to gauge their sweetness. There were honeydew melons and garma, a type of cantaloupe famed in Afghanistan and Pakistan, and then the King of Melons: the watermelon, green on the outside, bright red on the inside, pit-black seeds embedded in its flesh. Like Dad he would sprinkle salt on his watermelon, drawing out its sweetness, a sweetness you could drown in.

At these weekly meetings, the imam fought Guncha Khan for centre-stage. During prayers, the imam was definitely in charge: he knew how to lead the congregation, he knew what was right and what was wrong for the faithful. He knew the scriptures. However, in the assembly of the committee, Guncha sat as his contender on an imaginary throne, cross-legged on the carpet inside the inner chambers of the mosque.

It was Guncha Khan who triggered my fascination with Mrs Thatcher. One Friday afternoon after prayers, a group of some ten men had gathered in the kitchen and the sitting room next to it, talking with unusual animation. They were all part of the mosque committee, and Guncha created the rota for each of them to clean, hoover and polish the mosque every couple of days. The holy day of Friday involved extra chores of scenting the mosque and washing down the ablution areas with Zoflora.

I had accompanied Dad into the corner room that day, as it was the summer holidays. He liked to show me off: proud father and son, walking side by side. As we both entered, we said in unison 'Peace be upon you', and they all replied 'And unto you, and unto you.'

As usual, Dad nudged me, pushing me to shake everyone's hand. I stepped forward, dutifully hiding my boredom as I endlessly circled the room shaking hands. I arrived in front of the forbidding Uncle Guncha, who smiled and showed me his pearly white teeth. He took my arm and squeezed it in one of his colossal hands, as if that wasn't enough he pulled the skin of my cheek with his other hand: 'Good boy!' Having paid my salutations to everyone, I sat down next to Dad and eagerly eyed up the watermelon.

The scribe Akhunzada was sitting in the corner. He had spread out his English newspaper and on it I read in big red bold letters: 'A Quarter Million Jobs Lost in Birmingham'. Akhunzada looked up over his newspaper. 'What wind is this, that's come and shut all these factory doors?' Since losing his job at the foundry, Akhunzada was in the mosque for most of the day, every day.

Sitting next to him, Guncha Khan was all fired up to show that he too possessed learning and could read and write (though not as well as Akhunzada, who had studied and read many disciplines, as Dad often said, but who had a greater sense of modesty). Guncha Khan put down his slice of watermelon abruptly, sending a few pips and saliva flying. 'You know, these motherfuckers they have finished with us.' When Guncha Khan spoke, everyone listened. 'WITH ALL OF US! With the Paddies, the Pakis, the Blackies. The factories have all been shut down, and they have sent all our jobs to Japan, to Hong Kong, to new lands. The recession is no longer looming over them in the south, in London, but for us here they shut everything down. They have forgotten about us . . . They have no use for us any more.' He sighed out those last words, his breath heavier than usual.

Guncha wasn't stopping; he had listened to a lot of sermons throughout his life, and now he had the spotlight. He took a quick swig of his milky chai and started on one of his lengthy stories.

'You know, when I came to this country in 1962, we worked and worked all the hours. Day and night I worked.' He looked around and everyone nodded or lowered their heads in respectful agreement. (Dad often said the same to us at home.) He carried on: 'These English people, they wouldn't let us work properly, there were notices in plain daylight for everyone to see: "No Coloureds, No W**s". We couldn't use the toilets inside the factory and had to go outside. They wouldn't give us a place to sleep. We asked to sleep in the cellar, in their coal sheds even, but they said no; so we slept six, seven to a room in the worst

areas, where they would charge us more rent. We took shifts for the bed; the same bed occupied again in the morning by those on night shift. They disrespected us so gravely, and the kind of work they gave us – the worst, the worst kind.' He shook his head. 'Cleaning, sweeping, the dirty, the heavy jobs, but we had no choice . . . the work they didn't want.'

He was in full swing. 'You know . . . personally, I had three strikes against me.'

I wondered what three strikes meant, if someone had perhaps struck him three times, but I was sure, Guncha being so tall and strong, he would have hit them back.

He looked at Akhunzada meaningfully, coming to his Important Point regarding these three strikes. 'I'm sure I've told you before. After eighteen years at Leyland, I was so proud, they had seen what a loyal and good worker I was and now I was being rewarded. My manager offered me a promotion, for me to become a section leader of a small assembly belt that fed into the car plant. I was the only Pakistani, Indian, Bangladeshi, the only Asian in that division, and I worked all the hours they gave me. And you know what they did? They put their tools down, the *whole line* put their tools down, and went on strike. They didn't want an Asian, a bloody Paki, to supervise them. Thank God I was part of the same union, and there were long meetings. I think a phone even went ringing to Number 10, that they spoke to the Prime Minister about my situation – you know the company was owned by the government back then. My manager pushed and pushed, saying that I was the best person for this job, so eventually I got the promotion.'

Guncha raised his voice angrily. 'I've been spat at, I've been sworn at. We all have! They have not been correct with us. We were illiterate and didn't understand. We were powerless and weak, so we accepted what was served to us. No matter what you give them, they will give you a slap in return. You know we have suffered, and you know, brothers, it wasn't a little suffering, it was suffering which leaves you with no dignity.' He shook his head, and then smiled a brief but bitter smile. 'But look at us now, we are everywhere, on every street in this neighbourhood, and now with the grace of Allah, look at this place of worship, look at this mosque we have built. Praise be to God.'

Then his face closed down with anger again. 'But now it's over. You can't trust these people . . . At least the Irish can hide and merge in but our colour is dark, you can tell us from afar, and it will be easy for Thatcher to catch us, round us up, and send us back.' His voice was thunderous now. 'She has finished with us, she doesn't need us any more.'

Akhunzada looked up through his wise blue eyes. 'They have not all been this bad, look at your manager, Guncha, he believed in you. When I came, these English people were good to me, they were nice to me, they were so happy to see me each day. If you asked them directions, they would take you to the place themselves, they wanted to know you, and they respected you.'

One of the men in the group chuckled. 'They were only nice to you because you had blue eyes, and they had fallen in love with your blue eyes; they thought you were one of them.' Everyone laughed loudly but then the man continued, on a more serious note. 'These people, they don't do anything without

a reason, they were only nice to you because you were doing the work they didn't want to do, and now there are too many of us. She wants to send us back. That's it! It's simple!'

Akhunzada was undeterred and took his comments in good humour. He looked around, ruminating, and shook his head. 'I don't know where those good people have gone: these politicians, Mr Foot, Mr Benn, good men, and who has come to replace them . . .'

'That woman, Thatcher,' said Uncle Guncha.

Akhunzada continued: 'In the streets, all these racists, these skinheads. It's been over twenty-two years now that I've been in this country, I've never taken a holiday, I worked overtime every day, and now there is nothing. Where do I go, what do I do?' He shook his head for a long time and said softly, 'Now we are old, this is our time for prayers and the reading of the scriptures, we need to have patience in our hearts.'

I had been sitting next to Dad all this time, watching everyone, listening intently to all this, observing this strange mood I'd never felt before, when suddenly Dad became aware of me and asked me to shake everyone's hand again. 'You go home now.'

Up I got and once again there was the endless circulating and bending down, my hand reaching out to touch those hands that were so much bigger than mine, so much rougher – work-scarred hands. When I got to Uncle Guncha, his face was set in its usual thunderous expression, but he reached into his pocket and gave me a ten-pence piece – and smiled. 'Now you can buy some sweets with this, make sure they are halal, you know which ones they are?' I smiled back, relieved.

On the way home I was confused, my thoughts racing, wondering what this 'recession' was still 'looming' over us and not 'them yuppies' down south. Akhunzada mentioned a new wind of change. Was it like the cyclone in *The Wizard of Oz*, which I had managed to watch surreptitiously on TV without anyone catching me? This one seemed more deadly, stealthy. I puzzled over its mysterious signs. So . . . this wind was something to do with Mrs Thatcher, who used it to shut down the workplaces for ever. More importantly, I thought about Thatcher and why she wanted to send us all back.

TV was still out of bounds at home, so I didn't see her every day on the news; she was an enigma, mythical and distant.

Thatcher came up again a few days later on one of my errands to Khan's to collect the day's offal for Jason the cat's dinner. There I came across Ghaez Khan, Hooriya Jaan's husband. Worn out by his five boys, his newly grown beard showed signs of greying, and his skullcap was hidden under the yards of fabric he had wrapped round and round his head to create his *lungi*. Gigantic turbans were part of our heritage, but his was one of the most gigantic of all. I walked in midway through a conversation between him, the butcher, Ali Khan, and another man.

'I go every day to the Job Centre, and now they want me to go to the classroom to learn English.'

Silence and nodding of heads. No one looked at me.

'What am I going to do? Go an' look at the white walls? I can't read at my age. I'm over forty. I am completely illiterate, like a blank white sheet of paper, completely unlettered.'

Another pause. I waited, not wanting to interrupt.

'They said if I don't go to these classes they will stop my unemployment benefit.'

Ghaez Khan was now angry, shuffling from one foot to the other, looking straight at the butcher. 'They invited me to come to this country when they needed labourers to sweep the floors. Now how do they want me to learn English? I know some words, but when did I have time to go to school? I can't even read or write in my own tongue, how am I going to learn English?'

Ali Khan looked on with quiet sympathy as he smoked over the carcasses of meat, then picked up a newspaper from the counter. He pointed at the faces on the cover. 'Mrs Thatcher and President Reagan' was written on top. Ali Khan smirked: 'She's made out of iron – the Great Iron Lady and her boyfriend.'

It was his son who finally served me and handed me the cat's dinner, wrapped in last week's newspaper. I said my salutations as I walked out.

On the way back home, I passed the newsagent's and stared at Thatcher's face on the same paper in the newspaper stand. When I had first seen her in a rare glimpse on TV, she looked very important, with her pointy face and her power suits. The more I heard about her, the more she began to preoccupy my thoughts . . . She was a very strict woman, and her suits had the widest of shoulder pads, worn over silky pussy bows, somehow softening the strictness. To finish off her look she always wore a glistening set of pearls or big clip-on earrings.

But it was the hair, I realized now, that made her the Great Iron Lady; her hair must have given her special powers. The

colour shone and glinted, but it was not blonde or dark or red or grey. I had only seen that colour in films or pictures. It was the colour of a helmet, a burnished dark-gold helmet. I looked at it some more. It was coiffured in a way which made her look much taller, just like Uncle Guncha and his *karakul*, though Uncle Guncha had cut off his hair and replaced it with a beard.

How was her hair so perfect? I decided she must have set it in her Carmen rollers every morning, back-combed it to add the lift, and sprayed it into shape before she was ready to face the world. Her hair was her armour!

After that, I kept an eye out for her. Every time I saw her picture in the papers or on television her hair never seemed to move, even when she got in and out of cars.

In the meantime, I was confused. She had a husband called Denis. He wore thick-rimmed glasses. So how was she allowed to have this boyfriend, this President Reagan she kept meeting? And didn't her husband mind her being pictured in the paper with her boyfriend? Did Denis beat her up when he was upset?

Everyone knew that the Great Iron Lady had closed down all the factories, while also ushering in a decade of excess for the yuppies down south through the 1980s. Yuppies, 'money, money, money', leg warmers, David Hasselhoff, neon, Big Hair. She did all of this.

But there was no end of recession, no 'money, money, money' for us in the middle of England, in Balsall Heath; nor could the men, with all their prostrations to God, turn themselves into yuppies. God wasn't listening. Dad and his friends' endless

journeys to the unemployment office couldn't change them into yuppies, it changed them into Bushmen instead.

Men like my dad had progressed gradually in society, accidentally. He had worked with the Irish on the roads as navvies, which is where his carpentry and masonry skills came of use. Someone had called in sick, or hadn't turned up, and the team needed help on the brickwork, so one of Dad's comrades who spoke English piped up and told the foreman about Dad: 'He knows how to do it, but he doesn't know the language.'

Dad was summoned, put in a truck and driven a few miles up the road where the sides of the newly built bridge over the motorway were being finished. There were a few brickies there already, and Dad was shown his section; he picked up a trowel and started working, brick upon brick buttered with mortar, and Dad would say proudly he had doubled his wages from that week.

All of this was lost on the Iron Lady's bright new horizon, as jobs – including my dad's – disappeared. She thrust her handbag forward and said she wasn't for turning. The previously dapper gents who came home tired every day after clocking out had clocked out for the last time. The machine that stamped their cards had simply stopped turning.

Our elders were truly scared: unemployment stretched ahead of them, and every month many more came home with redundancy papers they couldn't read.

'She is going to throw us out, send us packing, back to where we came from.'

'We must continue to save and send money back home, buy

land and build property, she won't let us build a home here, it will only be taken away.'

We younger ones would listen, fearing the worst, or sometimes one of us would say, 'She can't, we were born here! We are British, we were born here, she can't just throw us out or send us back.'

The men had given fifteen, twenty, thirty years of their prime to the Workshop of the World, and now, in the new deindustrialized economic order of the Midlands and the North, the Department of Social Security wanted them to retrain, learn English and find jobs in the new service economy.

The result was that more and more had become Bushmen, running into the arms of mullahs who set them on the right path and instructed them to prepare for the hereafter instead: this world was so obviously ephemeral, and not worth investing in; it was the afterlife which was the true life.

The transformation of the Pashtun and other migrant Muslim communities in Birmingham into an increasingly enclosed, religious, disparate group had begun to take shape in the early eighties. More than a decade later, the Bushmen were everywhere. The worship of the one true being became the focus for the community, a way to keep the consolation of our culture, our dignity, intact in the face of such indignities. It would protect us from the evils of the freer, non-believing societies who despised us, who danced and drank naked, and couldn't feel the cold. 'It is the alcohol and the meat of the swine that keeps them warm,' Mum said. 'You know the white people don't feel the cold.'

The onslaught was easy to read, easy to see. Leyland had shut its doors, and all the men had swapped their greasy overalls for salwar kameez. With more time on their hands, the mosques became fuller and fuller.

The imam continued to sing from the pulpit, guiding the imitators of Cary Grant to change. In his sermons, he regularly insisted on our identity as Muslims; a Muslim is an exemplary being, and the world should see us each as one. 'Don't wear clothes like the non-believer, don't eat like the non-believer, don't associate with them. If you do, you will become enemies of the true way . . . Whoever imitates a people becomes one of them . . . Beware, beware! You should not imitate them by shaving your beard.'

They no longer modelled themselves on types like Cary Grant, the icons of their youth or of the decades they arrived in the country. Gone were the Sunday suits – worn with such pride in their new homeland – with which they had cut dashing figures in both the black-and-white and Kodachrome photos taken in their front rooms. Their dark, pomaded, old-Hollywood hair was now shorn and covered with handmade skullcaps. Those who had beards grew them longer so they were able to make a fist of them with their hands, knowing they were on the correct and righteous path – just as the Prophet's teachings had instructed – to distinguish themselves from the unbelievers.

From the neck down they wore baggy salwar kameez and for some reason the same brand of mottled acrylic cardigans in varied shades of brown and khaki. There must have been one original trend-setter who spread the news far and wide – 'These cardigans and brands of socks will last you well' – so they

became the uniform of the Bushmen. To complete this look, in the winter they wore dark Melton coats over their ensembles, and in the summer the jackets they wore were from their best Sunday suits they'd stopped wearing.

'No one should ever be confused about your religion. Look at the necktie, my brothers, it is the sign of the Christians, the knot the sign of the cross. You mustn't wear ties; you should not dress like the kafir, the non-believer.'

So the dapper ties were gone too.

This was a new fusion of dress, born out of the practicalities of having to cope with the weather and of religious necessity; the need to stay true to their faith. Beards grew longer month by month as the unemployed congregations at the mosques grew exponentially larger. The hurdle of being an unskilled or semi-skilled labourer with a language barrier wasn't easily overcome. The arms of the mullahs were open, and they sent the faithful on the right path.

Dad, the best Cary Grant lookalike, began to seem alien, altered. His new attire made him somewhat more menacing: the flowing tunic, his snuff, the spittoons made from empty fruit tins, the baggy trousers which inflated even more when he got angry. Apart from going to the mosque, where we were in the company of other Bushmen, his appearance on other jaunts became a source of guilty embarrassment to me. Some expeditions took us to far-flung places where we stuck out like a sore thumb: on the bus into town, to the markets to buy some fruit, some hake, some fabric. Dad wore his *kapol* hat, his Melton overcoat, his baggy trousers, his beard, his orthopraxy . . . and

there was me in my parka, trailing behind him. Regardless of my embarrassment, there were some things I just couldn't get out of accompanying him to: if Dad told us to do something, we had to do it.

I myself had stopped wearing traditional clothes apart from at the mosque for daily prayers, and on each Eid. I would ask that my new clothes were western and not traditional, new trainers a must, a new pair of trousers, a new sweater.

Now Dad's conversion from Cary Grant to Bushman was completed in God's noble sanctuary at Mecca. He left on a journey there and approached God's house in a state of awe and reverence, guided by the imam. He had left all his worldly attachments behind. At Mecca the clothes he wore were unstitched, *ihram* clothing, and his feet were uncovered. After sacrificing a sheep he himself had chosen, he distributed the meat to the poor. His final act of submission to Allah was the shedding of the hair that adorned his head. Thus he shaved off his sins and manifested his humility to God.

Dad returned from Mecca a fully reborn Bushman. He was one of a growing number. Each year a different set of men would be canvassed for the obligatory journey to Mecca. 'God is calling you to his house: are you not fortunate? How can you say no?'

Thousands of the faithful went on the journey of a lifetime, to return with their sins absolved, hair shaved, having been among

a vast swathe of brothers and sisters from the four corners of the world. Together they had circled God's house, the first house built to the true God on this earth by Ibrahim. The men wore two sheets of white cloth – one over their right shoulder, one around their waist. The women wore black or white or their colourful regional fabrics. Here in God's house they didn't need to cover their faces or hands.

And here in this famous mosque, in these garments, all were considered equal, whether you were a man or a woman, a king or a clerk or a taxi driver. You circled the *Kaaba* – the square stone building in the courtyard of the Great Mosque at Mecca – seven times, announcing your presence to God. 'Here I am, oh Allah! I am here! I submit to you again and again!' Then you re-enacted the Prophet Ibrahim's wife Hagar's search for water for her thirsty son, the Prophet Isaac, running between the two hills of Safa and Marwa to the south of Mecca. Finally you headed to the open deserts of Mina, contemplating your place in the world, stoning the devil, then shaving your head, and sacrificing an animal in God's name and distributing its meat to the poor.

You could do this pilgrimage for yourself, and then you could do it again and again for others: for your mother, your father and for those who hadn't been able to perform these duties themselves in their own lifetime. When Allah called, nothing held you back. And even when you returned to your homes in non-Muslim lands, nothing could take your rebirth from you. When your friends, relatives and community came to visit you, along with the waters of Zamzam, the holiest of waters, and the

sweetest dates of Mecca and Medina, you would also offer wisdom and give them *dawah*, the call to duty, encouraging them to go to the house of Allah and be reborn as true Muslims.

As the community grew here in Vilayat, along came new guides, new imams, sent over from the Frontier by God to reclaim the souls who had strayed from divine law into the arms of prostitutes and drink, spawning illegitimate children in those unions. These weren't relationships like those in *The Buddha of Suburbia*, which satirized the stories so beloved of the middle classes of princes or darker-skinned intellectuals with black-rimmed glasses who would open up your chakras, or play you the sitar, recite Rumi or enlighten you with their eastern ways. The new imams were here for those illiterate and simple men who had come to England to make their fortunes, leaving their families behind; men who were often lonely, familiarizing them-selves with a new land, a new culture, in order to work out if it was worth transplanting wife, children, nephews, nieces and parents into pokey, damp rooms in cold terraced houses.

But this new-found religiosity clashed with the acquired habits and temptations of the flesh that were so readily available to earlier arrivals, flaunted in windows and on the streets around Cheddar Road and the now-demolished Varna Road. The moist legs of the white working girls parted to reveal the nest of hair that beat against the righteous, shaved genitals of the new migrants. God's law from Talmudic times demanded that all armpits and genitals were to be kept clean, that hair should not be longer than a grain of rice in these areas of chastity. Yet the taboo of those women's unshaven parts was not strong enough

to stop the act or the regular stream of visitors. Some would slink off straight after the act, hoping not to be seen, returning once their guilt had eased off. Others stayed and settled down with those free-spirited women, who gave birth to their children. Some of these mixed-race children were whisked back home as soon as they could leave their mothers, to be reared by relatives who would be the new gatekeepers and instillers of faith, carving out any element of the kafir, the non-believer, with whom their fathers had collided.

On the same street as our house in the Frontier lived two young girls who were referred to as 'daughters of the white woman'. Their presence always puzzled me – they seemingly had no mother or father, only a grandmother. They were similar in age to me and Banafsha, and Banafsha would play with them regularly. Like us, they were born in England, their father *vilayati* and their mother English, but weirdly they spoke no English. I didn't understand why they were there, why they had been sent away to the Frontier so young. I later realized that they were sent there for their own good, to learn their father's culture, his religion, to be brought up as good Muslims. Little of these ruptures made sense; things of this kind were spoken of in murmured conversations.

Back in the UK, I gleaned more one day when Dad had an unexpected visitor from up north in Bolton, the nephew of a friend. Mr Jameel was Bangladeshi: he and Dad had lived in the same boarding house for a while as new immigrants, and this was his first visit in a long time. He was younger than Dad but older than Barak-Shah, very skinny, with a dark complexion and

tight, curly hair. He kept smoking one cigarette after another. They began talking amongst themselves about times gone past, and after delivering their tea, instead of leaving the room, I sat myself firmly on the settee.

Dad asked why it had been so long since Mr Jameel visited, saying it was good to see him, and that he should visit our home more often.

'You know, after Uncle died I scarpered and went to Portsmouth, then Swansea and then Norwich. I went over the line. I went to these clubs, you know, and I met someone.'

Dad looked disturbed but nodded. If Barak-Shah had confessed the same about clubs and meeting a woman, Dad would have slapped him.

Mr Jameel lit another cigarette and carried on. 'You know the people in those places, they were racists, you can't blame them. But I was nice to them so I made friends. Tell me one Muslim country that is happy? There is corruption in every Muslim country. At least in this country there is peace, no one bothers you, they leave you alone.'

Then he lowered his voice. 'I married an Asian first from back home and then I married an English girl. When I married the second time, I was working away from here: I had a fast-food business in Wales, cooking sausages and bacon for the British. I have two families, you know, I was bad: I used to come home every fortnight for one or two nights, just to sleep.'

'My son, I wish you had come to me sooner.' Dad looked genuinely worried and was too absorbed to ask me to leave.

'People use to say "Leave the Welsh girl, not the Muslim girl,"

but I already had a baby boy: if I left then he would become a Christian, an infidel, and I would get punished for this in the hereafter.'

Dad agreed and shook his head at the situation Mr Jameel had got himself into.

'So I stayed, yes, praise be to God, I stayed with her, and we had three boys and two girls. The first one, I put him in the Coventry Road madrassa, and he did three chapters of *hafiz*, learning the Koran by heart. But then he fell out of line. He stopped.' He looked down, away from Dad's gaze, nodding his head. 'Now, I tried my best. For all of them, I did my *best*. I came back to the community, I taught them the Koran. You know, my kids won't touch anything *haram*, they will only eat halal. But it is the eldest who has gone out of line. I want him to start attending the mosque again.'

Dad intervened, 'You know, son, come to the mosque with me. The imam, he is a great man, he has many answers.'

Mr Jameel contemplated this and then spoke defensively. 'You know, I am happy, my conscience is clear, my children are safe, they are grown up. They know the Kalimah, the declaration of faith. They have to answer to God themselves now. There are many of these children of mixed marriages who don't know anything. *Nothing*! They have been abandoned.'

Dad looked at him and said firmly, 'He will give you the amulet that you should get your son to wear, and we will protect him from the devil.'

I never found out if the amulet worked but Mr Jameel followed Dad into the mosque in hope of resolution. Men like him were

encouraged to come back to the fold, where their service to the mosque – post-transgression – would wash their sins away. They might help to build a mosque for the community, donating towards its creation and upkeep, cleaning it daily and then thoroughly every Friday, washing it down. This was their penance on earth.

It was said in hushed voices that Uncle Guncha had fathered children with a white woman but he hadn't sent them back to the Frontier, and so he 'lost' his son and daughter. He hadn't been able to save them from the infidel.

The mullahs going into the community gradually became outreach workers, giving *dawah* regularly. Their calling was to save lives and souls, so they encouraged the fathers of illegitimate children to take up their parental duties: Islamic law decrees that if the parents are separated, a child should live with their mother until the age of seven, and then afterwards the responsibility is handed to the father. Yet many of these children of the night would be passed around from mother to distant relatives before the age of seven, across continents and thresholds and cultural divides. I was told that these offspring, like the girls down our street on the Frontier, were mixed race, and therefore widely believed to be prone to 'other' influences of their mothers' culture – especially the girls. Many of those who weren't whisked off to the homeland ended up in care homes after the illicit relationships faded and the righteous men had been brought back into the community, forgetting their former lives. Before Mrs Thatcher arrived at Downing Street, she had claimed that Britain was being 'swamped' by arrivals from the Commonwealth, and

particularly Pakistan. She said we were incompatible with the whites who lived here. When I learned this, I began to understand why some of these mixed-race children might have been sent back to the Frontier, in case we were all sent back, and they became stranded.

And when, in the same newsagent's where I'd first seen her, I saw a picture of the Iron Lady crying behind the window of a car, I understood even more. She herself had been sent away, from her house at Number 10, by her very own men.

A BUSHMAN GOES HOME

S PINZAR'S DAD, HAJI BABA, COLLAPSED on the settee without touching his dinner of fried pakoras and chapli kebab served with a dip of hot, spicy walnut chutney. His wife had left the room to bring back a plate full of radishes, tomatoes and cucumbers to go with his meal and on her return found him unconscious on the sofa.

Haji Baba and Dad were like siblings; they'd grown up together, wrestled together and talked in the open courtyard of the *hujra*, where all young men make lifelong bonds before marriage, so we visited him regularly. He was lying there, his eyes closed, taking long and then short breaths. He had slipped into a coma. The nurses came often, injecting him with morphine for the pain, and would then leave again. During our visits, his wife and sons would read prayers from the Koran. They didn't want to send him to the hospital: the doctor had already given them an answer; there was not much they could

do, so now they wanted him to be comfortable and die at home.

For over a week he lay there, taking those long and then short breaths. The imams came, telling the family that God was cleansing him before He took him, that his protracted death was to expunge him of all his sins, purifying him for his departure. This was in contrast to the requests I heard from Mum and her friends in open prayer upon hearing the news of his burdened and lengthy death: 'May God give us the death of the walking, and not the death of the wretch. Let us not be a burden to anyone, let us have our dignity.'

After a week of lying on his bed, he finally stopped breathing.

Spinzar's relatives collected him from Dewsbury and I found him standing next to his father's deathbed. I walked forward and embraced him in the customary manner. His beard had already begun to grow and I wondered whether being that much closer to God in the seminary meant you reached puberty earlier. I could also see the mystical 'light' on his face – or maybe it was the reflection of the white polycotton robes he wore.

To match his long white robe, Spinzar also sported a slick white minimalist turban tied around his head, but it wasn't as impressive as the turbans of our fathers and uncles that, as they aged in England, harked back to the fashions of their forefathers, with five metres of fabric wrapped around their heads.

Even if Spinzar's turban wasn't yet big enough, he was destined for greater things. He had rocked back and forth cross-legged, curling over the holy book and learning it chapter by chapter. He was now memorizing the last two, so that when he died he

would have nothing to worry about. When he entered heaven he would be wearing a crown so bright, brighter than the sun, and his clothes would be more magical than any eye had ever seen. Haji Baba would sit next to him, proudly, also wearing the same style of crown.

Spinzar had a direct ticket to heaven's seventh level – just under the throne of God, at his feet. This was the best heavenly real estate, where the rivers of paradise sprang forth. We all knew that God would accept his intercession and he could bring ten people in with him, saving them from the fires of hell.

I was pretty sure that Spinzar would pick me – we had been friends since primary and his family only amounted to five, so he had plenty of room. Anyway, I was still eating some *haram* sweets on the sly, so in need of some extra help from him.

The news of Haji Baba's death broke out very quickly. Haji Baba took his last breath just after 1.30 p.m., the end of midday prayers on Friday. The mosque was full, with some of the congregation standing shoulder to shoulder, and overflowing into the hallways and landing. Part of the crowd moved into the front garden of Spinzar's house, and some of the children were instructed to go knocking on everyone's doors to tell the women that Haji Baba had died.

I had managed to slip into the front room briefly. Spinzar looked as white as his robes.

His father lay motionless on the bed. Before the ambulance had been called, his wife had tied his mouth shut, pushing his

mandible upwards so his lips would rest closed. He was ready to receive his mourners with a dignified, closed mouth: there was only serenity and calmness on his face.

The crowd swelled, waiting solemnly for what was going to unfold. After a little while, the men started leaving or side-stepping onto the pavement as women started pouring in from the surrounding streets. I too had to leave. The women needed a clear and discreet path into the house; no direct mingling with men. I couldn't see through the net curtains, but I could hear a trance-like lament that kept growing louder, and the murmurs swelled as the crowds of women grew. This wasn't all about Haji Baba, but an outpouring of a collective grief, a public yet veiled display of the losses each had borne.

The women were praying over him, prayers for the dead; prayers for a safe passage; prayers that his journey to the hereafter would be filled with the perfume and breezes from heaven; that his time in his grave would be short, and the gates of paradise would open up for him swiftly. Word spread outside of how peaceful he looked, how he had the light of heaven emanating from him.

After an hour, the ambulance still hadn't arrived; the crowd outside had dwindled to mainly relatives, a group of boys from the mosque excited to see what was going to happen, and some close friends of Haji Baba, including Uncle Guncha and Dad. This was my new place now, outside, standing with the men. I was older now, at secondary school, so this wasn't like before, when I could have moved around the women's quarters, inside, watching them unfurl their garments, revealing themselves, their clothes filled with embroidery and colour. I could no longer

observe them hugging, weeping, praying, and then morphing themselves back into the shapes of their burqas and walking out of the front door, concealed as ninjas, into the streets.

Now I could only see them leaving in the same shape as they had arrived; my ingress had been blocked.

Across the road, several doors to the right on the corner, was probably the largest house on the street with a big oak tree in its drive. Through its open attic window the breeze carried a surreal whisper to us mourners; the patois, bass melody and off-beat guitar of roots reggae.

The ambulance finally arrived and the men, including Dad, went in, asking the women to step aside, into the back room, while they took the body of Haji Baba. We watched them wheel him out on the trolley, zipped up in a black body bag. The wailing got louder and louder, the screams and sobs emerging from inside. Spinzar's mum and some of the women had followed the body out. They stood discreetly in the doorway, their faces cloaked, hiding their grief.

The Bushmen guided the body out into the front garden and over the porch, and then across the drive towards the parked ambulance. Haji Baba lay on the stretcher as everyone touched and pushed the trolley forward – a sign of respect. The ambulance crew lifted the trolley into the vehicle and locked the wheels into place. As the wide doors shut, an explosion of reggae, 'I Shot the Sheriff', came from the window across the road.

It was Bob Marley, sending Haji Baba on his way. The women had cleared out of the front room, and we men made our way in, shutting the door to the music outside. Inside were Uncle Guncha, the imam, a few of Haji Baba's friends, Spinzar, his

older brother, and my Dad. Now it was a waiting game to get the body released without it being put through a post-mortem; without it being cut open and fiddled around with and then sewn up with a great big scar the entire length of its torso. The body needed to be sent back to the Frontier unharmed.

Spinzar walked in from the women's quarter at the back with tea for everyone. This was a role I was only too accustomed to, but with Spinzar's virgin beard-fluff and white robes he seemed like an angel offering holy, misty tea. I never liked tea and even this celestial sight wasn't going to tempt me.

The imam lifted his hands up and asked everyone to pray.

Spinzar's older brother Roshan, who was probably around eighteen, was sitting in between Uncle Guncha and Dad. He had started working in McDonald's, where there were very few halal products on the menu – Filet-O-Fish being one of them. He had lost out on going to Dewsbury since he had shown little aptitude for memorizing the holy book – all 77,797 words. Besides, you only needed one imam in the family: they were all going to heaven. Uncle Guncha and Dad were talking to him from each side. I couldn't hear what was being said until Roshan himself spoke and silence befell the room. The shuffling of feet, the clanging of cups on saucers, the slurping of tea – all stopped. Roshan was wearing a crochet cap, his voice clear and strong.

'Uncle, we think – that is, all of us think – we should bury him *here*, his family is *here*. Who will visit him in Pakistan? At least we will visit him regularly, tend his grave, put flowers on his grave. Who will go and pray at his grave back home?'

The look on the elders' faces changed dramatically. It was as if

Roshan had converted to Satanism and was possessed by evil spirits who were talking through him. The silence seemed to last for hours.

Dad eventually broke it and started speaking. I had rarely experienced Dad so gentle and measured.

'Son, your father was like my brother and this isn't our country. I wouldn't want him buried here, I don't think he would have wanted to be buried here. He needs to be buried in the same earth, the earth of his birth, in the land where he was respected, not where he is spat upon. We need to give him his dignity. You will see how many people will come to his funeral: thousands, the whole village will come, people who grew up with him, you will see. He was a good man.'

Roshan looked confused and stayed silent; this was the only country he knew.

Uncle Guncha had the final word. 'I feel it's only a matter of time until they will send us packing. What do you think, Roshan, son? When they throw us out, we can't dig our bodies up and take them with us. We have to think about our future.'

· 17

THE ACTIVISTS, THE MISSIONARIES,
AND THE DISGRACED

O N 3 APRIL 1968, IN Memphis, Tennessee, Dr Martin
Luther King finished his speech with the following words:

> Like anybody, I would like to live a long life. Longevity has
> its place. But I'm not concerned about that now. I just want
> to do God's will. And he's allowed me to go up to the
> mountain. And I've looked over. And I've seen the Promised
> Land. I may not get there with you. But I want you to know
> tonight, that we, as a people, will get to the promised land!

The next day James Earl Ray opened the window of his hotel
bathroom, took aim with his Remington rifle, and shot Dr King
dead.

Sixteen days later, on 20 April 1968 in Birmingham, England,
at the old Midland Hotel, two miles from where Dad had recently

settled in his new homeland, Enoch Powell stood up in his dark suit and with piercing blue eyes delivered an infamous speech to a gathering of Conservative Party members. 'Like the Roman, I seem to see "the River Tiber foaming with much blood". That tragic and intractable phenomenon which we watch with horror on the other side of the Atlantic but which there is interwoven with the history and existence of the States itself, is coming upon us here by our own volition and our own neglect. Indeed, it has all but come.' Earlier in the speech he had quoted a man who told him, 'In this country, in fifteen or twenty years' time, the Black man will have the whip hand over the white man.'

Dad hadn't come here, to his 'Promised Land', to hold the whip over the white man as the Empire had done over him and his ancestors. He had come for a new life. Mum had followed him seven years later with Barak-Shah and one of the smuggled 'sons'. The rest of the family, including myself, were born here. Dad may have done the jobs no one else wanted, but the Promised Land for him meant his sons could eventually become both pious reciters of the Koran and educated enough to become doctors, or other professionals worthy of respect.

Much of this had passed me by, of course, until an incident with Mrs Vincent. It was Mrs Vincent who accidentally kick-started my own awakening as to where I stood in the racist and economic world order just before I hit my teens.

Mrs Vincent was some kind of head of the lower school, but I never worked out her title back then. All I knew was she wasn't a normal teacher with her own class: she floated around, invariably with a cup of tea and a plate of choc-chip biscuits in her hand.

She came in one morning to cover our class, our teacher being unwell. A few of the teachers would occasionally bring mugs of tea into the classroom, but as teachers led by example, bringing food into the class never happened. She was the only exception, the only teacher I always saw eating outside of the staff room.

There were no chocolate chip cookies that morning accompanying her tea, but a nice iced-finger doughnut sitting on a plate on her desk; I couldn't take my eyes off it as she nibbled at it throughout class. Wasn't it rude to eat without offering to someone else? This is what Mum said, 'Always offer', and the English, with their superb manners, said the same thing – but Mrs Vincent didn't.

Mrs Vincent had Shirley Temple curls and huge, rimless, eighties-style glasses. Their thick lenses magnified her blue mascara and eyeliner. Her huge eyes stared out at us in full force today. She wanted us all focusing on the railways, on the sheer brilliance of the British Invention of the Steam Engine, how Birmingham had played such a big part in this process, and how Great Britain had been 'the benefactor of the world, transferring our technology far and wide – even to India – helping everyone'.

As she had it, the British had done so much good. They had given India its railways, along with other wonderful things such as 'great educational institutions', where 'they' could go and learn. They thought everyone should learn English.

So Hooriya Jaan and Mum were right when they spoke of how good the British were, who gave them everything in this country. I understood why now. I also understood why it was called 'Great' Britain – considering how 'great' they were.

Later that day, after school and after Koranic studies, I found my cousin Payman sitting with Dad. Years ago, Dad had miraculously escaped death in a car accident when he went to collect Payman from the airport, the day he first arrived in the UK. It took Dad a year to recover from his broken ribs and shattered shoulder-blade, but he honoured the words to his dying sister-in-law, that he would take care of her children. Dad had registered Payman, his two brothers and one sister as his own children. No matter that Payman called Dad 'Uncle', he was his father on official documents.

Payman owed his new life to Dad, and as is the way with the burdens of gratitude, he responded sometimes with respect and sometimes with disloyalty.

I walked into the front room and said my salutations. Payman was reading a newspaper called the *Kala Tara* (*Black Star*). He had it ordered especially from Bradford. Payman worked in our local Community Centre filling out forms for the illiterates, or those that couldn't read or write English, helping lost causes, or good causes needing an effective voice – on everything from immigration, workers' rights and refuse collections, to grants for kitchen extensions.

What's more, he would occasionally let me rummage before anyone else could in the jumble sales they held, allowing me to acquire copies of the *National Geographic* and *Reader's Digest* and other books for my collection, and sometimes perfume bottles that were nearly empty, which I would bring back for Mum or Banafsha. My sister and I would gaze in awe at the exquisitely crafted glass bottles with a few sprays of golden perfume left

inside, or at the almost-empty, topaz-topped vials of cold cream that seemed precious artefacts from another world.

Dad had forced Payman to study even though Payman's father sent regular letters asking Dad to make sure he started working on the factory floors. 'We need more money,' the letters implored. Dad intervened, said the boy was clever, let him study, maybe he will become a doctor. As Payman spoke English so well, Dad had put in a telephone in the front room so he could book tickets for people who wanted to travel back home to India, Pakistan, Bangladesh, or on pilgrimage to Saudi Arabia. I even heard him booking a ticket to South Africa once.

Dad and Payman had more or less lived together as father and son for six years before Mum arrived. Now Payman had grown up and moved out but he visited regularly.

Uncle Guncha Khan was also visiting, bubbling away on the hookah, pressing a lit match down on the bowl of tobacco that he had ground in his hand before wetting it with the water from the base. He sucked in and let smoke out into the room like a gigantic haze machine. I watched the smoke snaking fulsomely towards the ceiling and disappearing. Thank God Dad didn't smoke.

Guncha Khan looked towards Payman. 'Tell me, son, what does it say in that paper?'

'Uncle, it's a calamity. Remember that incident a few years back when I told you about those police cadets and the disgusting essays they wrote about us immigrants? The one they made a TV programme on . . .?'

Uncle Guncha was trying hard to keep up by blowing harder on his hookah.

'Well, this article is talking about the race riots last year, here in Handsworth. They are still trying to divide and rule us, creating division between us Asians and Blacks. Everyone is saying that the Asians have all the business, and the Blacks don't, that is why they burnt down our shops. The police want to blame someone else, so the *Black Star* has published some of those police cadet essays again. I don't know why they hate us so much. Why should we be here, when they hate us so much? Listen, this police cadet is saying that "all these tin-pots and curry-heads should be sent back, with their loud music and smelly food, send them back". This is police racism and they are all in it, including the government!'

Dad and Uncle Guncha didn't understand all the argot, and nor did I, so Payman improvised, emphasizing the demeaning insults then putting down the paper abruptly. 'You have been too kind to them, you need to fight: they only understand the language of the stick, that is the language they use with us.'

I assumed he meant we needed to assert ourselves against the white man but I couldn't be sure he didn't mean using proper sticks as well.

'"We are here to stay, here to fight, this is also our country." That is what this journalist says here.' He pointed and vigorously shook the paper. 'You know if we *had* started fighting earlier we wouldn't be in this position. These British are so clever, they just use us.'

I interrupted earnestly, peering past Uncle Guncha, still billowing smoke out of his mouth. 'But the British did very good for us. Our teacher said that the British have been

very good to the Indian empire, they built us roads and gave us railways. They helped us get educated.'

Payman looked at me in disbelief and sneered, 'Look, this is what they teach them in schools, they brainwash them. Have you seen the picture of the Taj Mahal, Osman?' Payman was now shouting. I nodded, watching them all with alarm as they began heating up with outrage. Payman continued, 'One of the Mughal emperors built it, one of the most beautiful buildings in the world. You know it's one of the Seven Wonders of the World? And it is us, *we Muslims* who built this.' He shook his head in disgust. 'Can you go in tomorrow and tell your teacher: "You only built your railways because it helped you get your army around and get all the riches out of the country. You did it for your benefit. We were the richest country in the world, and after two hundred years of British rule, we became the poorest." Remember what I said, can you repeat this now? What are you going to say to her?'

I swallowed the spit building in my dry mouth, and began repeating what I could remember, then Dad interrupted furiously: 'The Koh-i-Noor, son, the Koh-i-Noor, the very best diamond the Queen wears in her crown, that is from Afghanistan, they stole this from us. These people are cunning thieves.'

Payman's indignation had puffed him out so much his frizzy hair was standing on end and his handlebar moustache was twitching up and down independently. He jumped in again, 'You tell her: "This country is rich because we are poor, and the reason why we are *here* is because they were over *there first*, they took everything from us."'

They all murmured angrily in agreement. 'Osman, so tomorrow you will go and tell your teacher, and then you come back and tell us what she says?'

I sat there trying to take it in. How was I going to tell Mrs Vincent all this tomorrow? She didn't have a kind face; her curls jumped up and down as she moved around the blackboard, clawing into it with her chalk, and one look from her was like that from the Medusa, it would turn you to stone.

The very next day, as I walked to school, I noticed how someone had newly sprayed 'Pakis go home' in black over the Woodbridge Road railway bridge. The paint glimmered evilly as it caught the morning sun, as if talking to me, beckoning me. I repeated it again and again under my breath. 'Pakis go home.' On the other side it read 'IRA' in three big black letters. I didn't quite understand who IRA was, but 'Pakis go home' got me disturbed like never before. It was normal to be called a 'W★★', a 'Paki', or sometimes a 'Black Bastard', to hear it shouted from cars full of white passengers with their windows rolled down; normal to hear it in one's ears for a fleeting moment, like a greeting, before carrying on. To see those indelible letters emblazoned for months on walls on my route to school, however, was more worrying. I was born here. Where was the home I was supposed to go to?

The first lesson was English with Mrs Vincent. I walked into the class as she was about to take the register. After she had finished, I stalled, my bravery waning by the minute. I couldn't say what I had promised Payman and Dad in that first lesson.

The second was French, so it was another teacher.

Then came the last class of the afternoon. Mrs Vincent bobbed

in. She was back; it should have been geography, but in her wisdom she decided to carry on her history lesson about the railways.

'Now, do you all remember what we talked about yesterday?'

Something stronger than myself made me put my hand up, a strength from duty more than just agitation. I simply started and didn't stop. The whole spiel poured out of me . . . 'My Dad and my brother say that you only built the railways and roads because it helped you take stuff and steal it from us, you did it because it was easier to take stuff out.' On I went: 'Even . . . even the Koh-i-Noor, the biggest diamond in the world, on the Queen's crown, that is Afghan, it was stolen from us . . . Grabbed and put on a train so it could be taken back to England!' I finished abruptly, exhausted, dazed but looking around, wanting someone to say I had said the correct thing. No one did.

She regarded me narrowly through her curls. 'That is enough, Osman! Please be quiet!' and carried on with the lesson, undeterred.

Later that day, after evening prayers, I came in to see Payman and Dad talking. They looked up at me and smiled. They'd forgotten.

'I told her, I told the teacher.'

Payman smiled again, his face finally registering that he remembered. 'You did? And?'

'And she was so ashamed, I made her cry.'

'Good boy.'

Dad looked proud but concerned. 'You won't be getting into trouble for making her cry?'

'No. She knows she's a liar,' I said and walked out, holding myself as straight as Uncle Guncha Khan.

★ ★ ★

Mrs Vincent might well have been partly responsible for my visits to the mosque taking on more meaning. But they were gaining significance for me anyway. These days the mosque was full of the Jamaat missionaries, who would travel around to preach the *dawah*, to bring us all closer to God. Whilst the old guard of imams from the seventies had worked to bring back our misguided fathers and uncles, teaching them the correct scriptures and prayer, by the eighties there was a need to homogenize them. As if the local imam wasn't doing enough, we needed more visitations from numerous walking examples of the ways of piety, the ways of the Prophet.

Like Uncle Darya, these men travelled to cities around the world, calling the faithful away from impious society, urging all to embrace the same Islamic lifestyle, which had its own code. Not only should they dress like the Prophet, but

Sleep as he did on the ground, on one's right side;
 Enter bathrooms leading with the left foot,
 But put pants on leading with the right foot.
 Not use a fork like the infidel, but instead your index
finger, middle finger and thumb;
 Shave your upper lip but let your beard grow;
 Wear pants or robes above the ankle as the Prophet
proclaimed, allowing clothes to drag on the ground being
a sign of arrogance.

The congregation grew through the generations, as the community grew in size. People from the city of Swabi, villagers from

Zarobi, Batakara, Topi and Saleh Khana, from Mardan and Kalabat; all came, all Pashtuns from the valleys between the River Kabul and the Indus. Our mosque overflowed. Now there were four grades of after-school Koranic classes; one imam couldn't teach all of them, so the committee decided to hire a supporting imam.

This new breed of imams of the late eighties and nineties arrived to inspire the children under their tutelage. They had trained at the seminaries of Saudi Arabia and Egypt, seminaries which had strong links with new outposts in foreign lands like Dewsbury. They arrived in London, Bradford and Birmingham furnished with a brave new message: the example of the Mujahideen, who had taken up arms against Russia, had beaten a superpower and ousted them as an imperial force in our occupied homelands. Their new, more puritanical doctrines, their strict interpretations, were promulgated alongside the traditional four schools of Sunni Islam.

The new thinking and preaching were meant to create uniformity, one identity, to remove the contaminated colours that Islam had taken on from the many lands it had inhabited and migrated to. It was felt there was too much litter, too much confusion on the righteous path. God's true law and religion had been polluted. Before Muslims went the way of their cousins – the other people of the book, the Christians and the Jews who had lost their way – these imams stood up in their finery to reinforce pure Islam with fiery sermons.

Our new imam had much to say on *shirk* (idolatry), on the veneration and deification of saints. He was particularly fond of saying: 'You cannot ask at the shrine of a holy man to fulfil your

needs. Why do you ask the dead? They can't help you, it's God who you should be asking.' Here he would smirk, congratulating himself on his clever logic, then repeated it in case anyone had missed it: 'Think – what can the dead do for you? It is the *living* who can help you, and that if only God wills.'

He would move on to the shining example of the era we needed to emulate. 'If we return to the glory days of the Caliphate, the time of the first four caliphs, we will be great again! United together! The Muslim *ummah*, all brothers and sisters. How powerful we will be if we all come together.'

Here he would pause triumphantly to look around, smiling and displaying his white teeth, his freshly oiled black beard, his large, white turban matching his white robes. He would carry on: 'God loves you, but He is unhappy with us, He sees fragmented ways, He sees us emulating the way of the infidel. Look what we are doing with the Ruski devil, we are making them tremble in Afghanistan, in our homeland. These are God's men, *mujahids*, and when God wills, even America helps them. We can do the same here. If we live by the book, no one can stop us, as *this* is God's law, the perfect, divine law – Sharia law.'

Looking out from his pulpit, he would finally exclaim with huge gusto: 'Come back to your senses, oh chosen people. Do not forsake Him, He hasn't forsaken you!'

This was going to be our new, true identity and these imams were here so we understood it correctly.

<p style="text-align:center">★ ★ ★</p>

Other exciting things started happened at the mosque with the arrival of the Jamaat. There were sleepovers with special prayers. I was elated to be joining in my first one. Dad had reluctantly agreed, happy at least that I was showing a voluntary interest in faith. I was to use his sleeping bag, the one he took to Mecca. He'd asked Chenghiz to look after me.

He must have had second thoughts, because after evening prayers he walked into the room in which we were to sleep and said, 'Osman, you get your stuff and come home. You are not staying here tonight.' I pleaded, 'I want to stay . . . look, the Jamaat is here, I can learn so much from them, we will pray all night.' After looking slowly around the room at each of the other boys, Dad relented.

There were eight of us staying that evening. Chenghiz had turned eighteen and was the most pious. Everyone trusted him. Then there was Amal, the oldest, around twenty. Balach was one year older than me and went to my school, as did Khagalay, who was in another year. Darman was the same age as me but we didn't go to the same school. And the twins Khog and Lajbar, sons of Dad's friends, were the same year as me but went to the Islamic day school.

Evening prayer was followed by a sermon from the visiting missionaries to the congregation in the two drawing rooms which made up our main hall. Then we chatted for a while upstairs – me, Darman, Khog and Lajbar – and afterwards it was time to go to bed. We were sleeping in a room away from the main prayer rooms, which the Jamaat had taken over. The sleeping bags were laid out ready.

Chenghiz was in charge in our room. He tried to teach us

the prayer for when you go to sleep. He started with the prayers of the Four Quls, the short, closing chapters of the Koran. These are used regularly for protection and to ward off evil.

Chenghiz made us sit in a circle. He led the way, holding his hands up towards his face, and we followed. It seemed as if he was crying, crying in prayer, rocking back and forth, which seemed to give him solace. This went on for twenty minutes, then he finished with a prayer I didn't understand at the time, but later I looked up: 'Oh Allah, I submit my soul unto You, and I entrust my affairs unto You, and I turn my face towards You, and I totally rely on You, in hope and fear of You. Verily there is no refuge nor safe haven from You except with You.'

He then turned off the light, and sent his salutations to everyone, in case he or we didn't wake up the next morning. We were continually made aware that this life was short and any one of us might never wake up again. God was in total control, and He could take your life as and when He wished.

After five minutes with the lights off and a lot of whispering from one side of the room, I think it was Khagalay who blared out a squalling noise as if he was possessed, or had been attacked by a demon or a jinn. Someone turned on the light; it was Chenghiz, smiling with some annoyance on his face.

'Quit your messing around! If the Jamaat hear you upstairs, we will be in trouble. We don't want to embarrass ourselves. This is not the way to behave, this is not the way for Muslims to behave, especially in the mosque – this is the House of God.'

He was facing Khagalay and Balach. Balach was sitting cross-legged and upright like the rest of us, looking bemused, whilst

Khagalay pretended to be fast asleep, head under the sleeping bag. Chenghiz told everyone firmly to sleep, then his pure white form in its sweet chubbiness, devoid of anything *haram*, with his soft, uncut beard, his crocheted skullcap, all of it waddled to the light switch and returned to his sleeping bag.

A few seconds later Khagalay let out another horror-moan, and then all of a sudden in the dark I saw what looked like Balach and Khagalay attacking Chenghiz.

Chenghiz shouted, 'Get off me, get off me!' From what I could make out, Amal and Khagalay were hovering over him, tickling him, whilst Balach was actually sitting on top of him. Chenghiz kept shouting, 'Get off me! Turn on the light!' I got up to turn the light on, and there under the bare bulb that illuminated the room was the raucous, rogue trio, caught red-handed disturbing the peace of the mosque.

Chenghiz wasn't happy. His piety hadn't stopped him being the target of jokes and ribbing from the tougher kids. 'I will speak to your dads tomorrow,' he said, and with that he got up and waddled out with his things, declaring he was sleeping in the other room.

At this point Amal and Khagalay burst into fits of laughter, saying, 'It was a joke, don't take it so seriously!'

After the horseplay, the laughter simmered down and I needed to go the toilet, which was in the basement. This house was once one of the finest on the street, with its own servants' quarters, and now it had been consecrated as a House of God, the House of Allah, a mosque for our community. The mosque committee had chosen a caramel-coloured carpet,

which must have been donated or subsidized by one of the local businessmen. This had been laid wall-to-wall throughout, like an icing of caramel throughout the whole interconnected building. I wandered past the main hall, where the Jamaat were sleeping, and down the stairs to the main entrance, and then down the stairs again to the toilets in the cellar. These were the toilets that Dad had built and tiled in glowing Cartland Coral Pink.

The light was still on when I returned and everyone was chatting. I went towards my sleeping bag. Khagalay shot up, grabbed me from behind, and shouted: 'LET'S TAKE HIS TROUSERS DOWN!' There was a sudden swarm around me, hands grabbing me, hands keeping me down, hands meaning to disgrace me.

Amal, the eldest, had got hold of my legs, pulling me down. Balach had both of my hands behind my back and, as I went down, he yanked out my arms. Darman joined in, getting hold of one of my hands. Khog and Lajbar were laughing. I was struggling, shouting, 'HELP, HELP, HELP me, let me go!'

Amal shouted at Khog and Lajbar, 'Hold his legs DOWN!' They did this as Amal, kneeling to one side, reached for my drawstring, smiling: 'He is enjoying it – look at him.'

Khog and Lajbar kept laughing as the limbs that pinned me down got stronger and stronger. To stop me shouting, Balach put his hand over my mouth. I tried to bite him but he covered it firmly shut.

My drawstring was pulled open and my salwar pulled down to my knees. Then abruptly, the act complete, the hands let go.

I lay there in shock for what seemed like an eternity, but was perhaps only a matter of seconds, then I pulled up my trousers and tied up my drawstring. They were all jeering and laughing.

I got up, thinking, Do I go home now, what do I do? Do I tell my dad, do I tell my brother, and get them beaten up? The light was turned off and with it my shame was hidden. They all decided finally to go to sleep. In my sleeping bag, I lay in the darkness wide awake. I didn't understand what had just happened to me; their cruelty made little sense. Chenghiz wasn't there to protect me. Finally, I comforted myself with this thought: If I don't tell anyone, I will be fine.

The following morning all seemed normal. When the congregation got up to pray, ablutions were carried out, and, with the visiting missionaries, the hall was fuller than I had ever seen it for the first prayer of the day. Afterwards in the kitchen, steaming hot tea was served with rusks. I didn't drink the tea but dunked the baked rusks one after another.

The time arrived to go home. I rolled up my sleeping bag, pushed it into its sack and, since Khog and Lajbar lived on the same street, all three of us walked home together. This had been our first sleepover, mine marked with violence and shame. My first ever stay away from home had confirmed what Barak-Shah always said: I was weak. And that made me a permanent target.

Mum was at home, but Dad wasn't. Mum looked at me and smiled, proudly recognizing her growing son. She would compliment us regularly, and inadvertently herself: 'My children are some of the best-looking in the community.' But now these looks

had attracted the wrong attention. I hid my shame at what had happened at the mosque and all-night prayers. She greeted me and kissed me on both cheeks and asked if I wanted anything to eat.

I had to go back to the scene of the crime at solar noon, the time decreed for the second prayer of the day, Zuhr. It isn't always exactly at midday, but when the sun is highest in the sky. Women start reading their second set of prayers at this point. For men, it is considered obligatory to pray in the mosque with the congregation.

When I reached the mosque, a deadly silence seemed to greet me. Faces turned to me and then turned away. Dad was waiting for me as I climbed up the stairs after my pink-hazed ritual ablutions. He grabbed me and walked me to the imam's room, and in front of the imam he asked, 'What happened last night?'

I stayed silent. He asked me again, looking bewildered.

The imam was looking at me and I looked down at the floor. His voice was calm but distant. 'Son, what happened last night, what did they do to you?'

I kept looking down, no words would come out. He asked me again. Normally the imam would smile, put his hand on my shoulder or tousle my shorn hair; he didn't touch me.

Dad started to get angry. 'Tell me what happened! Why won't you tell us?'

I buried my head again and my secret, wondering who had told them, and why they had told them; they surely had incriminated themselves, they would all be punished. Why was I in trouble? *They* should be in trouble! This was unfair!

Dad put his hand on my shoulder, and I tugged at my kameez

and started crying, somehow blurting out that they had taken my trousers down.

Dad asked, 'Did they do anything else?'

'*No*! Only my trousers.' I didn't see Dad's face, as I couldn't look up. I kept my face averted, the tears streaming down. I didn't know why he was angry with me: had I brought shame on him? I read my prayers, I went to the mosque, it wasn't my fault . . . Nothing made sense.

The imam started reading prayers over me and Dad nodded: prayers to keep me safe, prayers to keep me on the straight path. Then the first call for midday prayers started resonating throughout the entire building. It was Guncha Khan standing at the top of the stairs calling his *azan*.

Dad asked me to wash my face in the sink in the imam's kitchen and then get ready for prayers.

Outside the imam's room, people looked at me strangely, askance; some avoided me; I was a pariah, a leper. The air was thick with repulsion – repulsion for me. No one wanted to talk to me. Children didn't speak to me. I had been desecrated, tainted with sexual impurity, my pure robes not pure any more. I had been stained.

I headed back home with Dad, looking straight ahead. Soon after we got home, Khog and Lajbar's father came round, pleading with Dad, apologizing, touching Dad's beard. I wanted to leave but stayed in the room. He had beaten his sons already, he said. A good thrashing with a belt! I knew he was afraid of Barak-Shah and my father's retaliation. His family had dishonoured ours. He didn't look at me once, even when he went out.

Mum didn't overreact but the next day Khog and Lajbar's mother came to see her. 'This is just horseplay, boys will be boys,' said their mum. 'It's nothing, just innocent play, taking his trousers down: boys do that to each other all the time.' Mum told Dad about her response, pride glinting in her eyes: '"Oh well," I said to her, "then let me take *your* trousers down."'

That evening, Barak-Shah and Payman went looking for blood. They went to the mosque and, after prayers, Payman stood up at the front of the congregation to make an announcement, with Barak-Shah standing shoulder to shoulder, hard-faced beside him. I sat several rows back, with trembling hands and bowed head. My name was not mentioned.

'Whatever happened to that child,' Payman said, 'he was forced and it was wrong to do it in this House of God.' Then I got up hurriedly as people started leaving.

Payman saw Khagalay leaving and ran after him, straight down the stairs towards the basement. Barak-Shah followed, and when he arrived Payman had Khagalay pinned down, his arms behind his back, his face pushed into the carpet. Barak-Shah took over, holding him down, while Payman tried to take his trousers down. I watched from the top, not sure if this was good or bad, or disastrous. Before Payman was successful, the older men arrived and broke up the fight.

From that day on, things got weird. Stories continued to circulate, that I had enjoyed what had been done to me. The twins came up to me not long after their father's beating: 'You loved it, that's why you were really screaming.'

The different manner towards me at the mosque wasn't just

one of avoidance. Older boys who'd never given me a thought before began to sit next to me, to smile too frequently.

I was reading the scriptures once after midday prayers, alone in one of the rooms, when one of the older boys came and sat next to me. 'I like you,' he said. I kept looking down at the scriptures, rocking back and forth. He wouldn't go away and I began to shake.

After this, when it was dark, every so often I felt I was being followed home, so I would run, run down the streets, straight home, and my heart wouldn't stop pounding until I sat down at Mum's table.

Dad changed towards me too after the sleepover. I had tainted the family honour, and I dreaded his anger. But for some reason he became a little gentler, and somewhat more protective towards me. He was the strong man from Swabi, and like many in the community had to balance a sense of propriety, juggling the patriarchal, the familial and the honourable.

Eventually the rumours died off, but I still carried my shame.

18

SAM THE HAIRDRESSER, BUSTY
BARBARA, AND THE SHOE-SELLER

AMONG THE MANY PATRIARCHAL FIGURES in our community were two colourful characters who particularly stood out as alternative takes on the male species. By a curious fate, I came across them simultaneously.

There was Karim the shoe-seller, whose epicene ways reminded me of Madonna and Simon Le Bon all rolled into one. But let me start with Sam.

I had never been to or even heard of Sam the hairdresser till Barak-Shah took me to Sam's Salon. I didn't know that this was the place where dreams came true, the place that could grant you the hair of George Michael; of Michael Jackson even. This was the place of starry transformation.

Many of the more fashionable boys from our streets would go there: Sam's was where you graduated to. I wasn't yet old enough to make my own choices; Dad would march me off to Hanif's

whenever I needed a trim. Hanif was the barber of the faithful. He only gave one haircut: this was where all the Bushmen had their hair sheared with a number 3 or 4 all over. It made it easy for their skullcaps to sit on top of their freshly shorn heads, and even easier for yards of turban to be tied over the skullcap.

The imam had mentioned in one of his sermons that if you were to grow your hair, it could only be kept in the manner of the prophets, that Jesus oiled his skin and hair with olive oil, and after him the Prophet did the same. If growing your hair long, you needed to follow a strict style: one length, which could go no further than your earlobes. All this, just in case anyone confused you for a woman. Get it wrong and God would curse you, and in the hereafter you would incur the most unthinkable punishments.

Not many of the brethren grew their hair like the prophets – probably because it was a nightmare to maintain curls folding behind their ears but under no circumstances caressing past the nape line. Barak-Shah's hair didn't look anything like Jesus'. It definitely looked more like that man from Duran Duran's.

Having your hair cut by white hands was a novelty, so you would only go to Sam's if you had left the righteous way and had other aspirations; if you'd started thinking about your appearance more, and begun to see the world – and crucially your hair – quite differently.

When Barak-Shah took me to the salon I was still dressed in my mosque clothes and my navy blue parka that I wouldn't grow into for a few years, and my not-so-freshly-cut number 3 all over, which looked more like a French pixie cut.

Inside Sam's small salon were two barber's chairs, back to back, and further along two swivel chairs. These last were Busty Barbara's domain. She was either his partner or worked for him, I'm not sure which, but she had more people waiting for her than Sam did. I understood why later when I heard that the boys would come and stare at Busty Barbara's tight t-shirts, tight-permed big blonde hair and tight bleached jeans. On that first visit, Busty Barbara had three people waiting for her, two women and a guy with peroxide hair, but since Sam had no one waiting, Barak-Shah walked straight in and sat down. The guy with peroxide hair glanced over, smiled at us and said, 'Hey, Barak-Shah, how are you? It's Karim. I haven't seen you for ages – not since school days.'

Barak Shah nodded back proudly but said nothing.

I looked around at the wall-to-wall mirrors, wooden panels, a set of maracas and some postcards with the word 'Spain' written across the images. These were arranged on the wall near Sam, along with black-and-white posters of models and the types of haircuts you could be inspired by and request.

I took a good look at Sam. His paunch was trapped like an inflated balloon inside his button-down work coat. Given he was a hairdresser, luck was not on his side: you could see a great deal less of his mane than of his shiny scalp. The loose, thinning strands of hair – like on the TV advertisements for Hamlet cigars – were brushed over the top and slicked behind his ear. The remainder of his oily hair had grown into a thin mullet, curtaining the back of his head and coming to rest meagrely on the protruding collar of his patterned shirt, which

he'd left partly unbuttoned to expose some of his hairy chest.

I sat and waited for Barak-Shah, and while I watched him, my older brother watched himself in the mirror – or rather he was watching himself watching himself in the mirror. He was handsome; he knew it; we all knew it. He had become a fine specimen, winning most of the fights he got into. We didn't have such a big mirror at home, so here I realized he could really regard himself in his full glory.

Sam cut away, but when he moved back and didn't actually have his hair in between the scissors, Barak-Shah would some-times make a slight jerk of his neck like a majestic cockerel admiring himself. There was not much talk between Barak-Shah and Sam, unlike over in Busty Barbara's corner, where she chatted and cooed away with her clients. In fact, most of the time Sam would snip expertly, then take a step back to look over at his poodle, which sat in a basket in the corner, and send it air-kisses or special little stares.

The radio was a constant in the background and Barbara moved constantly around her clients as she gossiped and pulled, cut and curled, her hairdresser's apron tied into her slight back. I didn't know who to watch more: Barbara, Sam or Barak-Shah.

Sam kept cutting, holding some of Barak-Shah's hair in clips to get the layers to sit over each other perfectly. I watched transfixed as Barak-Shah had layer after layer of a mullet shape cut from his untidy mop. Sam kept fanning out the mullet, which caressed Barak-Shah's neck, and then gave him a side parting with long flicks that looked quite similar to a model in a photo

on the wall. Then he styled it all with a blow-dry. To finish it off, Sam sprayed his hair with sweet-smelling hairspray. In fact, Sam and Busty Barbara sprayed enough L'Oréal Studio Line to anaesthetize the entire salon and the newsagent's next door. Of course, this was a few years before the big hole in the ozone became newsworthy, but I'm sure between them Sam and Barbara made a generous contribution to it.

When he was finished, Sam showed Barak-Shah the back and sides of his hair with a mirror and Barak-Shah began putting his hands through his mullet, shaking his mane backwards and forwards with delicious satisfaction.

Now he had been brushed down, Barak-Shah looked at me and nodded his head towards the door: a sign for me to get up. As we began to move, Karim looked up at me, then at Barak-Shah.

'Hey, you know, Barak-Shah, I've opened up a shoe shop on Ladypool Road. It's just near Imran's restaurant, literally on the other side. Since we went to school together, I'll give you and your family a discount. I have opening offers for everyone, all the best prices. And you, Barbara, you've got to come and visit. It's going to be the best and most fashionable shoe shop on Ladypool Road. I have all the latest styles, just like these.' He held up a magazine to show everyone the pixie boots Madonna was wearing.

Barak-Shah looked surprised at this news, then nodded aloofly and managed a polite 'Congratulations.'

Once in the car, I asked Barak-Shah who the guy with the orange hair was.

'He went to my school. He is a poof, a queer, a faggot,' and then he looked at me. 'Don't go anywhere near him. Stay away!'

I knew what a poof was so I thought it was best not to ask him to explain the other words, but I guessed they must have meant more of the same. Barak-Shah looked ahead, pushing his cassette tape into the player, and Sting started transfixing him, and me too. Barak-Shah started singing along to 'Walking on the Moon', his freshly cut layers moving in perfect rhythm. We drove off, Barak-Shah adding extra gas, revving up his Toyota Supra to show everyone his wheels, the very wheels that were going to drive him away, out of the ghetto one day soon.

We were off to do Mum's weekly shop, the big shop Barak-Shah always did from the £50 he gave Mum every week out of his wages. That week it consisted of one big bag of flour that lasted three weeks, a big case of toilet roll, and bags of fruit. I was there trying to carry what I could and then some. Each week Barak-Shah took me with great reluctance, but it was easy for me to navigate him: I just kept shtum and didn't say much. Despite Barak-Shah's reluctance, Mum would always send me, saying that I picked the best fruit and vegetables; the freshest carrots, the firmest plums that hadn't lost their moisture, cabbages whose heads were compact and firm, egg plants which didn't have any brown spots or were too big so they would probably be bitter on the inside.

All this I'd learned from Dad when I accompanied him to Khan's or down the Ladypool Road. He had showed me how, with okra, you could pop off the edge of the pod and check from the way it popped that it hadn't dried out. 'Avoid the larger

okras. Pick the smaller and medium-sized pods,' he advised. I listened and learned.

On top of this Mum always said, 'Ask them if the meat is fresh, and is it from today?' (As if they had an abattoir in the back garden of the shop.)

Since Mum couldn't go out, I became the best way of controlling what came into her home, and what she had to cook with. She gave me very specific instructions from behind the walls of our house on Willows Road. When the shopping arrived home, she would move from sewing machine to stove, unleashing the aromas of her cooking from inside these fortressed walls, out into the world, a way of telling everyone she existed.

It just so happened that the week after Barak-Shah and I had gone to Sam's, I had the chance to check out the guy with the orange hair due to this one client of Mum's, Buland Khan's wife, who came to visit. Our family relations went way back, and she was another of our many regular visitors proudly proclaiming, 'I'm visiting my brother's house.' My Dad's and Buland Khan's grandfathers had been the best of friends back in their village, and that bond was still alive today, across continents, down the generations, in Birmingham, Vilayat.

As always, I found myself hovering, sitting on the edges of the room on the upside-down crates that Mum had turned into padded stools. This particular aunty, Mrs Khan, always had an eye for the most prized fabrics to be sewn into suits. Today she

was collecting a suit that had given me and Mum so much pleasure in the making. It was the most exquisite crêpe in orange sherbet, with a fil coupé diamond pattern that repeated itself throughout. She had had a few other suits made, but none as beautiful as this orange. I had gone out and chosen the lace for the *dupatta*s of her other suits, but the bright sherbet-orange with its matching chiffon headscarf didn't need a lace trim; the edges had already been embroidered with scallops.

Mum and I had both looked at it in wonder. Mum held it up and draped it against herself, saying dreamily, 'It's such a beautiful colour – so, so sophisticated. Maybe I can save some of the fabric and make my little one a dress from it.'

I helped Mum cut the fabric, smoothing it out on the floor. Mrs Khan was quite slight, so Mum managed to save some fabric for Marjan.

I wanted to be really close to this woman, whose husband chose her the best fabrics to wear. On this particular day, Aunty Buland Khan chatted over tea, then tried to settle her bill. As usual, Mum tried not to charge her, but as usual she insisted. It was a regular routine. Mum said, as always, 'But you are the daughter of this household . . . How can I take money from you?' And as always Aunty Khan replied, 'Sister, I am giving this money with happiness, please take it, I will be very upset if you don't.' This complicated dance back and forth went on for at least ten minutes, especially when no one was around. I realized that this posturing and ritual allowed them both to keep countenance and fan each other's egos, yet still allowed a monetary transaction to take place.

When this was finally over, Aunty Buland Khan said, 'I've still so much to buy for when I go back. Everyone demands a gift and you know they ask you straight to your face: "What have you brought me back?"'

She was going home after fifteen years. All her children had been born here, and she was also going to visit the graves of family members who had departed while she'd been in England, and to pray for them.

Then Aunty Khan looked despondent, saying 'Oh, we are so *majboor*', which I knew meant 'helpless'.

Mum nodded along. 'Of course, we are *majboor* . . . We came here for our livelihood, to feed our stomachs, we had nothing there before; there was nothing.' She shook her head and reiterated, 'There wasn't food for both meals, and now we are stuck here and all our loved ones, our elders, have departed and are buried: we couldn't say goodbye. Look, our children are born here and they are British, they want to be English.'

Then Aunty looked at me briefly with great significance and shook her head. 'You know the pain of being a *pardesi* – back home they don't understand, they don't understand this life, they think we are drinking from golden cups.'

Mum nodded, Aunty nodded, and then they both nodded together and looked stoically at one other, accepting that life had dealt them these cards, that this was God's doing; that they couldn't change what fate dealt them. They had to learn to love England.

Except this time Aunty suddenly brightened up and looked at me, and then at Mum, beaming. 'Palwashay Jaan, if the little

one doesn't have anywhere to go, can he run an errand for me? Can he go and bring some sensible low-heeled shoes from Khattak's? I still haven't got all my gifts, and I wanted to get a new pair of shoes for myself.'

'Of course,' Mum smiled. 'Osman is free, he doesn't have mosque until later.'

Then came a rush of instructions and praise all at the same time.

'Such a good boy.'

'You're so clever, he always chooses the best things.'

'And tell Mr Khattak that it's for the Buland Khan house . . . he will know who she is. And that she is visiting us, tell him that . . . That they have requested for him to show you shoes for her . . . Don't tell them that she is going to Pakistan!'

'No! No! . . . No, don't, otherwise everyone will find out and turn up and give me something to take back . . . Who can I say no to and who can I say yes to . . . Sister, I haven't told very many people, the gifts become too much, everyone wants to send a suit, some cloth, a cardigan, socks, or shoes for someone back home. And if the luggage is too heavy, you have to pay so much more, or ask someone behind in line to help or they ask you to take it out in front of everyone.'

'Oh, sister, that is too much, so embarrassing, but you should weigh everything before you leave.'

'Oh, and my shoe size is six, and don't let them be too high, like the white women wear.'

I started to run out, head spinning. Aunty Khan stopped me, adding, 'They shouldn't be too tight from the front, I have a wide foot!'

We all looked down at her feet in her white socks and plastic slippers.

'I don't want my toes crushed or bound: I want to be comfortable.'

As I managed to get to the door, Mum called out the usual 'Come back quickly, I'm going to spit on the ground so before it dries you're back!'

'*Shabash*!'

'*Shabash, bacha.*' ('Bravo, child.')

Mrs Buland Khan finished off in English: 'A good boy! A very good boy!'

I wandered out in huge excitement, down the two streets that would take me to Ladypool Road, then crossed the traffic lights over to Khattak's. I was out, making choices for those who couldn't come out and make their own.

Viewed from outside, Khattak's was a small, perfect square, a yellow see-through blind in the window to stop Mr Khattak's many sensible, orthodox shoes fading. I knew Mr Khattak from the mosque. He was a little shorter than my dad, with a darker complexion and long beard peppered with white hairs. I could never really work out if he was fat or skinny in the long flowing robes, the loose-fitting salwar kameez he wore. Nor could I tell if he had a double chin, as his beard covered it.

He said 'Assalam alaikum' and I replied 'Peace be upon you.'

I couldn't see it myself but everyone said that his face had the light of *noor*, a sign that you would see in the most pious. Like a lot of Bushmen, he wore *khuffain*, the special leather socks worn by prophets and disciples which made it permissible for

him not to wash his feet during ablution; these simple things made sure his feet remained pure throughout the day.

Inside, shoes were stacked all the way to the ceiling on all four walls. Against one of the stacks was a small ladder he'd go up and down to retrieve a box. Then he would unfold the tissue paper inside to bring out a God-fearing (i.e., appropriate) pair of shoes. These were mostly in black and maroon with block heels, along with a few trainers. Scattered amongst this modest offering of decorum and deportment were a few sparkly sandals and one pair of red stilettos with a cone heel which I thought would definitely match a red wedding dress.

He had men's shoes on one side and women's on the other. Khattak knew the drill: this was how his business had been built, serving the orthodox community. The Bushmen would come and buy shoes for their wives and children, taking a few pairs back for them to choose from.

The other route for women to purchase shoes was for them to visit Mrs Khattak. Mr and Mrs Khattak both lived above the shop, and on the odd occasion, those women who were on visiting terms with the family would go round the back, climb up the metal staircase and enter into Mrs Khattak's pristine sitting room, with its embroidered spreads hanging from the shelves, all in matching white. From here, Mrs Khattak would call down to her husband the sizes and particular styles so those women who weren't allowed into shops on the high street would be able to make their own choices.

I told Mr Khattak the size of Aunty's feet and picked out a few styles – the ones I liked, totally oblivious to Mrs Khan and

Mum's instructions. His choice was so limited, I only picked three and handed them to him. I told him the size again and he added a few of his bestselling styles on top, saying 'They will surely like these.' In case I forgot, he wrote each price on a small bit of paper and stuffed it into the front of the shoe, and then all were popped into a bag.

Coming out of Khattak's, instead of heading back home as strictly requested, I walked the opposite way, away from home, down the length of the Ladypool Road. This detour was part of my endless, fascinated search for new shops and new wares, which would result in me being showered with compliments on my taste and finds. Halfway down, just opposite Imran's Balti Restaurant, in bold neon lettering, was 'Karim's Shoe Store', with 'Fashion Shoes' printed in the window. Fashion Shoes! Those big letters were too much to resist and anyway I was curious, having only just seen Karim the week before at the salon. In I went.

Karim was busy in the far corner with a very stout Kashmiri lady and her slightly less stout daughter. Kashmiri women fell into the 'modern' camp and were allowed to go out and shop. Over on the counter where Karim took the money was a ghetto-blaster, belting out Bollywood songs at full volume. Sitting behind the counter in a very leisurely fashion was the most beautiful boy that I had ever seen on Ladypool Road. I wasn't sure if he was Pathan or Kashmiri. He had curly locks and blue eyes, and as I watched he lifted his curls up, tucked some into the back of his hair and caressed others to frame his face, setting them to hang at angles. His shirt was open under his leather jacket, which

exactly matched Karim's. I was confused – was this a uniform? Was this Karim's assistant? He didn't look like he worked at all.

He smiled at me, and then carried on miming to the Bollywood songs, all the while playing with his hair and glancing into the mirror.

Karim walked briskly over to me, checking out my shoe bag with all the boxes.

'Are you Barak-Shah's younger brother?'

I nodded. 'Yes, I've come to choose some shoes for my mum.'

He knew that women from our community didn't go out, so most of the vendors on the street would allow you to take away samples.

'Of course.' He asked me my name graciously. I told him.

'That is a beautiful name.'

The questions kept flowing. I flushed with the attention as they came: what school did I go to, who was my favourite teacher? And then Karim tilted his head to one side and asked me who my favourite actress was. I didn't know many actresses, so he pointed at the walls. So many Bollywood posters were splattered everywhere, it looked more like an idolatrous teenage bedroom than a shoe store. He pointed to each of them in turn: 'This is Rekha, this is Parveen Babi, this is Madhuri Dixit, this is Sridevi.'

I had a distant cousin called Parveen, so I thought it was best to answer with a Muslim name.

Karim's plucked and arched eyebrows made him look like Prince. His fair Kashmiri skin, inherited from his mum, stretched over his chiselled face, and at the bridge of his nose rested a flick of peroxide hair. From this point descended the deep convex

slope of a nose that meandered round his nostrils, finishing off Karim's pride. He knew there was something different hidden inside him and it seeped through his peroxide hair, radiant in its orange hue.

This neon-orange hair, the tweezered eyebrows and the majestic K2 of a nose were the chief distinguishing features of this alternative shoe-seller of Ladypool Road. And the shoes . . . the shoes that lined the walls were like multicoloured crystals in a cave. 'These are like the sandals that gilded the dancing, size seven feet of Sridevi under her sari,' he proclaimed, holding one up. (Karim knew all the sizes of the Bollywood stars, and if he didn't he made them up.) 'Rekha, her size is six.' He lifted a pair of heels with a diamanté brooch. 'And these are exactly the same shoes that she wore in the blockbuster *Sadaa Suhagan*. Take your time, look and choose. You know you are like my family, Barak-Shah is like a brother to me,' he said.

I was puzzled – that was not what Barak-Shah had said. I looked around his room of treasures; there was too much to take in. He offered me a Coca-Cola. I accepted. I lost track of time.

Karim turned back to the women, shaking his head sadly. 'Aunty, I can't give you them for anything less than five pounds. Look how beautiful they are. Have you seen anything like them?' He lifted the gold sandals higher so they sparkled like tinsel. 'They will be gone soon, Aunty, and . . . how they will finish your suit off! I swear, Aunty, everyone will ask where you bought them from.'

Karim was in full salesman swing, his hands dancing in circles, head gliding from side to side, that nose leading the way,

his weight shifting from one hip to another with each strategic sales pitch. Here he was, the finest peacock, and his mouth was full of words which sat there at the tip of his tongue, gliding out and drawing you in.

I instinctively knew Karim wasn't like any of the other men at the mosque, nor Mr Khattak, nor Dad, Barak-Shah or their friends. He didn't carry numchucks like Barak-Shah or walk on the balls of his feet to appear taller. He didn't want to copy the walk of a Black man like a lot of the older boys in our area did. Karim had a different magic.

Another boy – thin – who looked much more like an assistant appeared from the stockroom, and Karim sang out 'Anjum! Sizes 5 and 6', as he sashayed sinuously across his lino-leum domain to the boxes that created a plinth for the particular, prized shoes he had carefully selected for his display. The rest were lined up on deep shelves. From the small stockroom Anjum would run back and forth to locate the correct size, whilst the boy at the front desk sat there.

I couldn't tell if the Kashmiri mum was shopping for her or for her daughter because Karim had them both trying on a huge number of shoes. They would shuffle their feet in and then stand up. Some lifted them off the ground with three-inch cone heels that made them both wobble.

'This piece, Aunty . . . this piece, my sister, is the latest fashion style!' He would address them separately but also somehow together. 'Yes, it looks so perfect on you! Everyone will compliment you: don't tell them the special price I gave to you, this price is only for you and only for today!'

His customers had just settled on his grey velour fancy chairs with silver tubular legs to wait for more shoes when three boys gathered outside and started shouting 'Faggot! Poof! Faggot! GAY!' at the tops of their voices. They would shout 'Faggot!' and then run off, then come back and shout it again. Karim just ignored it. It seemed he had heard it all before. Everyone in the shop heard it but said nothing. I wondered if they knew what it meant.

Then the beautiful boy stopped his Bollywood singing, got up from behind the counter and faced full-on in the window so he could see them. '*Motherfuckers*!' he screamed as they came back. 'And your mum's a faggot!' He made sure they heard.

Karim looked over proudly and smiled at him. It reminded me of Akhunzada the Scribe and how softly he would look at his wife, Saba Jaan. Then Karim came out of his momentary trance and spoke to the aunty he was serving. 'Look at these boys: they are always making a nuisance, always in front of the shop. Their parents don't say anything to them.'

She looked up at him, tutting with sympathy. 'I know, they have no respect!'

I started to pick out my favourite shoes to take back to Mum and Mrs Khan. It perplexed me that Mum wouldn't wear these kinds of shoes. She only had one pair of heels, the platforms that Dad had bought her when she arrived in this country. He eventually bought her a second-hand coat. In the meantime, she would borrow Kala Aunty's coat: a brown faux mink with chunky black buttons.

Even if I was told not to, I always wanted to bring home the most sparkly, the highest-heeled shoes, especially now from

Karim, the purveyor of glamour. Unlike Mr Khattak, Karim allowed me to pick them all out myself. I knew Mum would make me take all of them back, so I added one or two mid-heels.

The big thing for me was to watch Mum, my sister, Mum's clients, neighbours or friends look at the shoes, pick them up and then try them on in front of me. They called high heels 'liftian' – perhaps an extension of the word 'lift'. Some of the women would hobble around, but others were able to walk so well in them as they looked down, admiring their feet. Everyone would look at them and marvel. No matter what all the women would say, protesting these heels weren't for them, *not at all*, they would still try them on, stepping into a different life for a few minutes. I was the chief encourager: 'Look at these, Aunty, look at this colour, it's like gold dust on your feet.' I was almost as good as Karim.

Nevertheless, every time I left on a shoe errand, Mum would always remind me sternly, 'And don't bring back any of the high heels! No one can walk in them.'

Mrs Buland Khan didn't buy any of the shoes I brought over from Karim's, but she did take a pair that Mr Khattak himself had selected. He knew what his God-fearing people wanted.

We all knew what the imam had said about high heels: he regularly proclaimed that those women who walked in them would have to pay for this crime in the hereafter. The noise the heels made, the attention they attracted, would push the wearer further into the fires of hell. The way these heels made a woman's hips sway meant they would endure even further punishment. One female imam warned my sisters, 'You will be judged on the day

of reckoning, how you have walked on this earth, and the earth will cry out, "You walked on me with shoes like daggers, you showed no mercy for me back then, why should I forgive you now?" The earth will say to God, "Throw them into the fires of hell!" No matter how you protest that you didn't know, the angels will come and pick you up and throw you into the eternal fires.'

But still I kept bringing back high heels.

Karim's shoe shop didn't last too long. Later I found out that his mother arranged for him to get married to a woman in Kashmir. I heard from one of his neighbours that he hand-picked her dowry and very carefully chose the wedding dress, jewellery and ornaments that were bought for his future wife. Mum sewed one or two suits for his mother for her trip back to Kashmir, and more gossip kept coming from one of Mum's regular customers, an aunty who lived across the road. Karim had got married in full splendour, on a white horse with a two-foot-high turban and a veil of jasmine flowers.

Soon after, he and his wife came to live with his parents in Birmingham. A while later at school, a story spread among the boys. One day, Karim's wife returned from an excursion with her mother-in-law to find her husband in bed with another man. Karim was wearing her clothes. She left and went to live with her cousins.

As for what became of Sam's salon, by the time I was old enough to visit him, his poodle and Busty Barbara for my

pop-star cut and hairspray, I heard frightening news from Farooq, who had turned up with a spanking new haircut. He warned everyone: 'If you go to Sam's you'll get AIDS – Sam has AIDS!'

Intrigued, on the way back from school one day I went past the salon, petrified of what I would find or what I might catch. His shop was closed and it wasn't long before the windows were shuttered for good.

Barbara moved on to Moseley Village, to one of the trendiest hairdresser's, where Farooq had just been. The staff were all dressed in black, and so cool. Everyone looked like Barbara – big perms, layers of make-up. I went in there for my first proper haircut, by skilled white hands. The lady behind the counter said I couldn't just wait, so she gave me an appointment; I was to come back and see Julie. I told myself that I should have asked for Barbara specifically; I could see her bent over someone's hair in the corner. Maybe next time.

19

THE LADY FROM LAHORE

WHAT REALLY MADE A WOMAN inhabit the 'modern' camp was embodied in Farzanah. She was the lady from Lahore, and had lived on Tindal Street since the first day she had arrived. Here in England, Farzanah wore a bright floral silk scarf to cover her mini chignon, tying it under her chin and letting the corners hang down over her chic camelhair coat that closed with large plastic buttons.

It was her handbag that really made her stand out, a black mock-crocodile lodged in the crook of her left arm, making her pose just like Mrs Thatcher's as she paraded up and down Tindal Street and Ladypool Road. Inspecting the vegetables displayed outside stores, she would nod to the shop-owners in approval, or greet a passer-by with casual yet restrained ease, all whilst exuding a highly patrician air. She was definitely local aristocracy.

Just like jelly, handbags were sacred objects that mesmerized me. To my mind they classified women as modern. Very few

women from our orthodox community carried them. These plastic and leather compartments were signifiers of memsahibs or freer white women and the decadent lifestyles associated with them. There were those that carried them, and those that slung them over a shoulder to keep their arms free as they walked. What did they carry inside them, that they grasped them so tight and close, and only put them down in front or firmly beside them? Guarding them, keeping them near, always sensing their presence. I'd look hungrily whenever Aunty Farzanah opened hers: the gold-plated clasp like a rich mouth revealed the two inner compartments. She kept her purse in one of these, which contained her notes on one side and her loose change on the other. This made so much more sense and was much more glamorous than Mum keeping her money tied in the corner of her scarf or in the pocket of her kameez.

Sometimes Farzanah would sway the bag from her hand elegantly as she left, before putting it around her elbow. Her husband, who had built a business smuggling money back to Pakistan in the *hawala* system, kept two houses, since he had also married a white woman, Linda, fathering three children with her and buying her a separate house on Edward Road, a five-minute walk from Farzanah's.

But despite her husband satisfying himself with the flesh of another woman — a white woman at that — Farzanah always kept herself together. Her hair was always immaculate, and Mum made her suits from some of the most expensive fabrics out of all her clients. Mum would nearly swoon over the fabric and I'd be transfixed and hop over to look.

'Sister Farzanah, how much is this a yard? *Where* did you get this from? Could you get one of these for me, with a scarf to match it? I will put it in Barak-Shah's dowry.'

Farzanah was definitely local nobility: she could read and write. She was the sophisticated one. Mum was as fascinated with Farzanah as Farzanah was with Mum. Mum admired how Farzanah knew the ways of the world, how she was able to open her front door, walk out and see everything without a veil to cover her face – without anyone to answer to. 'You make your own decisions. You city people are so clever,' she'd say to her. Farzanah in turn was captivated by Mum's talent, her ability to cut and shape a garment so quickly and precisely, to cook three dishes a day, and make everything seem effortless.

The Lady from Lahore would bring her small gifts – pieces of spare lace which Mum would then make into dresses for Ruksar and Marjan. Mum would warm her some hot turmeric milk and offer her anything else that she had cooked during the day.

What confused me was that in her absence the orthodox women expressed pity for this independent woman.

'Such a literate, smart woman . . .'

'Yet her husband has gone off and married a *white* woman.'

'He has no shame, and at his age, fathering three more children . . .'

Occasionally, as the gossip became really juicy, Mum would notice me. One day they began grilling Farzanah about Linda, her husband's other wife. Mum didn't spare me. 'Osman, go outside into the garden, or into the front room now.'

I got up, trying not to show my annoyance, dragging my feet

out as everyone watched me go. Once into the dark corridor I darted behind the dividing curtain. I had left the door ajar so I could hear better.

'But we are never good enough, a woman's life is never easy.'

'When you get old, they find a young one, they tell you you are sick and can't satisfy them.'

'What do they care? They will just marry another.'

'A man is still a man, even if he is a fool, a woman has no value, no matter how gifted or refined.'

Hooriya Jaan spoke in Pashto, her voice always the loudest. 'The old man remembers his youth and now pisses with his leg raised.' Someone translated it for Farzanah and everyone chuckled mischievously. I never knew what it meant in its entirety, but I still found it funny every time she said it – an old man pissing with his leg up in the air like a dog!

Hooriya Jaan carried on, asking what everyone wanted to ask: 'Have you *seen* her? What does the white woman look like?'

Farzanah answered coolly, with detachment. 'She looks red – red hair, red face, totally uncooked, she has no colour other than red, and her features are big and round, like a peasant's, and look, she is so much, much fatter than me. I don't know what gold or diamond he thinks he has found, because I can't see it. I'm telling you the truth: I can't!'

At this point the room erupted with laughter. Hidden behind the curtain, there was no one I could laugh with. I swayed side to side, trying to tune into the frequency and decipher what was being said. Sometimes the voices were clearer, and sometimes

not. Behind me was the door out onto the street. Eventually I got bored and walked out.

The following day the Lady from Lahore and Hooriya were back again. Mum brought in hot tea and madeleines that she had made that morning.

'Red lipstick is not for me, sister,' Lady Farzanah was saying. 'It is too garish. Pink is my favourite colour; I can wear red clothes but *never* red lipstick; pink lipstick is more sophisticated.' She was saying this to Hooriya Jaan. I held my breath. Even if she wasn't today, Hooriya Jaan would often wear red lipstick when she felt like making an effort on special occasions. She didn't say anything in reply, but her face had changed.

Another time, Aunty Farzanah turned up, immaculate as always, wearing her signature ice-pink lipstick. This time I heard everything she said to Mum; they were far too engrossed to notice me.

It seemed that Farzanah's husband spent less and less time at her house on Tindal Street, visiting her for lunch or dinner, eating her food – the food he loved and complimented her on – and then, fully gorged, wandering back to Edward Road to spend the night with his second wife and three young children.

I heard Farzanah saying proudly, 'You know, I'm happy that I don't have to look at that fat owl all the time.'[1] She added, 'Sometimes when he comes, I don't even cook more than one dish and he eats what he gets. Before he would have been sulking, with his cutting remarks. Thank you, Allah, I don't have to listen to that now. He is worse than a woman, now he can't say

[1] An owl is considered stupid in most south Asian cultures.

anything, he won't open his mouth. He knows if he did I would tell him where to go – that his new white-skinned wife can boil him some potatoes.'

Mum laughed at that for ages, with huge delights of giggles.

Farzanah's children had grown up and she had married them off, one by one, two daughters and two sons. Her youngest daughter would visit regularly, sometimes staying over, and I'd often see mother and daughter heading off in the daughter's Ford Cortina. In our community women never drove, so Farzanah and her daughter would cut a dash, two women driving around alone, independent, both with handbags – and to top it all, her daughter wore sunglasses, just like the stars in the movies.

Farzanah began to lose her cool over one thing and one thing only. It wasn't over her elder son, who was living in the land of the pure, in Saudi Arabia, 'close to God's house'. Dad had said to Mum how lucky her son was to be able to visit God's house whenever he wanted, and Mum repeated it to Farzanah. No, it was over her younger son, who had married an Indonesian woman whilst visiting his uncle in Jakarta, and was now living in her native land. During my summer holidays I became aware that Farzanah was obsessed. The couple had come for the summer and were thinking of moving back to live with Farzanah, who was preoccupied not with her son, but with this daughter-in-law. Soon, I was the same: she intrigued me and my ears pricked up whenever she was mentioned. I even crossed my legs, holding off going to the loo for ages so I didn't miss any detail.

'You know my new daughter-in-law?' She shook her head in disbelief. 'My son makes her tea. Can you believe it?' Farzanah

looked up to the heavens, holding her hands up, asking the Almighty to explain this conundrum.

She looked at Mum again. 'Palwashay Jaan, she lies in and gets up when she wants! He takes tea and toast upstairs to her.'

Mum asked, concerned, 'Is she unwell?' and we all wondered who this beautiful woman was, who was served tea in bed.

'No! She is the daughter of the rich. Her father's an Indian businessman who settled in Indonesia and knows my brother out there. Of course they are Muslim,' Farzanah added before anyone asked. 'And now she comes and reigns over Zulfiqar and me. He is such a soft, sweet-natured boy. *She* makes *him* run around for her. She sits in her room with cold cream on her face nearly every day. Of course you know I enjoy adorning myself, but this, this is too much. God has given her dark skin, I don't know why she puts all those creams onto make it white. She bathes in that Fair & Lovely cream.'

She rolled her eyes and took a deep breath, causing her to inflate for a second and seem to hover like a huge balloon above us.

'I'm getting old and yet I have to look after my daughter-in-law – do I massage her feet? It's *my* turn to have my feet massaged . . . What has happened to this world?'

My mum responded, 'The girls nowadays, they are not the same, and on top of that she is a rich girl. May God give you patience, Farzanah.'

I was desperate to go and check out this lazy glamour queen from Indonesia, who spent the morning in bed. For two weeks I pondered how I was going to see her. Farzanah was spending more time over at our house than her own, and she didn't have

any children my age who I could go round and say I wanted to hang out with. It was like a Rubik's cube working out the solution, and this new lady from Indonesia, this new bride, never came out.

On top of everything, Mum had already paid Farzanah a visit without me, upon the arrival of her daughter-in-law, giving the latter a gift of five pounds and kissing her newly wedded face.

I finally got my chance when Mum asked me to take some halwa round that she had cooked. I jumped up quicker than I had in my entire life.

Aunty Farzanah opened the door, and both the young husband, Zulfiqar, and young wife happened to be walking towards it on their way out. I entered with my halwa pot and Zulfiqar stopped to say hello and shook my hand. There *she* was. She looked down at me and smiled briefly. She was wearing a blue jacquard salwar kameez with matching scarf draped over her neck, a white crocheted cardigan, and to finish it off a handbag over her shoulder. Her black hair was open and loosely tied with a clip at the back. Even Farzanah covered her hair, and of course Mum and our orthodox women never showed their hair (never mind face) to anyone outside of their home. Aunty Farzanah's daughter-in-law wasn't 'fair and lovely' like the photos on the skin cream that she put on her face; she was much darker, and her face wasn't that of a queen, but Aunty Farzanah said she was rich.

The couple walked past me and closed the door behind them, and I gave the pot of halwa to Farzanah, who ushered me in, and then leant forward and put her hand into a red mock-croc handbag and gave me a ten-pence piece. This gleaming scarlet

patent bag with gold trimmings was resting on the side-table in the hallway. I wanted to touch it. I was entranced.

The imam regularly shouted from the highest step of the pulpit that those women who carried handbags, who emulated non-believers and immoral women and walked in a manner that produces temptation, would go to hell. This same imam, holding up his hand in case you hadn't heard him, also exclaimed that women who parted their hair to the side, 'with their heads like humps of the camel leaning to one side, these are women who are clothed, yet naked. They have gone astray and are leading others astray. They will languish in the fires of hell!'

Despite his warnings, it bothered me that Mum had no handbag. The following day, I went to the Community Centre's jumble sale searching for new books, and there I saw a handbag. Chocolate-brown patent leather! Its clasp and metal frame were admittedly not quite so shiny as Farzanah's, but maybe I could clean it up a bit. I opened its mouth, and inside it had two compartments. The dust had settled in the bottom creases, so I turned it over and tapped everything out. I spent my 10p and took it home, excited for Mum and Banafsha to use it. Mum looked at it and put it carefully away; later she put it in Barak-Shah's wedding trousseau.

Several weeks had elapsed when a knock came at the door and I went to greet whoever had come to visit. As I opened the door, Farzanah came rushing through, ushering in Linda! Her husband's English second wife!

'Palwashay! Sister Palwashay!' Aunty Farzanah shouted for Mum.

Sure enough, just as Farzanah had said, everything about Linda

was large: her figure a huge sack of potatoes, her face a big, round, pale moon, her fringed curly red hair, her big blue eyes, her round, fleshy nose. Her lips, in contrast, were very narrow.

She moved slowly, and Aunty Farzanah, who was familiar with our house, tried to close the door with me still standing there. She guided Linda forward. I kept looking, my eyes transfixed and too many questions popping in my head. Why had Linda come to our home? What had happened?

Aunty hadn't brought her in to be displayed but with the sole mission of having a salwar kameez made for her. The gods were on her side: our house wasn't busy, not one customer had visited yet that day.

Farzanah had brought one of her kameez so Mum could measure it against Linda. Linda tried to slip it over her dress, but it didn't move past her neck. Farzanah smiled. Mum looked at Farzanah: 'It's not going fit.'

She brought out another kameez that she had made for her larger clients and which Linda tried on, her folds of fat rolling into it. Mum didn't measure, she did everything with a hand-span and her eyes. Now she looked Linda up and down, saying that she would make her dress half a hand-span bigger than this one. Mum was saying to Aunty Farzanah, 'If you're large, it's best to wear something not too tight. I'm going to cut it so it's a good flowing fit.'

Mum made the suit, and Farzanah picked it up and paid for it. There was the same dance of not taking money, but finally Mum did.

The next time I saw Linda was at the funeral of her and

Farzanah's husband. He had died in bed a few months after Linda's visit and Linda had frantically phoned Farzanah straight away. She told Mum later, 'It was the night of the full moon.' Linda had woken up next to him to find he was as cold as ice. The mosque subcommittee (known as the 'Death Committee') had turned up as soon as Farzanah informed them. This was a man who had helped the community. His transgression of taking on Linda wasn't going to stop the community rallying around and helping him get a proper Muslim burial.

The huge coffin wouldn't fit through Aunty Farzanah's front door and corridor, so it was lifted out of the hearse and sat in their front garden under the shade of a rose tree. Around one side of the coffin was Farzanah, her children and family, and the many friends and relatives visiting to comfort them (some of our women had come, taking a quick look at the deceased's face, paying their respects, and then heading inside the house to a segregated space to read prayers). In a corner with her three children, discreetly distanced from the coffin, was Linda wearing the suit Mum had made for her, with no one to talk to.

The lobbying to avoid a post-mortem began. No one wanted to cut up the dead, take out their organs, weigh and then put them back in, and then embalm it. And then the big question: where was he going to be buried?

Farzanah told the Death Committee he should be buried here in England. 'This is where his children are,' she stated.

There was no swaying her; she wasn't from our community so she could not and would not submit to the men of the Death Committee. She spoke herself, and not through her sons: everyone

listened. So after lying in state in his front garden, perfumed by the rose tree, Aunty Farzanah's and Linda's husband was taken off by the men to be buried in the Muslim cemetery.

It was around this time that the life I knew as an active participant in the world of the women was cut short. My existence there became taboo. The walls had grown taller, and the curtains thicker, and I couldn't peer over or around. Mum noticed I was getting older. I was nearly twelve. Time for me, as a young man, to stop hanging around the women in her salon, time for me to stop visiting them with Mum, time for me to stop playing with my sisters.

I had been ejected from where the joy and the colour came from. Now I would have to peer from behind the curtain and see who was around before I could go in. This light-violet damask curtain divided manliness on one side from the concealed colours of femininity on the other. The women's world was only a few feet away yet was no longer a space I could walk through with much ease. I was allowed near Mum, near close family and very close family friends, but it was never the same. Even if Hooriya Jaan was in the salon, Mum's best friend who had bathed me as a toddler and changed my nappies, I couldn't go in and speak or laugh with her if there were other women around. I had come of age, the worlds became segregated, and I could only reminisce as the distance between the male and female worlds grew bigger and bigger.

20

GIRLS DON'T GO TO SCHOOL

I DON'T REMEMBER WHEN I BEGAN to fully register the unspoken tragedy inside our homes, inside my very own home. Perhaps never, not while I lived in it.

As a twelve-year-old boy I was able to open the door and walk out, just like Dad and Barak-Shah, down the road to the mosque or shops; to have friends who would push the bell and announce themselves throughout the house. I could open the door to them and step outside into the fresh air and hang out on the wall of the front yard to watch people go past whenever I fancied. The only world forbidden to me now was among the cloistered world of the women. Above all, I could go to school.

For girls like my sisters, those born in England to our traditional immigrant community, born of righteous marriages in which the parents hadn't seen each other but accepted one another three times in a ritualized marriage contract according to Sharia law, for them, once they 'came of age' (one of our

euphemisms for the first trace of puberty) the world itself became forbidden.

As an entitled being by virtue of my gender, it didn't strike me as odd that there came a time in their very young lives when our girls just didn't go to school.

There came a time when no one came to ask for Banafsha, Ruksar or Marjan to play, no bell rang for them announcing their friends, beckoning them out onto the streets to run off, pigtails flying.

In fact, it came before their 'time', when they were eight or nine, at primary school, in which modesty was to be fiercely observed. They were withdrawn from swimming lessons and I would see the girls in my year whiling away the period in the spectators' gallery, heads covered like miniature nuns, overlooking the bright blue water. Those chlorine waters would never touch their bodies, no one would see these pre-pubescent lilies in their bathing suits. Above all else, they were to be protected.

Not long after, as they came of age, the girls, my sisters among them, were effectively vanished from life, illegally disappeared.

Banafsha, my older sister, came running in one day after visiting her friend Zarsangha, whose coming of age had happened before hers. It turned out that the local council had come round to ask the family about Zarsangha's whereabouts and the reason she wasn't turning up at school. Zarsangha's mum had acted fast and quickly hidden both girls in the cellar as they'd knocked on the door. She firmly declared that there was no one in the house, that her daughter was abroad with family and receiving education there. In the dark musty cellar, Banafsha's heart pounded loudly.

It was her turn next.

Being two years younger than her, I failed to notice her misery. She accepted her lot but she had it worst of all, leaving school at the age of ten to sit in purdah, her footsteps and chalk marks of hopscotch, the traces of her former play-life on our streets, eventually washed away by the Balsall Heath drizzle.

This was her new life, the only life she could prepare for: the moulding of her being into a dutiful daughter-in-law and wife. Now she walked seldom in those familiar streets, and even then, only through the pitch-black veiled prism of her burqa. I didn't stop to imagine properly what it was like for a child, just like myself, to leave covered and return covered in the dark shade of perpetual night.

Her coming of age into purdah coincided with Mum's despair, so while I still fretted about jelly being *haram*, Banafsha became the surrogate mother to us all, cooking, bringing us up. Marjan, especially, would always be hanging off her. In Mum's better moments she would teach Banafsha how to cook (the way to a husband's heart and your husband's family's heart being through their stomachs). To this day Banafsha cannot speak properly of that time.

Very few of us questioned the girls' sudden retreat from daily life. Not many in our community sent their girls to secondary school back then. When I arrived at Queensbridge secondary and saw girls from less orthodox Muslim communities sitting in the same classrooms as boys all the way through their teens, it began to dawn on me that not all communities treated their daughters that way.

This route was unthinkable for our community. A minor rebellion of isolated incidents had begun among Banafsha's British-born generation and terrifying rumours reached us of girls who'd dared to strike out and run away; girls that had been to school, and who now had brought lifelong shame onto their family, and through their actions were destined for hell.

It was thought there was no need for education. A girl would go on to enjoy the protection of her husband, the provider, the love of her father, the indulgence of her uncle, and her brother defending her honour. In any case, none of their mothers nor their fathers were educated. Why should their parents send them to schools that had a different value system, where boys and girls mixed freely, or to same-sex schools, where boys swarmed for prey outside the gates after school? Furthermore, they had no idea or understanding of what was being taught to them . . . God forbid.

An educated woman was unthinkable: she would not do the bidding of her husband; she would be difficult; she would meet someone else and make decisions about her future. And this was where honour became violent, and in extreme circumstances the righteous father would be forced to kill her, kill her mother, kill himself even to keep their family's honour intact. It went without saying.

All our parents continued cashing in the weekly government child-support benefit while these small girls were hidden out of sight, removed from daily life, even sent abroad. These precious jewels would go into hiding, or fake being sent abroad for a few months to start the subterfuge. We even forged airline tickets as evidence, for when the local council came knocking.

Everyone played a cat-and-mouse game with the authorities, the wagmen and others, trotting out their usual, predictable excuses, baffling the local officials by hiding behind the archaic strictures of our culture. It was all part of the game-plan, to keep the righteous young girls' honour intact, away from corrupting influences: no boys, no male teachers, no streets, no shops, no doctors, no lessons.

No air. Neither outside nor inside, behind the burqa or in the house, where the curtains remained firmly drawn for fear of the gaze of onlookers.

Next it was Ruksar's turn to disappear. By then I was at secondary school myself. Did I notice, even then? As a girl, Ruksar had liked to wander and roam. She'd run off to buy cigarettes for Barak-Shah in exchange for sweets and crisps, she played late into the night, carefree and semi-feral. She became a detective after the murder on our street, and happily spoke to the police in their temporary cabin at the top of the road. Her group of friends informed their parents of a strange man who sat in his car on our street and played with himself. They found him and beat him up. He never came back again. When Dad had thrown my rabbits over the fence because they were eating what he had planted, Ruksar had joined me excitedly on expeditions to track them down along the railway line. After that, she was brave enough to wander the railway lines as well as the streets, leading Marjan and her group of friends.

A day came when one of Dad's relatives, another uncle, was visiting; his eyes snagged on Ruksar, beadily looking her up and down. Later, as if in passing, with soft casualness he said to Mum,

'Sister, your daughter has come of age. You should take her out of primary school.'

Mum mentioned it to Dad that very afternoon after prayers, that it had been noticed that Ruksar had 'become older'. And so it was decided that, as Ruksar had blossomed and matured very quickly, they couldn't wait until the summer break.

She was ten.

Several weeks before the Christmas break, several months before her eleventh birthday and seven months before the end of her last year in primary school, Ruksar was told to tell her teacher that 'unfortunately' our grandmother back in the Frontier was very unwell and she had to go and visit her.

My parents deliberated over this, finally satisfied they could be excused for the explanation, since there was no risk of bringing on anyone's death with this particular ruse – our grandmother having died a few years earlier.

Days went by and Dad would ask Ruksar, 'Did you tell them?' No she hadn't; she was running out of excuses for not telling her teacher. She walked to school every day, thinking it could be her last – to walk down this road, to meet her friends freely, to run on the grass freely.

Dad kept asking her and eventually, near the very end of term, she told the teacher.

So, as with Banafsha:

She stopped going out and sat at home.

If she was ill, the doctor had to come to the house.

She could not be inoculated.

She could no longer answer the door.

She was only allowed to bathe once a week.

She could not cut her hair or experiment with make-up.

She could only plait her hair with a straight parting.

She could only wear loose-fitting clothes, a miniature burqa soon being fashioned for her.

She could no longer see her friends unchaperoned, just in case their brothers were around. In turn, her friends' parents restricted visits, as she too had grown brothers at home.

Barak-Shah showed his displeasure when he first saw her sitting at home.

'Why isn't she going to school?'

Mum began her spiel: 'Everyone will talk. Look, your uncle is already talking about how she is maturing so quickly. We need to hide them, no one should be able to utter a word about your sisters; his own daughters are already sitting at home.'

Barak-Shah relented.

Ruksar now learned to cook, clean, sew, knit and embroider and excelled at them all. On the very rare occasions she went out, it was never without that dark burqa covering her childish frame.

Yet God had given Ruksar a tongue, and she knew how to use it. She rebelled. She would answer back, and whilst Mum tried moulding her into a dutiful daughter and potential daughter-in-law, their relationship was combative. Mum thought that she was leading Marjan astray. She complained to Dad: 'Ruksar may be the clever and beautiful one, but she has the devil inside her.'

Mum, as many mums do, went on to take much of the blame in later years for not taking pity on her daughters, but she was

just enforcing the same rules that had been forced on her. When she herself was awaiting her betrothal back in her village, and then when she was newly married, she couldn't leave the house unaccompanied – and never in the middle of the day, only stepping out in the dim light of the setting sun, and of course always chaperoned.

I didn't see any devil inside Ruksar and was old enough by then to feel pity if not yet indignation. I had begun to acquire a new role: leading my covered, cloistered sisters through the streets of our ghetto, to their language classes of Pashto and Urdu in a land that didn't speak Pashto or Urdu. I would lead a few steps ahead or on occasion stay by their side as they took steps into their proscribed new life.

I began to consider the burqas in detail when I realised that I never saw (nor have ever seen) a cloaked ninja go out into the rain with an umbrella – because raising their hand to hold it would expose their shape, or draw attention to them. One canopy over another. The shape of the burqa, I realised, was made to obliterate form and outline: from the mound that is the top of the head, it drapes over the shoulders, cascading into a loose robe to the ankles, concealing everything.

Burqas may all seem the same to outsiders but there are different styles. Mum came to England wearing a shuttlecock burqa. Out of practicality, she replaced it with a two-piece city-style burqa worn in any big metropolis of the subcontinent. It was easier to handle. Mum would always be covered by her black burqa, first the coat with its large buttons, and then the cape draped over her head like a mantilla, with two ties that went under the chin

and tied tightly in place. From the edge of the cape dropped a face veil, which could be lifted up and down to conceal the wearer, just like a wedding veil, but all in black. It was these burqas in miniature that Mum sewed first for Banafsha, then Ruksar and then Marjan as they began sitting in purdah.

Marjan's turn came when she had finished her last full year at primary school, turning eleven. It was her final summer of freedom before adolescence, but at the time she wasn't concerned, she was prepared, having experienced her two elder sisters going through it. Some of her schoolfriends were also going through the same process; she took it with pragmatism as the 'done' thing; the damage would only appear a few years later. Marjan had a story ready for the teachers – of where exactly she was going abroad. She had even carried on the ruse of going to the induction day at her chosen girls' secondary school, where she had her first and only French lesson. And so, along with Banafsha and Ruksar:

She began the day being woken up at five or six in the morning to come down and start cleaning and cooking.

She was no longer allowed to sit or play in the room when guests came, but was being prepared as the dutiful daughter in the kitchen, serving tea and savouries, coming in and out quickly, with no loitering.

She made sure she was never in the toilet if Dad or her brothers needed to use it.

She learned that once the men came home, especially Dad, she had to be at the door to greet them and take the shopping from them.

She learned to listen out for Dad arriving home unobserved and that loud bang and the shout, 'Am I supposed to make my own tea and dinner?'

The only reprieve was the equivalent of the courtyards: the back gardens. These were predominantly the women's quarters. The houses their mothers had grown up in opened into sunny courtyards, fortified with walls. Here there were grey back gardens with washing-lines, and they could go out and take the air. But for Marjan and Ruksar this would be short-lived. Once we moved up in the world, to a more salubrious suburb, and acquired white next-door neighbours, even this was discouraged.

I must have felt the need to do something, to include them in my world, so my sisters became my library group. Every new book, legally or illegally acquired, was first devoured by me and then handed over to them to read in turn. From the neighbourhood centre, I also came back with spoils of faded glamour for them: old copies of *Just Seventeen*, along with those empty bottles of perfume and pots of dried-out old make-up. Banafsha would gather them up and try for ages to extract the perfume from the bottles. All of this remained hidden from Mum and Dad.

Marjan wasn't very good at sewing and knitting. She was the sous-chef, tidying, chopping, prepping and cleaning up after everyone's cooking mess. What I didn't know then was that she missed her friends. Occasionally Imama, Shezadi and their mum used to pop over, but it was never consistent.

Years later she told me that when her period started she went to the bathroom and stared at the blood in shock. She knew nothing about any of it. Mum had never discussed it with her.

She fetched Mum, who taught her what to do, how to use rags, as the women from our orthodox community didn't buy sanitary towels from the shop. These would later be soaked in the large yellow Khyber Ghee tub and then washed out, hidden and discreetly hung to dry under more conventional washing. Opening the door to the cellar, I would often look quickly at the ominously covered ghee bucket, its bright yellow exterior. Never quite knowing what it was but knowing that inside lurked a dark, murky secret that no one would explain to me.

It was only during Marjan's periods that she was allowed to wear underwear. Banafsha, older and married by now, had to fight with Mum to get Marjan a bra. Mum said, 'You want to hoist them up for your dad and brothers to see? Have you no *sharam* [shame]?'

One day someone knocked on the door asking to speak to Mum or Dad. Mum came to the door. There were two of them and it became perilous when one of them began communicating with Mum in a language she could understand, so she couldn't hide behind the usual incomprehension.

'You don't send your children, your daughters, to school,' said the woman.

'All my girls are abroad,' replied Mum.

Just at that point, Mum was saved by confusion. A neighbour's daughter headed for the door from our kitchen. She'd come round to sell vegetables. The investigators, or social services, became suspicious and quizzed the girl, asking her where she lived. When they established the girl's identity, they left in embarrassed confusion. Proud of herself, Mum said to Dad later,

cackling with laughter, 'This little twelve-year-old walked past them and out of the house and they couldn't tell who was who.'

This was an unspoken mystery and shame in the British education system: girls like my sisters. Everyone knew that these girls would go missing straight after primary school; it was happening under the local authorities' noses, but nothing was done. The problem continued well into the mid-nineties, along with some girls going to secondary school and then disappearing. There didn't seem to be any active undertaking by local government to get to the bottom of it, though there must have been numbers to call – but even if they knew about them, the girls had been conditioned to think differently, too scared to call for fear of the consequences.

Each of my sisters would go on to different lives. Banafsha married at seventeen and her husband left her with three children and the inability to support herself properly; she still can't write, spell or read fully.

Ruksar's journey was complicated and more openly rebellious.

Marjan married soon after Ruksar rebelled, to save the family honour.

Ruksar's awakening came about when Barak-Shah got married to his second wife, Nadiya. When his first marriage ended it broke my dad's family in two, causing a ruction with his brothers and a feud which will survive several generations. This second marriage was untraditional from the start. Even the wedding

ceremony was alien to our ways, with trappings of Bollywood from head to toe, but Barak-Shah was leaving his old ways, and he wanted a modern wife.

Ruksar and Marjan saw the life of their sister-in-law, Nadiya, her coming and going as she pleased, driving, going to concerts, shopping for clothes herself, wearing make-up, having friends round, whilst they stayed at home and babysat their new nieces. They watched her go in and out of the front door freely, and without knowing it Nadiya left a door ajar for them.

21

MINCE PIES, PORN MAGS, AND DAYTIME DISCOS

I WAS FOURTEEN OR FIFTEEN NOW, and Year 10 saw us introduced to Home Economics & Personal Education, a strange concoction of life skills which made us boys giggle as we put on aprons and weighed flour on intriguing contraptions I had only ever seen in home-shopping catalogues or used by shopkeepers. The scales' precision intrigued me – I was never precise – and the fact that 250g of flour was only and always 250g of flour, and couldn't be anything else, gave me something to think about. Mum never used scales. She cooked by eye and hand. She never needed to know how many cups of water to how many cups of flour; she just knew, feeling her way instinctively around her ingredients.

Every Thursday afternoon these domestic crafts were drilled into us. Occasionally the class involved spending time in front of sewing machines, to which I needed no introduction: making

pincushions came easy, but the cooking I found less straightforward. We made pancakes for Shrove Tuesday, which I could have eaten every day, just like jelly, but however much I loved the pancakes, I could never replicate the exact consistency of the batter at home. Nevertheless, week in and week out, I returned home with the new skills that I had learned and shared them with my sisters, who were now restricted to learning any new life skills at home.

In the first term, Miss Jones handed out a list of ingredients that we needed to bring with us for the following week to make mince pieces. She talked us through the list:

500g jar of sweet mincemeat
350g plain flour
150g butter
zest of 1 lemon
icing sugar
2 apples
2 large eggs

She informed us that all these ingredients were available at the supermarket in the village.

I puzzled over the ingredients: a 500g jar of sweet mincemeat – where was I going to get a halal version? I supposed maybe the English kept their mincemeat in jam jars, but at our local shop Ali Khan's handwritten sign on cardboard advertised mince-meat at 50p per pound and it would always come weighed and wrapped in newspaper. Maybe you mixed in the icing sugar to make it sweet?

I had been to this large supermarket in the village only once before, to buy bleach, so it felt momentously different as I wandered through the aisles searching for the ingredients from my list. This felt so much more than just a shopping trip: it was an initiation ceremony, an entry into a new world and its secret codes, as if searching for lemon zest in itself was a sign of my readiness and they would nod their heads at me, that I might be invited and accepted into their world.

Cream Cakes and Mince Pies were part of a symbolic language I needed to learn to allow me to traverse into a white world, to their parties, their songs, their fair skin, their light eyes and their long blonde hair. Into the glitzy world of pop stars, the mixing and mingling of sexes, boyfriends and girlfriends. I kept wandering around, through the endless aisles, certain that on those shelves was the key to being white, the key to not being a 'Paki'. I held my very white list from Miss Jones with a steely purpose – to make the food of the white folk, the food they enjoyed at Christmas, the food that was advertised.

I recalled Dad often saying, 'All white people do at Christmas is get drunk and get into fights,' and he would chuckle and say that they didn't even know that Jesus wasn't crucified on a cross, that God had taken him up to heaven next to him; the Romans had crucified the wrong man. 'Look at them crying over the wrong person. God wouldn't have let that happen, they have got their story all wrong, and mixed up.' This would make him chuckle even more. 'Big mistake.' Like the Jews also, he said. All of them had changed their texts, their holy books, and did not know what the truth was, and that was why Allah had sent

another prophet, the last prophet, to bring everyone back to the fold and onto the righteous path.

Whatever Dad said, however, these white folks were the masters of my parents, and I wanted to be part of their world, as good as them. I was born here so I had a right as much as anyone to be a part of their Christmases, with the baby Jesus in the manger and all the presents – so many presents! We only got money at the end of Ramadan or on our Eids.

On top of this, the white folks had their Halloweens, and bonfires and those fantastic fireworks, and their Easters, with Easter eggs, and before that the pancakes – and those birthdays! We never celebrated birthdays. Dad said the imam had told him that celebrating a birthday was the mark of the infidel, and that those who copy the infidel will be tossed into the fires of hell, and that the fires of hell were nothing like the bonfires that we had on earth: they were apocalyptically hot.

In fact, it was worse than that. Come our birthdays, Dad would regard us seriously and say, 'These people don't know what they are doing, they celebrate a year closer to their death and they get happy. They are stupid! Why would you want to celebrate a year that is closer to your death?' And then he would look at us sternly, very pleased indeed with his own logic.

Anyway, Dad wasn't there next to me to protect and guide me away from the world of white food, so I kept wandering deeper into the aisle of baking and confectionery goods, past the almond flakes, past the fine, desiccated coconut and different flours, from plain to self-raising. Next to them was lemon juice in the shape of a lemon – Miss Jones had one of these. I marvelled

at all the dried fruit and fine orange peels, the glacé cherries in different colours, cupcake mixes and food colouring, the tins of golden syrup and treacle. There was granulated sugar, caster sugar and icing sugar, which had a big promotion sign on it. The store had probably bought too much, or perhaps the sell-by date was getting close and they were getting rid of it. Mum always made me double-check the date of products from Khan's – once when I was buying it and then again when I arrived home, so she knew which one to use first.

I grew dizzy. There were far too many items on the shelves: I knew the people in this area were richer than those in Balsall Heath, because unlike Mr Khan's shelves, which were neat and had just enough of each product, these were packed deep. Even the counter at F. Allen's, before it closed down, had just a few 'sweet' ingredients for making delicious cakes and desserts.

I stood before the multiple rows of jam and marmalade by Robertson's, with gollywogs on the label, admiring the Royal Warrant given to them by King Edward VII. They still used the gollywog image until 2002, even though everyone knew it was racist.

I picked up a pack of this strange sugar – icing sugar. Mum was bound to inspect it, looking carefully at the packaging. She would memorize the colours on packages and any symbols or emblems, study their fronts and backs, examine the size of lettering and packaging of the brands that she liked, and those that had performed well for her. If you brought home anything else instead, you were reprimanded, and then you would have to take it back. This was the same with all her branded goods

– Vim household cleaner, Zoflora disinfectant, McDougalls self-raising flour, Daz washing powder. She refused to use any others.

I wasn't going to let her open this packet of icing sugar, however, as I wanted it totally pristine when I opened it in my class at school.

In the baking and confectionary aisle, I asked for mincemeat and the shop attendant sent me to the meat counter. There confronting me were all these strings of sausages, everything *haram* and full of P-I-G. I stood there, pondering the dilemma.

This was a line I wasn't going to cross.

I decided to get the minced meat from Khan's. It would not be brought to class in a jar the way Miss Jones had requested in her list; maybe she would tell me how to make it sweet. Khan's would wrap it in last week's newspaper but I could get away with that. I'd ask Mum if she had a jar I could put it in.

After I bought my pound of minced lamb from Khan's, neatly wrapped and sealed with Scotch tape in old newspaper, I took it home and Mum put it in the fridge, and then it was time for mosque, where all I could think of was the excitement of making those mince pies the next day. My upside-down pineapple cake had been a success at home; everyone said I had made it really well, moist and sweet.

Other than the sugar and mincemeat, Mum had the rest of the ingredients I needed at home: the plain flour that she used to make luchi – deep-fried chapattis – and eggs. I made a small egg carton by cutting a larger one up to transport the two large eggs and the two apples.

The class was in the afternoon; I had to get through the rest

of the morning. The hour finally arrived, and I unwrapped my ingredients, putting them in front of me, eager to start. I looked around excitedly at the ingredients all the other students had brought, only to find to my embarrassment that my mincemeat wasn't what they had: not because it was halal but the mincemeat the white people used for their Christmas tarts was something else! Jar after jar was sitting on the table-tops and I had turned up with minced lamb wrapped in newspaper!

Miss Jones looked perplexed and tried to explain what mincemeat was, that it was sweet. Eventually she gave me some of hers, which resulted in a small batch of mince pies, around six, to take home.

I took the minced lamb home to Mum, and she turned it into kebabs. She asked me why I hadn't used it and I mumbled something. They liked my mince pies back home, but I was mortified. I'd failed the White Cooking Test, the passport into white privilege. Not only was mincemeat not minced meat, but this deficiency in my language, the language of the country of my birth, made me as much of a 'Paki' as Mum and Dad. Even all the other Asian kids had brought in jars of sweetmeat: they had passed.

By the summer term, I had managed to get over my minced-meat humiliation. More exciting things were in store. The last term of the year covered Personal Education, which involved listening to and watching comical demonstrations such as Ms

Rivers unrolling condom after condom to show us how to use them. Having warned us sternly of the perils of teenage pregnancy and sexually transmitted diseases, it was hard to tell which she thought was worse.

Dad and Mum would have been horrified by this unrolling of condoms – on a dildo too! – for here was what the imam had warned us of: the abundance of sin was so apparent that the end of the world, the days of judgement, were surely near.

One day, as we were making yet more pincushions in domestic crafts class, Akbar casually took his willy out. It was small and surrounded by a bush of hair. It didn't look very erect, and he was holding it with both his thumbs and index fingers. He kept looking up and into the classroom and then gazing down at it, as if it were a precious revelation that he wouldn't normally put on display, but was sharing now with the back row. I looked over, wondering at his thick pubic hair, and thought about one of Mum's 'talks'. It wasn't Dad but Mum who had sat me down and told me that I needed to keep myself clean, and to shave my pubes and armpit hairs now that they had started growing, following the Abrahamic traditions like a good Muslim man should.

Anita, who sat at the end next to the window, rocked on her chair, back and forth, and suddenly noticed Akbar's exposure. She shot straight up, hand raised, and started walking to the front of the class. 'Miss, Miss . . . Akbar is showing us his private parts!'

Miss Jones ignored her and told her blandly to go and sit down. Akbar quickly lost his wide grin, pulled up his trouser zip and laid both his incriminating hands on the table in full

view. We carried on with the pincushions. I was still in shock, and thought the worst: maybe he had trapped his tiny willy as he hurried to zip his pants, or a stray pin had managed to get into them. But Akbar didn't look in pain.

My eyes wandered to the front of the class, where Anam, an oblivious look in her big eyes, was hugging a large silver frame. She was Kashmiri, one of the prettiest girls at school, her thick hair cut into bangs and parted at the centre. She had turned up that morning carrying a photograph in that silver frame, declaring to everyone that she was going to get married to the man in the photograph.

That night, I dreamed of Anam, her long hair fanning out, her hands cradling the silver frame which was facing me, the big moustache and oiled, side-parted hair of her husband-to-be in the black-and-white photo staring directly at me as Anam began to rise up in full colour, like a Botticelli Venus, her open, wavy hair catching sexily in the breeze. Yet still she held her black-and-white fiancé-in-a-frame.

The wetness in my pyjamas stirred my sleep, as I felt with my hands the most plentiful automatic ejection that I'd ever experienced. Sleep eventually took over and I woke in the morning to a hard, dry cake of evidence of my sinful thoughts.

The next day, Mum checked to see if my night clothes needed washing. Mum loved washing, and today's inspection revealed the large powdery stains. She was waiting for me after school: she sat me down in the front room very calmly for another 'talk'.

'When you are unclean you must wash, you must have a bath straight away, and say your prayers, and also you must pray to

keep unclean thoughts out of your head, and be cleansed – oh, and remember to shave all that unclean hair, I've told you already!'

I wondered how I was going to get away with it. Having a bath in the middle of the night, washing myself without the whole household knowing what I'd been up to . . .

As summer came, and the months grew hotter, other kinds of temperatures began to rise. Farooq said that he had wanked so much, expelling litres of juices the previous night, that his eyes were going funny. He said he had wanked *thirty* times. I had no idea you could wank that much without hurting yourself.

I understood his addiction, but every time the guilt was almost too much for me. The devil had entered the room, so after the act I had to go to the bathroom quietly and wash myself (without running a bath) and go back to prostrate myself, asking God to rid me of these thoughts. As I attended to my answerability in the hereafter and tried to avoid the hell-fires, I was simultaneously considering my own inadequacies. I didn't manage to come thirty times in a day!

As I progressed through secondary school, my mosque attendance continued, making up the bulk of my home learning. I had memorized six chapters of the Koran, and since the age of six or seven, each day after school I would come home, change my clothes, put on my long shirt and baggy pants, cover my head with my skullcap, and walk up towards the mosque, ready to study the book of God.

Occasionally, after evening prayers, there was a surprise, and we would have a visiting speaker from the Tablighi Jamaat to

deliver a special sermon and my home-time would be extended by another hour. We had no choice but to sit in the congregation, filling it out, so word could get out that the people of Balsall Heath listened to the word of God. That we got together when the call of God came. That we were virtuous people. These sermons were always about personal behaviour, how to stand out as exemplary models of humanity, urging us again and again to prostrate ourselves and to return to the true practice of Islam. Prophet Ibrahim played a vital role as someone we should emulate. Just before the Eid of sacrifice, after the pilgrimage of Hajj, the visiting imam stood in front of us and said: 'This is the test from God: if we are able to make a sacrifice it is one of the Commandments of God. This was the sacrifice, of Ibrahim, of his young child Ismail. Imagine if you had been asked to do this . . .' Here the imam pointed a finger at his congregation: 'And you, and you.' And one in my direction.

Imagine if God had asked you to carry out such a sacrifice. But Ibrahim was no ordinary man, this is one of the prophets of our Lord. He had been given many tests from God, he had left his family, and he had left his tribe. He was made to leave his wife and child in a barren land, without food or water.

Look at us, we are so lazy, we don't even pray at night. We do not go towards our Maker; we do not exalt our Maker. We are sinful, we are ungrateful. The tests from our Lord are here for your preparations for the hereafter. How would you react, how would you feel?

Meanwhile, at school assemblies the songs of the Christians roared from my chest – 'Kum Ba Yah', 'Morning Has Broken', 'O When the Saints Go Marching In', 'He's Got the Whole World in His Hands' – and I participated in these school activities and abundant harvest thanksgiving festivals – all rituals that I couldn't mention at home, that wouldn't be understood. I would be accused of heresy. Why did our schoolteachers, and white people, assemble cans of food, grass and grains of wheat along with piles of perishables, and then sing songs to it?

Gradually, the righteous parents became aware of our early morning acts, and began to demand secular assemblies, as they did not want to confuse their children with the ways of Christ, especially as his followers had got his story all mixed up. By the last year of school there was no bellowing out a song to start the morning. Singing had stopped for all the kids.

Five of us sat next to each other throughout that time, starting with Mrs Plant's class in Year 10: Lloyd, Farooq, Jasbir and Arjan. Lloyd was Black and wore glasses. His accent was regional, but with very plummy undertones. He lived on the seventeenth floor of a block of flats. Mum never liked flats: she said you were suspended in the air with no ground to walk on. Farooq was Kashmiri and one of the class jokers. He lived near Cheddar Road, where the prostitutes sat in the windows. Jasbir was Sikh and the swot out of us all. Arjan was Hindu and was my best friend throughout this time: we had a solid, quiet, strong bond and we were the same height.

We were all rebelling in our own different ways. Lloyd was good at commanding our audience of four. He was like a very

British version of Carlton Banks, the posh one from *The Fresh Prince of Bel Air*, though Lloyd was skinnier. One day he announced very solemnly, in his partly proper accent, that his brother Adam had been with a prostitute and 'she gave him THE CRABS'. He went on, describing the symptoms in detail. 'He says it hurt, *man*, so much. The crabs bit him so much that his scrotum became the size of a tennis ball! He was in agony for days . . . days, bro! The doctors tried to cure him but Adam said the nurses wouldn't come near him. At the hospital, they administered injections, but they would only do it from afar, throwing it at him. Taking aim from the edge of the room straight into his buttock — like a dart!'

This sounded horrific. Satan's temptations and God's punishments were reminder enough not to get your bits and pieces near anyone! Better off tucking them away safely in your pants.

Jasbir was the intelligent one. His mother would comb his thick hair every day and tie it up into a topknot with a handkerchief. She had obviously decided that she needed at least one child with long hair, adhering to the gurus' teachings, since both his dad and older brother didn't sport turbans. Jasbir *hated* it. Like me, he would rarely go into town. I wasn't allowed, and Jasbir wanted to *hide*. He would only go for his new school uniform once a year. That topknot sitting on his head defined who he was. It was his identity. That summer between Years 10 and 11, he went to the seaside for his family holidays, partly looking forward to them yet partly dreading them, all because of that heavy topknot. I had been envious of his holiday — sitting on the beach, looking at the open sea, its vastness, eating ice

cream every day. In our community such holidays didn't exist, or were deemed a foolish waste of money that led you closer to the devil than to God.

That was it for Jasbir. Wearing that topknot on the beach was the final straw and after a few days of ice cream, his mind had been made up. He asked his brother to cut his hair off at the lodging house, then gave it to his mother. Jasbir said she didn't mind. He turned up at school without it and I couldn't stop looking at this different Jas.

Most of us Black and brown kids were in Class O, and only Class R read Shakespeare. It was also in Class R where *Romeo and Juliet* played out in actuality. This was the love between Leroy and Elizabeth. Leroy's skin was luminous, not like mine. My shiny face came from the occasional bit of hair oil that dripped down to feed it. Leroy was mixed-race, or 'half-caste' as everyone called the offspring of all cross-racial unions back then. Everyone watched him affectionately – the girls, the boys, the teachers, the way he walked, not so tall and not so short. He was the perfect shade of everything. His Black father and white mother had given him green eyes, milky skin and tight curly hair that he would braid sometimes and sometimes set free. He had been selected for Class R from the start, and firmly established himself in this anointed class of predominantly white children. Being mixed-race was the coolest thing. All the girls wanted mixed-race babies, and Leroy and Elizabeth's coupling was the envy of the whole year. Of course, as Juliet in this story, Elizabeth lived in one of the big houses near the private park. In Class O's English lessons we read S.E. Hinton's *The Outsiders*,

playing out our real lives of 'greasers' and 'socs'. Elizabeth was a soc, with 'an attitude longer than a limousine', and we were greasers, always living on the wrong side of the tracks.

One of our English teachers, Mrs Smith, announced in class that she was looking for librarians, so I turned up. The library overlooked the netball court, not far from the horrors of the gymnasium where Mr Nanson would make us do one press-up after another until we collapsed, his whistle blowing furiously to remind us he was watching.

Here in the library were rows and rows of books, snugly jammed up together, with a few reading tables in between. At the front desk sat Alison, a frail girl with blonde plaits and glasses: she was in the year above. A pad of ink sat in front of her, with a stamp which she would lift with great ceremony and bring down on the inside of a book. I was envious.

My very own private library had a stamp, which said:

CARWASH

RECEIPT / DATE

I had found it at the local community centre. It was nearly perfect: I could write the return date for my sisters to hand back books next to where it said 'date'. The ink pad I found was dry, so I would wet it with water, which gave me a dull stamp to mark my books.

'I would like to be a librarian,' I announced. Alison just looked at the glass window of the stockroom and said, 'Mrs Smith is in there.'

I had rehearsed it all in my head, how I'd tell Mrs Smith I knew all about running libraries as I had a private one of my own, and hence plenty of experience for this particular job, etc. I knocked and she opened the door smelling strongly of coffee. Before I could say anything she said, 'Osman, have you come about the librarian job? Right, well, it's two to three days a week over lunch-time, and one to two hours a week after school closes. I will put your name on the rota. See you next week.'

That was that. I had become a proper librarian!

The thing with Mrs Smith's library was that not many pupils came in. So at lunch-times I could sit there and read, surrounded by all these books. I would stamp out a few, as horizontally as possible, though this was tricky because you couldn't see through the stamp machine. Then there was the whole new Dewey Decimal system to learn – putting them in correct classifications.

My habit of 'lifting' books was behind me, even though it was still agonizing to give books back when I had finished them. After a few months, Mrs Smith began to ask me to work on new acquisitions, classifying them. They needed protective covers glued on and the decimal number taped on their spines. This was my new job on the days I wasn't at the front desk.

All the new books were kept in this little stockroom. My old addiction reared up when Mrs Smith bought a new batch of C.S. Lewis Narnia novels. I'd read these several times a few years before, but these were a *brand new* edition. I kept looking at the

pristine covers, holding them up as they sat on the pile waiting to be processed into the filing system, waiting for me to type out the card catalogue and find its correct place in the long wooden drawers.

I couldn't resist it: those copies had to be mine. I had a plan. Lunch-time arrived and I got out of class ten minutes early with the excuse of library duty, wolfed down my school dinner before anyone arrived in the canteen, picked up the library key at the staffroom, and raced up to the second floor.

The stockroom key lived above the door frame. I looked around, went inside, picked up the Narnia set and put them all in my Reebok satchel. Then, heart pounding, I sat at the front desk with my bag just behind me. Jas turned up. Though he worked different days, he had come in to help Mrs Smith classify new arrivals. We nodded and I watched him nervously as he walked over to the stockroom, took the key down, opened the door and went inside.

The afternoon seemed to last for ever, my bag of gleaming new Narnia books began to get heavier, and I could barely wait until the last bell rang before running out.

Several days passed. Then I came home one day and Mum said that Mr Nanson, the PE teacher and wagman, had turned up. 'He took your books away.' She said it very calmly and carried on what she was doing.

Mum and Dad had let him in, authority was authority, and this particular authority was also white. Since no one could communicate with him, he'd wangled his way into my room, up the stairs in the attic, and found my entire collection on the several shelves that Dad had built.

I shuddered; my world had imploded. Tears began to push themselves from my eyes, one after another, and streamed down my face. Inside me there was a huge black hole of despairing panic. I ran upstairs. My shelves were *empty*. Not one book left. *Every single one gone*! How could he – and how could they? This was *my* collection, I had built it over many years, some legitimately, some admittedly less so, borrowed and never quite returned . . . What would my sisters and the girls from the community who borrowed the books do? I didn't have any more books to stamp, even if it did only say CARWASH. How could I show my face? There were *no* more books. This was way worse than Dad beating me and being locked in the cupboard at the bookstore, or visiting the police station and, yes, worse than the chase by the huntress in her checked apron.

Today, *I* had been robbed!

The following day Mrs Smith and Mrs Vincent came into my class and, along with my form teacher, we all stepped out into the corridor. It was Mrs Vincent who spoke first with that narrowed look of hers.

'Osman, you have been STEALING books. You are a *thief*!'

Mrs Smith added severely, 'You are banned from ever coming into the library again. You are lucky we haven't called the police!'

The punishment lasted until the final term of school. Well over a year. Walking past the library and looking into the rows of bookish Elysium through the glass doors took a heavy toll. I lowered my gaze towards the parquet flooring of the corridor. Jas had grassed me up! He'd annihilated me. I knew it was him,

but I couldn't prove it, and it was me who'd introduced him to the library!

We never spoke about it. Ostensibly, things carried on much as before with our little fivesome. Temperatures got even hotter, especially when Lloyd brought in a magazine, the type reserved for the top shelves at newsagent's, which he took out of his bag with great care. Unlike the *Sun* newspaper, with its topless image as soon as you opened it, Lloyd's magazines had full close-ups of vaginas with all their folds pulled back by fingers pressed into the soft, red tissue, and huge, veiny, uncircumcised cocks angled to penetrate or *actually penetrating*, captured both entering and leaving. Lloyd, Arjan, Farooq and I looked at them while Lloyd turned the pages and kept up a running commentary: 'I would give *her* one,' or 'My cock's much bigger than that.'

As for the books, I wasn't allowed to borrow from the Balsall Heath library for 'non-return of books'. I began collecting again, starting at the Community Centre, but it was never the same. What I still had was a book called *Changing Bodies* from Mrs Smith's library, which lived behind the wardrobe. Mr Nanson hadn't found it. My new secret addiction was helping me to overcome the sad end of the old one: the book-collecting.

This was our final year and Elizabeth was turning sixteen in February. The mysteries of a birthday party were still inscrutable to me. At home and at mosque we had gatherings around food to the sounds of chatter to usher in a birth; the

circumcision of a boy at ten months; the weddings; the wakes; it was all food and chatter, followed by prayer. Birthdays were an infidel tradition. We aged from year to year without the need to cut a cake or blow out the ever-growing heat of the candles; and no 'Happy Birthday' was sung to prepare us to extinguish the years that had passed.

How was I going to get an invite? And even if I did, would it clash with mosque, and would Mum and Dad send a search party if I didn't come home straight after evening prayers? I couldn't go for a casual stroll to the park to watch the boys play football, the sun had already set. Instead of going to mosque that evening I walked in the opposite direction towards Park Road, to the big houses with their front rooms illuminated like vitrines, the privileged world. I was sure to see a party, music, cake, jelly. Elizabeth had invited her guests to revel, to dance. I assumed all would be visible through those big windows, it would be easy to find, maybe if I stood outside someone would invite me in, or I could just go and ring the bell, and then I could brag about how I had been to a birthday party.

I didn't know the number, so I kept walking up and down, looking into each window, searching for the party, the mass of people. There were some people watching TV and some eating their dinner, some knitting, but no more than three, four, five. All fully visible, bereft of any net curtains. Important white people didn't hide and eat their dinner in their back rooms like us, they showed themselves. This was how they lived. I walked up and down, the big oaks creating shapes and shadows. This was where the jinn lived at night.

There was no dancing on Park Road or the adjacent Augusta Road, so I trudged back home.

Most days walking to and from school, reggae music boomed like a sonic cloud on our street, coming from our neighbour a few doors down. The bass steadily beat away, accompanying my walk. This was Abigail's house. Abigail would bring out drinks, and on some days two or three Rastafarians would sit outside and smoke ganja. If she wasn't outside, her window was open and you could hear her singing in her room. The sound trailed out into the street and followed me as I walked home. The jumpy rhythms of the tune she sang made me secretly move, limbs tingling, my thoughts turning to wanking.

Against the background of Abigail's music my wanking increased, and along with it my use of our bulk-buy pink toilet paper, which I would unroll and tear from the bathroom ring-holder and secretly carry into my room in all my pockets. The more I wanked, the more I prostrated myself in prayer and made pacts with God to save me if I promised not to touch myself ever again.

A day or an afternoon would pass, and then once more, I'd collect more pink toilet paper.

For some reason, I wouldn't throw it away immediately afterwards; it seemed much safer to hide the evidence behind the wardrobe rather than flush it down the toilet. I tucked it away and planned to wait for the right occasion when everyone was out and I could get rid of it in one fell swoop. But there never

was a moment when everyone was out, and so the paper would dry and turn into clumps of hard, abstract pink sculptures lodged on top of each other, trapped between the wooden back of the wardrobe and the wall. Also hidden here was my bible of self-exploration, *Changing Bodies*. It discussed and proclaimed that exploring your body was 'natural' and it also gave you tips . . .

Over the months, the pile of pink toilet-paper sculpture grew bigger.

It wasn't the wagman but Banafsha who found the stash and brought my shame out in the open. She told Mum. Once again, when I turned up after school, I was sat down for a very calm and composed 'talk' on praying, cleansing and pube-shaving. There was nothing said about the book. What embarrassed me the most was that there was no more book, no more heap of pink toilet paper. They had all been removed, vanished, cleaned, as if they had never inhabited the space between the wardrobe and the wall.

Eventually the time came for us all to go to college. Jasbir went off to St Philip's along with Arjan, and I chose Matthew Boulton. It was much closer, and I could walk there. I made friends with ease: Ashok, Neesa, Fareeda, Survjit, Meena, Ajay and Faisal. These were different Asians, upwardly mobile. Lakshmi, the goddess of wealth, had entered Ashok's home and had never left. They were a caste of goldsmiths with their own jewellery store. Everything dripped in gold. Most days Ashok drove a Mercedes to college.

In our first year, Neesa tied a talisman on my wrist, symbol-izing her love and the protection I offered her as a brother in the Hindu ceremony Raksha Bandhan. She invited our group of friends round to dinner in her family's new showroom house, with its brand new furniture, and I sat at a dining table trying to work out which utensil to hold in which hand. We only had spoons at home, and took our food to our mouths with the right hand, whereas here they held the fork with the left.

Fareeda was from Kenya. Although she was Muslim, her parents didn't mind her having male friends. Faisal was also from Africa and had been to boarding school, and already had a girlfriend, to whom he wrote long letters.

I began to have birthdays now, over these two years. All our birthdays were celebrated together, starting off in the canteen and eventually ending up at Pizza Hut, where Faisal worked. I wrote on cards and contributed to group presents. I invited only the boys back to our house for Pashtun hospitality of large, sixteen-inch chapattis that my mother cooked. She came into the front room, regarded everyone eating with pleasure, and said hello.

Everyone discussed their aspirations of going to university. I wanted to go to America: I had heard of an internship advertised in Ohio. I sent them a letter, but they never replied.

In those two years of sixth form what we did most, however, was dance. It began with Meena. One day we were all sitting in the college canteen, the sanctuary where music played, where lovebirds could kiss, where Muslim and Sikh boys would size each other up and fight. Meena had a flyer in her hand.

'We all need to go to this "do", guys, it's five pounds.'

I didn't ask what a 'do' meant for fear of sounding naïve. The flyers had an image of a drummer and cut-outs of girls dancing on it, and said 'Pagoda Palace'.

Mum looked deep into her pocket and gave me a fiver. I said I needed it for college. Wednesday afternoons were free periods when everyone would be expected to float into the library. Mum didn't understand free periods, nor could she read my class schedule. As long as I was at home by dinner-time, all was good.

We drove in Ashok's Mercedes. He parked, and then we made our way into the dark entrance: down the stairs we descended. The Palace was in the basement, and whilst the sun was still high in the sky, we were all hidden inside; hidden from the day.

Boys and girls arrived separately until a whole mass of people mingled under the pulsing lights. The club had black carpets, black walls, black everything, with every other wall mirrored.

I didn't know the beats they were playing, but the music pulled me in. Some of the girls were in their day clothes, others had dressed up – they looked like they were going to a wedding, in dresses with gold embroideries and scarves, and wearing blue and pink eyeshadow, bright red lips. My sisters never dressed like this.

I tried to learn the moves, mimicking those around me, raising my arms and rocking my hips. I got the hang of it, but at 5 p.m. the music stopped abruptly, the girls who had dressed for a wedding went to the ladies' to change back into their day gear, and we all scurried out.

This was a 'Day Disco'. The British-Asian bhangra scene was

in full swing: girls and boys of Asian extraction who couldn't go out in the evening were catered for by canny entrepreneurs who hired and filled out the nightclubs during the day.

Through these, I grew to love dancing, and now that I had my own room I would put on recorded tapes and perform routines with my sisters. The devil had taken hold of me and he wanted more disciples. Away from the ears and gaze of our parents, high above in my attic bedroom, doors closed, we danced.

RED LIPSTICK

DARMAN KHAN COULD SEE HIS own reflection in his shoes as he walked the streets of Balsall Heath. A Crombie coat seemed to float around his neck. He sported a scraggy little beard, a throwback to his ancestry: Genghis Khan. He would oil it regularly in hope, first, that the oily lustre would give an illusion of a fuller beard, and second that the oil would fertilize its roots, pushing them to grow stronger and thicker. To turn him into a proper Abrahamic Bushman.

His baggy pants hovered over skinny ankles covered in striped socks, at the end of which were his mirrored black plastic Gothic-looking shoes. Like his skinny ankles, the rest of his frame was slight, neither short nor tall, so in comparison the shoes looked enormous.

These shoes he wore day in, day out. They weren't sensible Bushmen shoes, but part cowboy boots, part wooden clogs, part winkle-pickers, with an enormous buckle that closed on the

outside; they shone all the more in contrast to everything else about him.

He had probably bought them in the flea market, or maybe a thrift store, the belongings of someone who had died. Possibly two sizes too big, they stretched out to a point in front of him, making him stomp as he walked.

It was these shoes that stomped him out of Gulbudin Shah's shop one day, smouldering with anger.

Gulbudin was a hulk, as wide as he was tall, with minute eyes and curly hair. He was able to carry two large sacks of flour effortlessly on his shoulder, plus boxes of fruit laden on top of each other in his hands. All this he orchestrated in his white overcoat.

Today Gulbudin said to Darman Khan: 'You know you are like my brother, my own blood; what hurts you hurts me; what is your shame is my shame; when you are hungry, I am hungry. I don't mean to pry, but your wife: I think she was seen in the Moseley Arms, the pub near town, with another man. This is the address.'

He gave Darman Khan a scrap of card taken from the corner of a Cornflakes packet and scrawled on in Gulbudin's blue biro. Darman Khan couldn't read: he looked it over again and again and finally he put it in his pocket.

'She was definitely smoking, and without her burqa.'

Gulbudin Shah had delivered his news and had to get on with sorting the deliveries, so Darman Khan left the shop.

What Gulbudin Shah hadn't told Darman was that *he* had befriended Darman's wife, Pari Jaan. Aunty Pari, as we called

her, had been to our house several times and was always, always immaculately dressed. Her bright, lipsticked mouth seemed to pop as soon as she threw back her black veil. The lipstick was the deepest, lushest ruby I'd ever seen – maybe it was her own special colour that she blended herself. She was an obvious example of why the prophets told women to sustain their modesty, and the reason the imams would repeat it again and again. Pari Jaan was irresistible, her lips would hypnotize you, luring you in. She had to hide her beauty, with its captivating ways.

Darman Khan wasn't as strict as Dad. His wife would wander in and out freely in her burqa, not being questioned as to where she had gone, who she had seen or why she had gone out. On his regular delivery round, Gulbudin, mesmerized and half-crazy with desire for Pari Jaan, threw in extra pineapples, pears and grapes – presents and payments-in-kind for calling upon Pari Jaan.

Whilst Darman Khan was out at the mosque or walking in his weird plastic shoes to the Job Centre, Mr Gulbudin Shah was visiting Pari Jaan, his path illuminated by that seductively full, ruby-red mouth. She would open the door and he would shower her with gifts: not just large juicy oranges and pounds of grapes, but mangoes when in season – the fruit of love. He even threw in extra bottles of Domestos bleach and cases of toilet paper.

Apparently these deliveries of lust had culminated in the consummation of an affair. His courtship having been successful, Gulbudin Shah saw to it that Pari Jaan became accustomed to sleeping with him.

However, Gulbudin Shah was first and foremost an entrepreneur: he worshipped money and kept the light on in his shop, opening it late into the night, delivering groceries to your door – nothing was too much if he could make money. He saw an opportunity and took it like the businessman that he was. He was a pragmatic man; he wasn't going to run away with Pari Jaan, elope with her and set up another home. He was already married with children.

What he wanted was to earn money from the flesh of Pari Jaan. He had ensnared her so he could make her go out, concealed in her burqa, through the back alley and upstairs to the top of his shop, to meet other men. There she would disrobe herself, Gulbudin Shah having collected the money beforehand.

To avoid any suspicion, he instructed her to go further afield, meeting men in rooms above shops in the hidden parts of the ghetto or in adjacent neighbourhoods, where our orthodox women didn't dare wander. Gulbudin, his friends, and friends of friends had pushed the harlots off our streets. Now they looked inwards to find flesh they could buy.

Months later, as we heard it, she'd wanted out; she had cried, weeping for forgiveness, praying regularly, a string of prayer beads in her hand, the scarlet mouth wiped clean. She stopped answering Gulbudin's calls. When the phone rang, she would let the other person speak first, and if it was Gulbudin she put the phone down, silently, leaving it off the hook.

She wouldn't open the door when he came round, letting him stand in his white coat in her front garden, a box of fruit

in his arms, waiting. So he was forced to leave, taking the box of fruit with him.

Gulbudin plotted and schemed so he could get a message to her. Finally, it came to him when he saw Darman Khan.

'Brother, it's been ages, when will you invite me to dinner? Your wife cooks the best biryani and the best kebabs; my mouth is watering thinking about all that delicious food. You know that you are so lucky, eating like that each night. My wife will never get to cook like that.'

Darman Khan was gratified as he regarded Gulbudin's smiles, so full of brotherly love. Gulbudin wasn't from our community, he was from Mirpur in Kashmir, but the bonds of immigrants in a foreign land were strong. Those extra gifts of fruit and groceries were tokens of his friendship, and it made Darman Khan think how lucky he was that Pari Jaan cooked so well, and that he should share her talents. Feeding a fellow Muslim would make God happy.

He duly complied, ordering Pari Jaan to cook a huge feast of chapli kebabs with pomegranate, roast chicken legs, lamb biryani and sweet, coloured rice. After they had eaten and Darman Khan had left the front room to do his ablutions for evening prayer, Gulbudin Shah ran behind the dividing curtain to the kitchen and threatened Pari Jaan, pulling out a knife.

'I need you to meet some men, they will be good to you. If you don't, I will tell him everything, I mean everything. I will tell the whole community who you are!'

He moved away as he heard a noise in the hall and whispered fiercely, 'Call me tomorrow – if you don't, I will call you.' As

an afterthought, he placated her: 'This is the last time. After you do this for me, you will be free, I will leave you alone, I promise.'

It was her friend and neighbour who broke the story and testified to all of this in court, but no one knows what was true, overheard, embellished or concocted. The elders wanted the story to be hushed, never spoken of again – that a woman from our community could do this! – in the hope that it would disappear, that the stain would eventually wash itself away.

Decades later, I had to pry open many doors to get to the bottom of it. Gulbudin, it seems, wasn't taking any chances: his plan was to tell Darman Khan anyway, and set up a situation where Darman Khan would beat Pari Jaan up, put her in her place like a pimp would, and unknowingly do Gulbudin Shah's bidding so he could continue to exploit her.

When Gulbudin told him that day, Darman Khan couldn't believe it, didn't want to believe it. He held the scrap of cereal box, looking again and again at the symbol of the Kellogg's red cockerel and, on the other side, the scrawled address. He was wondering how Gulbudin had seen his wife in a pub, and how he knew what she looked like when she was always in purdah. Darman's mind turned over and over. He looked at Gulbudin one last time and marched out of the shop.

The address that Gulbudin had written down was the Moseley Arms, a house of intoxication, that which God had forbidden. The imam had narrated how, when God instructed the Prophet to decree alcohol *haram*, the dutiful flooded the streets of Medina, breaking jar after jar of the jewelled liquid, and washing its streets clean. But Darman Khan knew well the interiors of these palaces.

He frequented some of them, drinking his fill and then finding his way home to fly into rages at Pari Jaan.

He hadn't yet drunk his fill today, but his rage propelled him back home in record time. He pushed his key in the door, opened it and screamed out: 'Are you in? Is someone in?'

His voice boomed around the house.

'I need some tea!'

No one answered. He marched, marched through the terraced house: the small corridor, the front room, and then the sitting room that led to the kitchen. He opened the toilet door, and then shouted up the stairs. The house was empty.

Darman Khan couldn't sit still. He held on to the Kellogg's Cornflakes card with the scribbled address, made himself a cup of tea and waited for his wife to come home. He thought of going back to Gulbudin Shah to ask him to take him where he had seen her, but he couldn't face that; the indignity was too much.

He walked around the house, and then walked out to the end of the street to the taxi rank, pushed the address forward, and said, 'I need to go here.'

Ironically, the Moseley Arms was opposite the unemployment office, a regular trek that he knew well, though he hadn't drunk inside this bar itself. It usually took him half an hour to walk to the Job Centre – especially in his shoes. But today he wanted to get there in a hurry, in case it was true, and also just in case it wasn't and Pari Jaan had just popped out to a neighbour's or a friend's.

The taxi dropped him off and he stood outside the pub for

a while. He had been inside many pubs, but not in this one. As he knew from experience, these were the houses where the sober walked in and then walked out falling over each other. What was Pari Jaan doing inside a house of evil transformation?

With one big breath, he walked in, pushing the doors open, looking around wildly. There, sitting in a corner, surrounded by wood panels and engraved glass and warm hanging lamps, was Pari Jaan, no headscarf on her head, laughing at the conversation of a strange man. They hadn't seen him.

Overcome with volcanic, frenzied fury, Darman Khan pulled out his pocket knife (most of the Bushmen carried knives) and, shaking with rage, walked towards them shouting: 'You prostitute! I'm coming for you, I'm gonna sort you out!'

When they saw him, the man ran away. Pari Jaan froze, and sat there, petrified. She hadn't seen what he had in his hand, or she would have moved. He pulled her by her hair and stabbed her in the neck. She died instantly, her blood spilling fast, thick, red on the beer-stained carpet.

Later, somehow, they managed to get her body and coffin into her small terraced house. A handful of boys had gathered outside, looking at the black hearse, noting its side windows and elongated shape. This was a special car for the dead to travel in as they couldn't sit up. In hushed voices, the boys whispered, 'Darman Khan is in prison for killing his wife,' that he had found her in the pub. 'Of all places!' they said. 'In a pub! An honourable Pathan woman in a pub. What was she doing there?'

I was too old to be amongst the women, but there was no way I wasn't going to take a look at her. As the attention of

those present fixed on the mysteries of Pari, I crept inside the house unnoticed.

I was shocked: inside there was barely a handful of women mourners. The open coffin was lying in the front room, and a few family members were praying over it.

Pari was lying there cloaked in white, her face turned to Mecca. There was no blood. I wondered if maybe the doctors had stitched up the knife wound, stopping the blood pouring out. Her female relatives must have washed the blood off when they got her ready.

She wasn't wearing her signature ruby-red lipstick either; they must have washed this off too.

Many years later, when I was researching these oral stories, I asked Mum about Pari Jaan of the beautiful ruby-red lips.

'Do you remember the murder down the road?' I asked.

'We shouldn't talk about such things,' she replied.

23

SEX, LIES, AND LIBERTY

I WAS BORN IN BIRMINGHAM ON a Tuesday and I left on a Tuesday when I was eighteen. Looking back from the train at the greys of my native, industrial city – greys we 'People of Colour' had decorated with hues of another kind. A cultural vibrancy brought in by our parents, from far-flung places, from the former empire, where the sun never set.

This colour they'd brought in was like that of an ineradicable foreign tattoo whose ink had leaked and mingled with their sweat to seep into the city of canals. The canals' stagnant waters could never wash out the colour we had brought into the city and which had made Britain great. This country and city had offered its crevasses, its underbelly, to us and now had changed because of it. And the colour of those far-off homelands took root between the cracks where the unkempt weeds and wild roses grew.

We said the city had changed for the better, though others

said for the worse and began leaving those areas. We inhabited what had been left behind, still partly in awe of its faded Victorian glory.

We settled and enchanted. Many came to taste our food and note our ways in exotically named balti houses – the Taj Mahal, the Khyber Pass, the Kabul Darbar, the Raj, the Lahore Kebab House, Khan's, Tandoori Palace – all forming the Balti Triangle. Our dazzling fabric shops filled the streets, as did our people with their foreign chatter – people that many, until then, would only have glimpsed in old travel books but who now lived a few miles from the homes of their erstwhile colonial masters. Of course, these people saw only me and my father and my brother. They might, very occasionally, have glimpsed my mum and my sisters, dressed all in black, passing by as shadows protected from their gaze.

Perhaps they didn't really see beyond my colour. It was me who noticed them and went back to tell my mum and sisters what I saw, about what the white people were doing. How delighted we were when they came to see us, checking our gas and electric meters or asking us to come and vote for them – actually speaking to us. Being associated with or seen with white people had its own pride and status – as long as they didn't try to change us too much.

We kept to our own codes and they to theirs. My sisters saw them sometimes on TV, but neither they nor I could properly conceive of or describe the essence, for the white world that they lived in was so startlingly novel, so shockingly different from the world we had navigated until now. We were preparing

to go to heaven, as God's chosen people, whilst everything they did was sending them to hell.

Now, however, I knew I was heading down that road to join them, to meet the unknown, my inscrutable destiny. I was leaving for the bright lights of a vaster and faster metropolis, going to SOAS, the School of Oriental and African Studies in London. No one had heard of it amongst my friends, and as it was part of the University of London, I told everyone I was going to London University. It sounded better than having 'school' in the title. I was definitely finished with school.

Mum sent me off well prepared; she had made parathas and eggs. She folded the egg into the paratha, wrapping it in kitchen towel to soak up the butter, then wrapped a parcel of them in foil, which she wrapped again in a floral tablecloth. She then placed it in a plastic bag, tied a big knot in it, and handed me my lunch. Mum kissed me on both cheeks and then my forehead, and began to cry, and said that I should call when I got there.

Barak-Shah had given me £250. I had never held so much money before; it seemed like a small fortune. He told me to get a black cab when I arrived, as they were very cheap in London and would take me straight to the halls of residence. The money was to help me until my maintenance grant arrived. Dad had been unemployed for some time now, so I qualified for a full grant. I had filled out the forms at the local authority office and signed Dad's signature, having walked in through that office door with a burgeoning self-respect: I was going away to university.

Apart from the paratha and eggs, which I opened on the train taking me to London, perfuming the carriage with the smell of

home, Mum had also given me a quilt, entirely homemade out of thick wadding, which she and my aunty, Gulab Storai, had quilted together for weeks. They had spent days at a time making sure that the wadding was even, and quilting stitches into the orange floral brushed-nylon fabric. The feeling of it was extraordinary, as if someone was lying on top of you; a big, ponderous weight. I had got so used to the weight of these quilts, the way their stiffness wrapped around you, massaging you to sleep, I couldn't sleep under anything else. Mum had even made a matching sack to carry it in, the opening of which was tied with an old *nara*, the cord used in a salwar. The whole set must have weighed ten kilos and I tried to hold it with one hand, my suitcase in the other. I had surreptitiously slipped some of Barak-Shah's clothes into my luggage – one of his favourite denim jackets and a few of his jumpers. I had already been experimenting with my clothes, personalizing my own second-hand jeans with safety pins, wearing these throughout sixth-form college. They couldn't be worn anywhere else – at home I would have to slip into my salwar kameez, ready for godly dispensations.

London was intoxicating, with its dizzying pulse of freedom. I gazed in awe at all the classic tourist sights: the romantic bridges that crossed the Thames, the Royal Festival Hall, the throngs of people everywhere, Trafalgar Square with its pigeons and lions guarding Lord Nelson standing high upon his pillar.

I was to live in Bloomsbury, a short walk from college. My room overlooked Mahatma Gandhi's statue, deep in meditation in Tavistock Square. Surrounding him were long, tree-lined boulevards which at each turn led you into another elegant

square surrounded by rows of tall Georgian houses. As I entered Connaught Hall, where I was to live, my heart swelled with trepidation and excitement. You could fit our house into a few of its communal rooms. The porter signed me in and gave me my key. Up I went to the third floor. I walked down the corridor towards my room greeted by wafts of incense and blasts of the Stone Roses from behind closed doors. This was my new home.

Registration and the Freshers' Fair were in the Grand Hall: desk after desk of societies, luring you in, promising you enlightenment, collusion, inclusion, events, parties: your diary full, and new friends gained. The Junior Common Room was jammed with slogans.

I was reading South Asian Studies with Anthropology. The school was tucked away in the corner of Bloomsbury, just off Russell Square. For all its demurely Delphic presence, its heart screamed out against the imperial world economic order, its north–south divide. SOAS had started life as an educational institution for the British administrators and colonial officials intended for overseas postings across the vast British Empire. And here within its walls, a revolution had slowly occurred and inconceivably come full circle. The intelligentsia thought differently now. I, the son of an illiterate former 'colonial subject', one of the 'governed', had come here to be educated.

I heard Edward Said lecture on orientalism to a crowded hall. He spoke about the Orientalist Gaze, and how white people

saw us through their Eurocentric lens. We were the East, the Orient, the submissive. White people created the modern world, but on our backs, our wealth, and omitted to acknowledge us in the process. I wondered what Mrs Vincent and her railways would have made of all this now. There were different ideas and different ways to view and express myself. Did I really want to be white? I had seen mistakes over my identity as a compliment, when people asked questions like 'Are you Greek? Turkish? You could be southern Italian!', all of these were a step closer to whiteness and its purity, its hierarchy, its superiority, with its fairness of skin, marble shades of eye colour and hair of auburn and blonde. Yet in the eyes of some I was still a W★★, a dirty Paki, the lowest of the low: a stain that couldn't be washed off.

I recognized now why our community looked inwards rather than outwards. How class divided us further, adding a greater burden to our skin, our race. When they came to this land, Dad and the other men like him from the banks of the River Kabul had no tools to navigate this world; they couldn't decipher its codes. Their class was illiterate and the barriers to acceptance in England were impassable. So they created their own cosmos, orbiting and dipping into the host world for opportunities of employment, yet still retaining a semblance of their former lives in a satellite ghetto – and yet also dreaming of the new life they had come for. I, meanwhile, the second generation, had a foot in both worlds.

Across the lobby, just below the Junior Common Room, was the college bar from which the whiff of marijuana snaked up the stairs. I had smelled it in the ghetto back home; in this

institution it originated from around the pool table. On the very first day, I went down the stairs, looked at the bar, and wondered if I should buy a Coke or not: did it matter that the same bar sold alcohol, and had my glass been washed well enough? The bar had begun to fill up, and I needed to make some friends or speak to someone. I would always prefer observing than speaking; it was going to take me time to be at ease in this sea of new people. I ordered a Coke and the girl behind the bar asked if I was a fresher. I smiled and nodded, and we introduced ourselves. She was Emma, in her final year.

I waited for something to happen. This was my first night away from home. The smell of weed intensified, and the passive high entered my airways. Emma had come out from behind the bar, rolled up a spliff and offered me some. I declined: 'I don't smoke.'

'Don't worry, we have diplomatic immunity here: this is SOAS, the *Queen* owns the land, and the police can't come in here, they've got to give us twenty-four hours' notice.'

Emma studied politics. Most nights she was behind the bar or sitting around the pool table chatting. Emma was beautiful: her skin glistened like freshly unwrapped butter, her brown ringlets made her look like Neneh Cherry, and on each bend to open the refrigerator door they would bounce and spring back as she moved. She exuded strength and cool: her Trinidadian accent, her oversized jumpers and white jeans with cowboy boots, her laid-back ways, the manner in which she would spring and stomp around in luxurious harmony.

I longed to get to know her, and for her to be my friend, so

I took to hanging out in the bar, getting high on the cannabis smoke, ordering Coca-Colas, and waiting for her to talk to me.

There were other freshers, of course. There was Alyia from Romford, with an inferiority complex that she covered up with sly digs at those she referred to as BBCDs – British Born Confused Desis. She herself was born in England, but had been educated in Pakistan for a while and didn't consider herself to be confused at all. Then there were the expat or international students – you could see their wealth and privilege, and their sophisticated ways. They were not the offspring of immigrant peasants looking for a better life; they already had one. Their parents were businessmen, modern feudal lords, bankers, high-flying judges. They came from all corners of the world. There was Zahra and Masahel from Karachi. Then there was Mariya, whose family lived in Dubai, and Adaego from Nigeria. They were daughters of oligarchs, sporting Chanel handbags and Ralph Lauren shirts – somewhat at odds with the fisherman pants, dreadlocks and ponytails of the white middle-class hipsters just returned enlightened from a gap year in India or Thailand.

Those long nights waiting for the bar to close and helping Emma collect the empty glasses for the dishwasher became a regular part of my chores. One evening Emma promised to take me out, somewhere 'special', somewhere 'magical', and I put on my best t-shirt, a pickleball raglan with a white body and sleeves in dark blue. She laughed and said, 'You're going to see the world differently tonight; you'll see a world where you will lose yourself.'

She swept me imperiously through glittering dive bars, one

after another, saying hello, me tagging along. For the first time, I saw genders become fluid, and love and self-expression taking many different forms. Emma knew everyone: James and Ian, drag queens who wore large blonde wigs and called themselves Victoria, 'The Yvette', or even 'Yvette the Conqueror', warming up the crowds in their sparkly or animal-print dresses — and all nearly seven feet tall. James obviously preferred dresses with fishtails, and occasional hats for dramatic entrances, and Ian adored his own long legs — every dress showed them off.

In that jewelled darkness shone these beautiful creatures, neither man nor woman. The imams would have been horrified, and hell's fires were probably stoking up, burning with high intensity to welcome these infidels with their majestic blonde Marilyn Monroe wigs. They would have walked into those hell-fires as they always walked, so very tall and straight in curvaceous, padded glory, hypnotizing me.

Emma gave me half a pill of something. 'Just take this and drink lots of water, it's going to make you feel bea-uooo-tiful.'

I obeyed and closed my eyes, and into the haze of the dance floors we descended, where euphoria ruled, and along with it an elation that allowed me to forget that I was going to hell. I was being lured into the world that would force me to forgo my place in heaven, where there had been beautiful virgins — pure and transparent — waiting for me.

I couldn't wait to be damned, the strobe lights caressing and thrashing against me, the ephemeral pleasures of the flesh every-where, the random snogs which meant something or nothing.

Night turned into day. The moonlight beckoned you in, and the dawn let you leave.

I went out again and again with Emma, each time dressing up in clothes I mainly made by day for myself and for Emma to wear out at night. The sewing machine from the halls of residence was firmly planted in my room; it was rarely requested by anyone, so I kept it. I made us bead chokers Lenny Kravitz himself would have been proud of, and added touches of the east in the form of embroidered hats that I could have easily worn to the mosque on special occasions, yet here they sparkled under the club lights.

We'd emerge into the day still high, eyes wide like prophets, and glide through Selfridges and Liberty just as they opened, sniffing bottles of scent, 'feeling' the intense high in the soft silks, the furs or the cashmere, trying on the kohl and the powder from rows of expensive open pots, and I would think back to those empty ones I used to take home to my sisters.

I found myself dancing in clubs a few feet away from Jean Paul Gaultier in his Breton top and walking down the catwalk as a toy soldier-boy in a ball where RuPaul performed 'A Little Bit of Love' and 'Supermodel'.

Through Emma I met Dalia. She was easy to fall in love with. Gentle and intense Dalia, her customary silences that mirrored my shyness, and then the madness of her endless chatter . . . We didn't care that our days and nights turned into one. The glowing warmth of the sun and the subtle coolness of the moon ignited our misty, insular halos. There was no one else. When we weren't together we searched for one another. We danced, we smoked

and we made love, and then she missed her cycle, and the sticks from the pharmacy confirmed the pregnancy. She cried and I held her; she said she couldn't, she wasn't ready, there was much more to do before this – so we decided on an abortion. The guilt was monstrous, I feared it hanging over me, grieving the loss, in terror of my eternal damnation – yet still we kept dancing, and eventually she moved on.

I met people who lived in bedsits and others who owned houses in plush parts of London. There were the Kuwaiti bankers whose art-deco flat in Baker Street had intercoms and porters and cannabis offered on silver platters. I sat on expensive, well-upholstered sofas, facing other guests around low-slung coffee tables on which sat sachets of marijuana and ecstasy in mini silver trinket boxes, with books on Versace and Madonna taking pride of place.

I met more and more people at these parties, the kind of people who had houses in Mustique and Ibiza, people who visited long-haul destinations like Singapore, Malaysia and the Caribbean.

Along with the dancing was always the talk – of going away, of leaving for the 'islands' in Greece, to Mykonos, skiing in Gstaad or out to the Far East. I couldn't afford to follow. They talked of boarding schools and their friends who would visit them from abroad, or investment apartments that they were buying in the newly gentrified East End.

Sometimes I forgot who I was and where I came from, so I told them my dad was a successful carpet-seller in Birmingham who imported rugs from Afghanistan and had many houses, that

342

my sisters were all studying, and that one wanted to be a doctor and the other a designer, and that my eldest sister was married to a very successful engineer, living in a gigantic house with a lake.

I spoke well and was always polite: I had learned which hand to hold my fork in by now, so they had no reason to doubt me.

Yet after telling these tall stories something kept pulling me back, and I would locate a phone box and push a twenty-pence coin through the slot and dial back home, calling my mum and my sisters. My younger sisters were still living at home in purdah, but were now even more alienated in that bigger house near Moseley Village and its private park.

After the first few months at SOAS, I was sleeping mostly in the day and roaming the clubs at night – well, every night. Naturally I began to ease my way out of university, mostly by not turning up. There were no registers taken during class; it was the end-of-year exams that allowed you to go through to the following year. Failure to hand in essays or assignments didn't stop my means-tested grant. The sum of £1,000 was paid each term and I supplemented it with work in the bar at the Albery Theatre. There I watched Cate Blanchett on stage talking of a salmon sky, and served drinks to Nicole Kidman, Lauren Bacall and Hugh Grant. I called everyone Sir and Madam.

Once, I was to take drinks to the Queen in the Royal Box. I thought of how I might bow, wondering how the celebs did

it when they met the Queen. But then I was carrying a tray of drinks . . . Maybe after I served them? I thought of what to say if she said 'Thank you' . . . 'You're welcome, Your Majesty' didn't quite ring right. Would she give me a tip?

The drinks tinkled dangerously as I made my way nervously up, my heart fluttering. (Wait till I tell Mum and my sisters I had served the Queen!) At the door I stood and grinned – and was firmly stopped by a security guard. 'Thank you, we'll take that in.'

When the interval ended, around 9 p.m. most evenings, I would head out to meet the new friends I had made, all of whom seemed to be studying much more fascinating subjects or working in madly interesting jobs. Heidi, who was German, was studying Fashion Marketing, Elias was studying at the London College of Fashion, and Noah worked at Jean Paul Gaultier's store.

The summer after my first year at university, I didn't know what I was going to do. Heidi, Elias and Noah all went travelling and I kept partying and working at the Albery. I borrowed a friend's drawings, adding in some of my own, putting together a small portfolio. I turned up at a Central Saint Martins open day, the best art school, where I'd heard you had to do a foundation course before you could do a degree. I was interviewed and asked about the eclectic drawings I had brought in. The tutor interviewing me said he liked the way I dressed, and offered me a place on the part-time foundation. So my second year in London, without any funding, involved turning up regularly at the unemployment centre to sign on and fitting in shifts behind the bar at the Albery in the evenings.

Throughout that first year of foundation, I looked over my

shoulder at the fine art students and the fashion students with their white-shirt projects, and at the senior students preparing for their final show. I could already make my own clothes, but I watched, and studied how they illustrated their ideas and cut their patterns, while I experimented with my materials, drawing, printing and painting. I drew the human body from nude, arts which were forbidden and didn't heed God's instructions. I didn't abstain, and on Judgement Day he would ask me, 'Show me what you can do,' commanding me to bring life into them, just as he had done to Adam and Eve.

It was the same railway tracks that took me back and forth from these different realities. I travelled back occasionally every few months, staying over the Christmas break, making my alibi that I had to work my first summer away to keep my job safe. The following summer Mum insisted I come home. By now my family had upgraded out of the terrace and into a detached seven-bedroomed home, my brother's Mercedes parked outside in the drive. When I arrived back that summer there was still the urge at twilight to sway in rhapsody, to take a pill or two, but here the whole experience was constricting and dark. I was too proximate to a reality that abstained from these pleasures. The smell of home was of warm eggs and buttered parathas each morning, my mum's delicious cooking, yet still this warmth felt restricted. I couldn't smoke in front of anyone out of respect. I missed London, my liberty. I could breathe there easier.

I would stumble home in the early hours of the morning, after trawling through the raves at the custard factory, and then have to solve the conundrum of how to get back inside. I would have to throw pebbles at Ruksar and Marjan's window as Dad and Barak-Shah would have double-locked me out, thinking I was already tucked in bed. Sometimes calls would come for me from London, and I would make an excuse to head back to the bright lights, if only for a few days. I never had enough money, dodging fares, hiding in the toilet, pretending to have lost my ticket. Searching endlessly and earnestly – a charade – and hoping the inspector took pity and gave up, was a regular arrangement. I once drew a portrait for the train inspector's girlfriend from a photograph he produced from his wallet. An instrument of court-ship and maybe a declaration of love in exchange for a free ride.

Just before the end of that summer my friend Keith rang me. 'You must come down, there's going to be a great party next Friday, dear . . . you can stay with me.' He called everybody 'dear', just like the nice man at the corner grocery store. He talked of his fragility, his hangover and his come-down from the night before. In the evening, I saw Barak-Shah's face had taken on an ominous darkness and he didn't speak to me for days. I had figured it out: he'd been listening on the other handset. When he finally did speak to me, I saw his rage again: I cowered, showing how weak I still was. He snarled, 'If you want to stay in this house you have to pay rent!' Violence reverberates through generations, and it all came back.

Barak-Shah and Dad were united in their fury, and I decided I wasn't going to stay. Other people had seen me differently

now: I had sat on expensive upholstery, in gentrified apartments, an imposter. I had tasted different atmospheres, I could draw for now without God asking me to put life into my markings. There was an unsettling hurricane inside me: I had seen alternate worlds. I wasn't going to accept or stand for this. The next day, holding back my tears, I told Mum: 'You don't say anything to Barak-Shah, he is your favourite, he always has been. I'm going back to London!' I wanted to hurt someone, to punish someone, for someone to feel the same turmoil, and it was to be Mum.

I left, taking what I could (it had been Barak-Shah who picked me up from London, with all my belongings). On friends' floors I stayed for several months, making no contact with anyone at home. I didn't phone, but eventually I wrote a letter to my family telling them I was okay, just to save Mum and my sisters from anguish. I added a sentence for the benefit of Dad and Barak-Shah, saying that I couldn't 'FUCKING' deal with their treatment of me and I wouldn't be coming back!

In my urgency I had left half my portfolio back in my room, and on their second move to an even bigger house, with its own entrance to Moseley Park, they burnt what they didn't want to take. By now my younger sisters were gone: Ruksar had run away, Marjan was in an arranged marriage.

Mum later told me how my brother and Dad had lit a pyre in the back garden and burnt all my belongings: my life drawings, my illustrations, my photographs, my linocuts, my paintings, my sketchbooks and the drawings of the green shoes that she had loved so much. Her words of approval still ring in my ear, 'You've drawn those so well, they are beautiful.'

The funeral pyre purified them. Its ceremony erasing me, perhaps to save me' and them from what I was to become. As they poured more and more kerosene to sustain the fire's blaze, the evidence of my difference was obliterated. They were doing it for the best, to save me from the eternal fires, and when it was done they were ready to move into their new home. Every trace of my creative rage, the folds of Lily, the voluptuous life model at college, the drawings I was proud of, must have all crackled and danced amongst the flames of this ritual. I had now left from one world into another, worlds which appeared not to overlap, no porous borders between them for safe passage back and forth. I had gone, and I couldn't salvage what the fires had consumed.

EPILOGUE
FROM THEN TILL NOW

S EVERAL YEARS HAD PASSED SINCE that summer I left home. I had gone in search of my own multitudes, and in that metropolis London – in its anonymity – I was somewhat free. I had not seen or spoken to either Barak-Shah or my dad, but every so often I would journey back, sneaking into Banafsha's home, eating her delectable food, and my sisters and mum would be waiting for me. Mum said that she regularly prayed for me, and that I was better off away from both of them.

I would hear signals, the tremors, the pulls from the epicentre, and through the flexuous grapevines I heard that my father had asked someone from the community who lived in London to search for me. At the mosque, or in any gathering, whenever he heard of someone going to London, he would entrust them with his quest. 'Can you please look out for my son? The *harami*. I don't know where he is. He has run away.'

On one of Dad's regular visits to Banafsha, he told her that

he was going to start searching for me. He was about to instruct the services of a private investigator – a very accomplished one at that – who had brought back runaway girls from the community. For now, he remained oblivious to my secret trips back to Birmingham: he lived in his world, and I lived in mine.

Talk of the private investigator continued, and Banafsha would call me up, saying I had to meet Dad, otherwise he would find me. 'He is missing you, I can see it,' she urged. 'He doesn't know if you're alive or dead. You can see the distress on his face . . . he is in perpetual mourning. He feels he has lost his son.' And then her voice would become more anguished. 'I can't see him like this. He will find you without your choosing it, and that will be worse, so much worse! . . . Or I'm just going to tell him that you've made contact.'

And so a day and a plan were arranged. I was to turn up to Banafsha's house, hide in her kitchen, and she would call Dad and invite him round under some pretence. On the allotted day, he rang the bell and I hid. Banafsha led him into her sitting room and offered him tea. At some point she hurried into the kitchen and pushed me out of my hiding place, shoving me forward, down the corridor and through the door of her sitting room.

'Salaam, Aba.' I emerged like an apparition.

Dad looked at me. His clothes shone: his turban, tunic and trousers were all pristine white; an advert for the most brilliant washing powder. Mum had always looked after him. Here was a heavenly creature with a temper of fire, a man who had fought for what he understood, without the tools of literacy: Tolyar, my

dad. In his eyes and on his lips I could see a smile. Unusually, I was confident, my introvertedness had left me.

'How are you?'

He said he was well. He kept looking at me, silent. I was his son, his blood, the boy he had dressed in embroidered waistcoats, showed off to his friends and asked to shake hands with his peers. I still loved him – the strong man, the protector. I asked if he was still upset with me. Dad replied with a saying: 'He who loses his way in the morning to return home at night is not astray for ever.'

I had never stopped searching for Ruksar after she fled, repeatedly calling the police officer who had handled her 'missing persons' case. She had been in contact with Marjan, but I had never known. Somehow, with dogged determination, Marjan had flourished, eventually graduating from an entry-level job as a dinner lady in the local junior school to a classroom assistant role. Then she had left her unhappy patriarchal marriage, put herself through university and was pursuing a PhD researching honour-based violence against women.

Years after Ruksar's flight, in 2008, when I was establishing myself as a creative, she felt she could finally reveal herself to me. When she was ready, Marjan turned up to visit me in my studio on Brick Lane with Ruksar standing alongside her. Ruksar had put herself through university reading political science and was now running the election campaign for a government minister.

When Ruksar resurfaced, I summoned the courage to tell my father that I had met with her. I didn't want to lie any more,

and I was hoping that, like me, she would be able to come back from the wilderness to our family, to our community. Dad looked at me with fury and said, 'You are without honour. You are without shame. This is a stain that won't be expunged, there is no salve for this. I can't hold my head up high any more, and if you had any honour, you should have killed her when you saw her.'

Every few weeks, I visited Mum and Dad, not knowing where I fitted in, the extremes of that life and the new life I was creating in London exposing more disjointedness between these parallel worlds that couldn't connect. I was making clothes for the rich and those who had gained fame. Mum didn't understand why a dress could cost over £500, and who would pay that sort of money. Mum also didn't understand why I wanted to use her bedroom as inspiration for a solo show (Being Somewhere Else) at the Ikon gallery in Birmingham. It was a conversation on migration, on female agency. I called the installation 'A Migrant's Room of Her Own' – a take on and a contraposition to Virginia's Woolf's bourgeois narration. When I took Mum to see it, her first visit to a contemporary art space or any museum, she pointed and asked, 'Who slept there?'

Just before the pandemic, our family began to gather around Dad as he became bedridden with pancreatic cancer. Ruksar was still absent and remained estranged. Mum ached for her to come home, to see Dad, and to make her peace. I'd asked him before, and he'd always looked at me with fury and said no. For Mum's sake I would continue, sometimes bravely pushing the deliberations and sometimes not, but the answer was always no.

Until one day he looked up at me through his failing eyes and said, 'If she wants to, she should come.'

When Ruksar finally arrived, he smiled, pulling his hands out from under his duvet and saying, 'Is that you, Ruksar?' Touching her face, he recognised her. He'd accepted her. Mum's mission had been accomplished.

In contrast, towards the end Dad began failing to recognise me. One early evening after prayers, we had visitors – cousins and extended family. Now that Dad's dementia had begun to set in, we would all try to jog his memory, encouraging nostalgic recollections that hadn't yet been erased from his brain. I circled around the room asking Dad who each visitor was, and he named everyone. It was the children, that evening, who turned my memory game around, asking Dad who I was. Dad replied he didn't know. They giggled with wonder, as children do. They reminded Dad who I was, and he wouldn't believe them. So they asked him, 'Where is your youngest son, Osman?' Dad replied, 'He ran away many years ago. I don't know where he is now.'

Dad died in the early hours of 6 April 2019. We don't know how old he was, somewhere between eighty and ninety years. When he was born, all those years ago in British India, no one had thought it necessary to record the date.

I had left and come back. I had sought a self-inflicted exile in order to protect myself and to find my own autonomy. Dad in some ways had done the same thing, the ambition of a new life for him and his family. There would be other walls, which would

begin to reveal themselves for me, as they had done for Dad. Other wider struggles, other othernesses that we couldn't hide from.

I had looked outwards, but our elders had looked inwards for safety and security. As immigrant labour, they didn't possess the codes of privilege to decipher, enter and embrace what was around them. Maybe in hindsight they knew that we would always be profiled. Nothing was to prepare us for 9/11 – when, on that single day, the fate of all Muslims changed worldwide.

My dad was in the frontier when the War on Terror began. Marjan had phoned up asking him if he was okay. He had told her: 'Their soldiers will come and they will die and then they will go back.' Today, his premonition has come true. As schools close again and girls are denied education in Afghanistan, it is not too dissimilar to the microcosm created by my own community in the eighties and nineties in England.

Unlike my sisters back then, our next generation of girls in England were luckier. Of course, they were chaperoned door to door, but they were eventually allowed to go to high school, to college, to university. The women of my community no longer needed a go-between. It wasn't frowned upon for them to take strolls in the park, or to buy their own milk, their own clothes. Like me, they had found their own keys to the outside world.

ACKNOWLEDGEMENTS

I THOUGHT I WAS NEVER GOING to finish. The words came either pouring fast in episodic floods or sometimes too slow in droughts and famines. Then there was the looming question of whether each paragraph was good enough, did it have the languid but lyrical nature that I desired? But then I couldn't give you all prose, I was told I needed you to read to the end. Another time. I understand now why some sentences took so long to construct, and others just flowed out. But I kept tinkering, rewriting and rewriting and then the eventual letting go, which wasn't easy. These were stories of people that I cherished, that brought wonder into my life. As I kept writing, I began to understand them more, their positionality, their entangled struggles in their hostile environments. The race, class and gender issues. The patriarchy. I have cleansed some of my feelings in this ritual of writing. It's a series of vignettes of love for people who shaped me.

And through this voyage, I am forever grateful to Clare Conville,

my agent, for the care, the guidance and the advice – all hallowed. To Darren who went over line by line on the edit and made me smoke again. To Maria Alverez, my editor, for getting me through sometimes painful and sometimes very painful times. For Alex for your unwavering belief and support, and for not being too short with me. To Allison DeFrees for your guidance and great tea. To my sisters for reading the chapters regularly, and letting me tell your story. For Oriole for the free advice, (you know what I mean lol!) and also your long-standing support. For my other sisters Suki, Aisha, Sophia, whose stories are equally important. To all the inspirational women who have come into my life, to my brown brothers Haroon and Mahtab. To Jonathan, Megan and Jude and our walks in Harborne. To Celia for all your late-night WhatsApp conversations. To my team at Canongate and Hannah Knowles for taking my regular calls, even on a Sunday. I'm sure I've missed people out, but my heartfelt thank you to those I haven't been able to list.